capture indy™

Presented by

INDYSTAR★COM

Foreword

Capturing the essence of our city is no easy task. That's why we invited everyone with a camera to contribute to this book, and more than a thousand did just that.

Capture Indy is the end result of a substantial local effort. More than 600 of the metro area's best amateur and professional photographers submitted 8,962 photos. More than 3,500 users then voted three quarters of a million times to help determine which were the best photographs, which images best represented the Indianapolis area and ultimately which sights and faces make up this book. You'll find every photograph submitted on the accompanying DVD, and those voted among the best are included in the book.

The content and quality of the photos submitted make for a great book, but Capture Indy also is a celebration of everything that makes this the city we know and love. The work of the photographers who participated in this project is illustrative of our metro area's excitement, beauty, history and people.

Those of us at IndyStar.com and The Indianapolis Star thank all participants for making this book possible. Working on this project was a privilege, and we greatly appreciate the time and effort that the participants devoted in taking the photos, voting for the images and sharing their favorites with friends and family.

We believe this book is a reflection of all that is great about our city. Thank you for helping us capture Indy.

Table of Contents

About this book.

Capture Indy™ is the most unique book project ever conceived. It started with a simple idea: Lots of folks take lots of pictures of the Indianapolis area — many of which would be worthy of publishing in a fine-art, coffee-table book. Knowing that thousands of photos would be submitted, the question was then posed: How do we pick the best from the rest?

The answer was genius. We put the editing power in the hands of the people. Local people. People that know the Indianapolis area. People just like you. We asked photographers, doctors, union workers, musicians, moms, right-handed people, pants-wearing folks, or anyone from any walk of life to vote for what they considered to be the photos that best capture the Indianapolis area.

From 8,962 photo submissions to the pages of this book, more than 750,000 votes helped shape what you hold in your hands. It's something that's never been done before: publishing by vote. Enjoy it.

How to use this book.

Open. Look at the best pictures you've ever seen. Repeat. Actually, maybe there's a little more to it. First, be sure to check out the prize winners on page 142 (also marked with ★ throughout). You'll also want to watch the DVD. It has more than a thousand photos on it! Here's the caption style so you can be sure to understand what's going on in each photo:

PHOTO TITLE *(position on page)*
Location photo taken, if available
Caption, mostly verbatim as submitted. 📷 **PHOTOGRAPHER**

Copyright info.

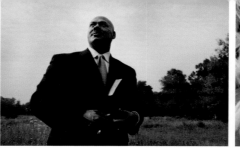
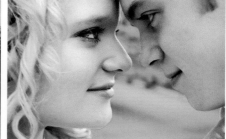

Friendly Faces

SPONSORED BY IUPUI

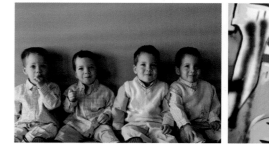

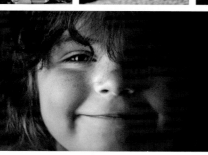
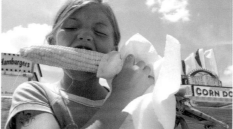
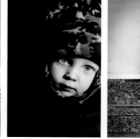
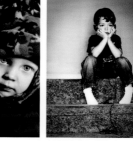
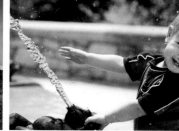

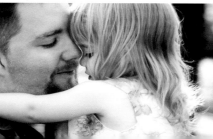
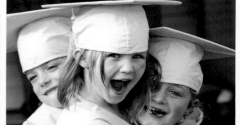

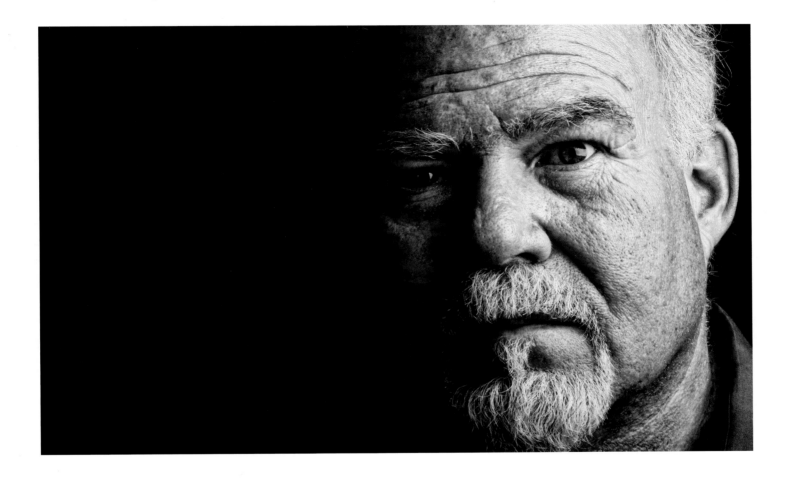

★ **RON** *(above)*
Do you think this self portrait captures the true me? 📷 **RON SANDERS**

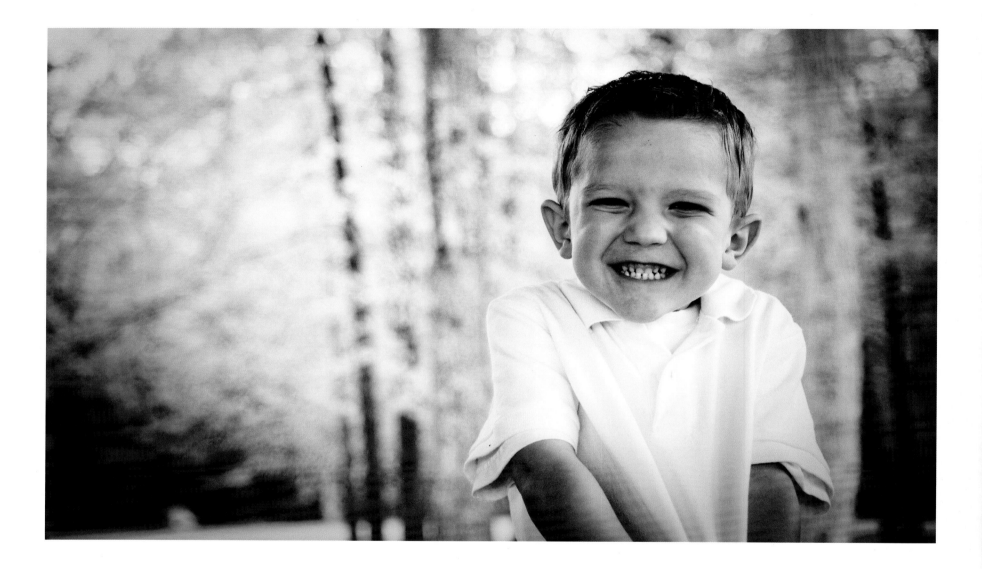

ESTON *(above)*
Southeast Way Park
Say cheese! 📷 **JEFF SULLIVAN**

TRIX *(opposite left)*
Fishers
Trix ... are for kids. 📷 **RYAN BURWELL**

LOVING HIS SWING *(opposite right top)*
Greenwood
The swing is his favorite place to be.
📷 **JON HERING**

ALWAYS HAPPY *(opposite right bottom)*
He is so full of love. 📷 **AMANDA HAYNIE**

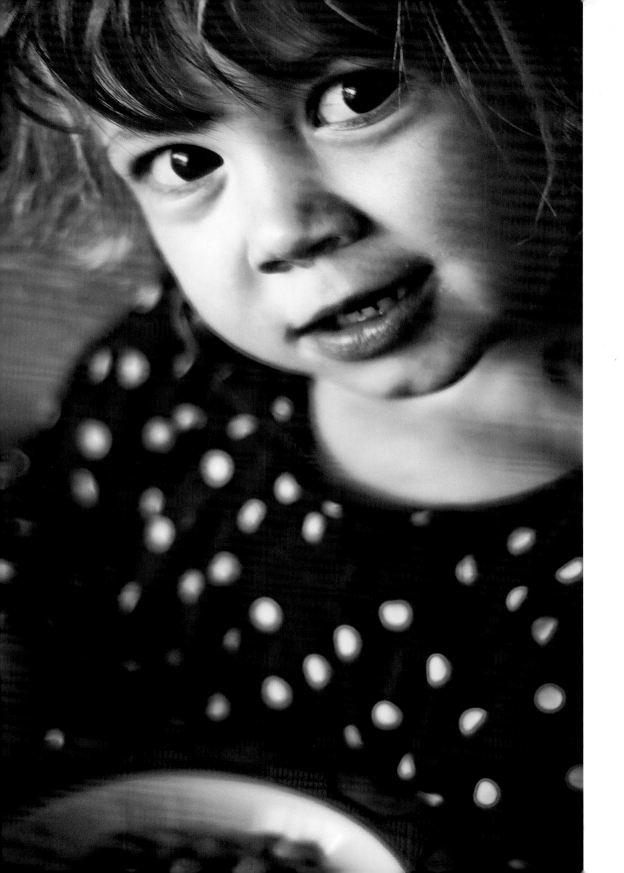

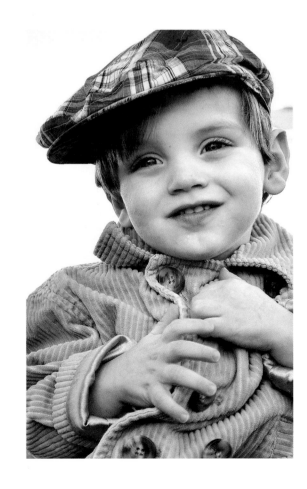

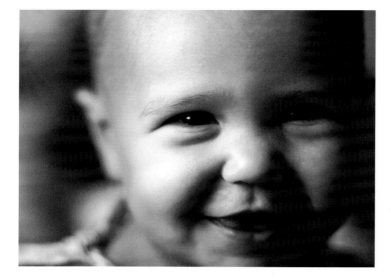

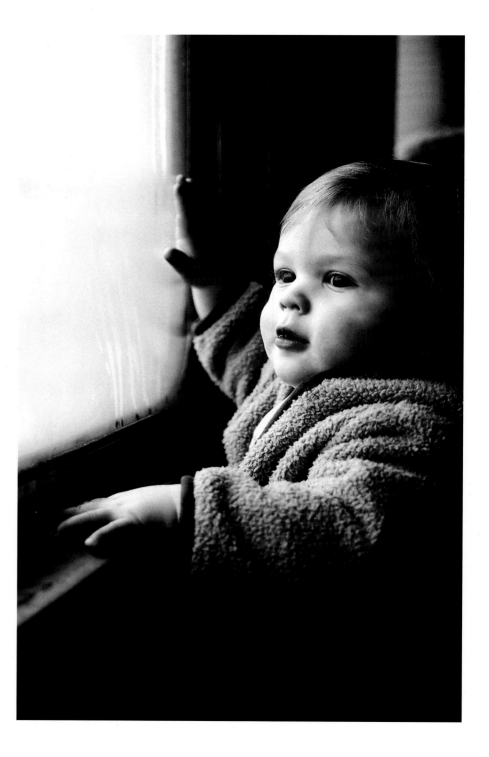

SUNSHINE *(above)*
My sunshine on cloudy days. 📷 **JOSH ADAMS**

RIDING *(right)*
Fishers, IN
First ride on the Polar Bear Express. 📷 **CURTIS GLEIM**

BRIGHT AND EARLY *(opposite top)*
Carmel, Indiana
Our little guy is a morning person. He wakes up happy and ready to start the day.
📷 **KATHY SHREVE**

BABE IN TOYLAND *(opposite bottom)*
Greenwood, IN 📷 **T. JASON WRIGHT**

GIGGLES *(following left)*
Garfield Park
Just being kids in the park ... smiles come from the heart, giggles come from the toes. What it would be like to be a kid again! 📷 **KRISTINA MOFFETT**

★ **SMILES & SLUSH** *(following right)*
Plainfield, Indiana
Despite the cold and rainy conditions of the "first day of winter," Plainfield resident Allison Williamson managed to smile enough to keep warm. 📷 **EMILY WINSHIP**

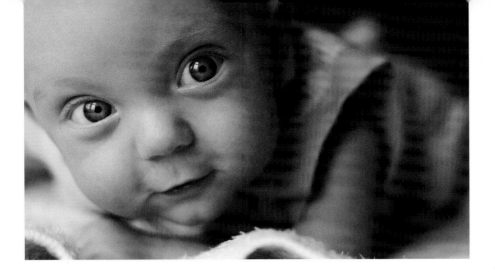

" It's not too hard to spot the real thing!
— T. JASON WRIGHT / BABE IN TOYLAND

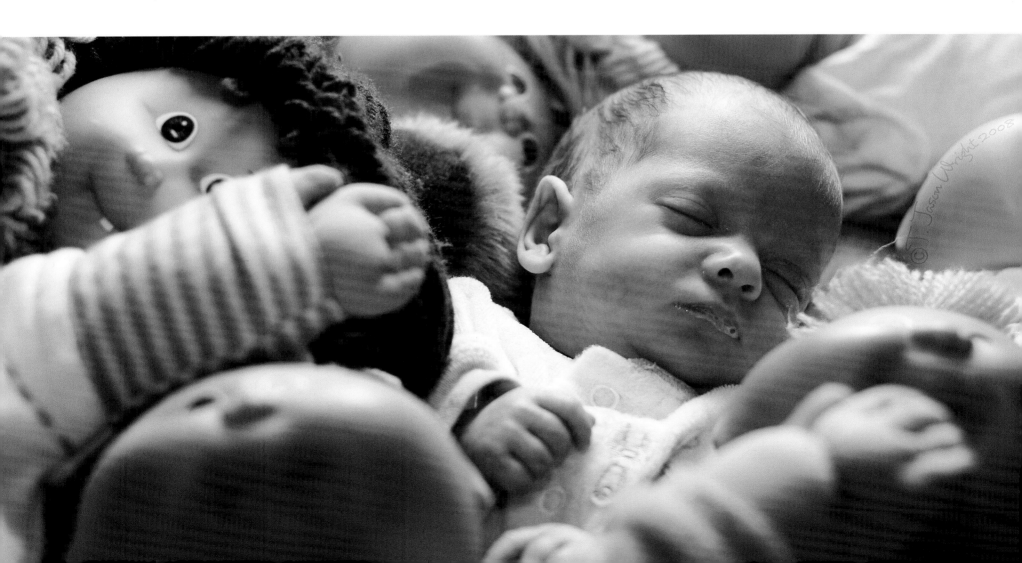

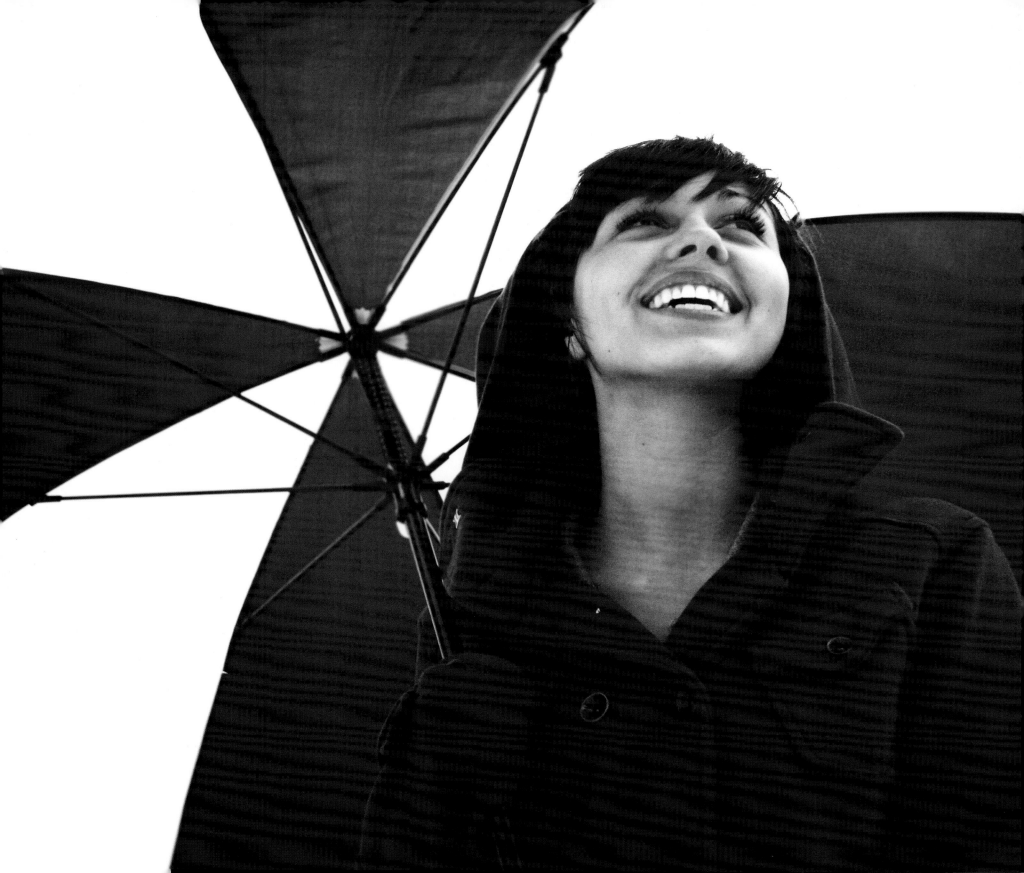

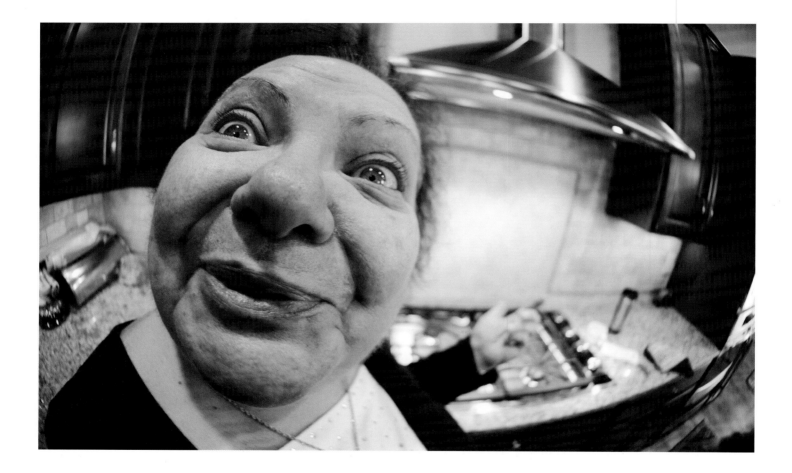

WHEEL OF FORTUNE: IU STYLE (above)
Boys and Girls Club, Indianapolis
A young boy spins the "wheel of fortune" as an Indiana University Cares volunteer looks on. 📷 **PRABHAKAR KODURI**

HIDING IN JACKET (left)
Happy! 📷 **ANDREA SANDERS**

MOM – COCO (opposite)
Indianapolis
Playing around with a fisheye lens... she's a good sport.
📷 **SERGE MELKI**

CHERI WHITE (right)
Cheri White, chief pilot and general manager of the Balloon Team. 📷 **PAUL D'ANDREA**

TAKE THE PICTURE ALREADY (opposite)
Cheese! 📷 **ANDRE DENMAN**

MONGOLIAN DANCER (opposite left top)
Dulamsurem, a Mongolian dancer, prepares for the Dalai Lama arrival at the Tibetan Cultural Center for a ribbon cutting ceremony. 📷 **DANESE KENON/INDYSTAR.COM**

SALUTE (opposite left bottom)
James Edwards of the Montford Point Marine Association salutes during the 11th District of Indiana's 'A Memorial for Vietnam Veterans' in Crown Hill Cemetery . 📷 **DANESE KENON/INDYSTAR.COM**

WISHING (opposite right)
Greenfield, IN
Wishing on a dandelion. 📷 **AMANDA HAYNIE**

MUSCLES (below)
Nora
Christopher Robbins (CJ) is showing off his muscles for his Mom. 📷 **LOU TAYLOR**

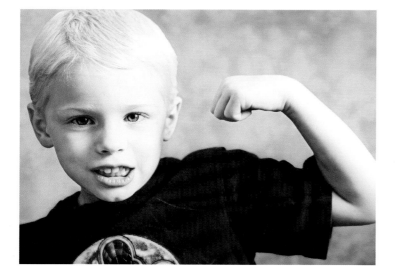

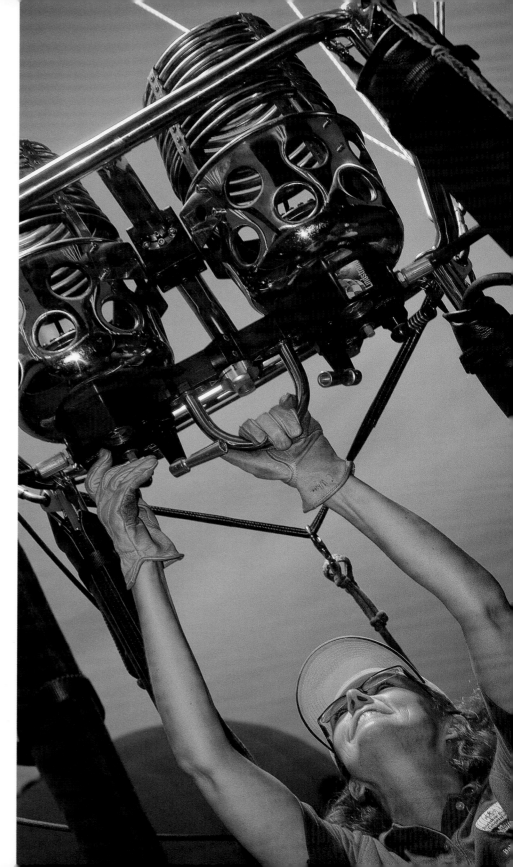

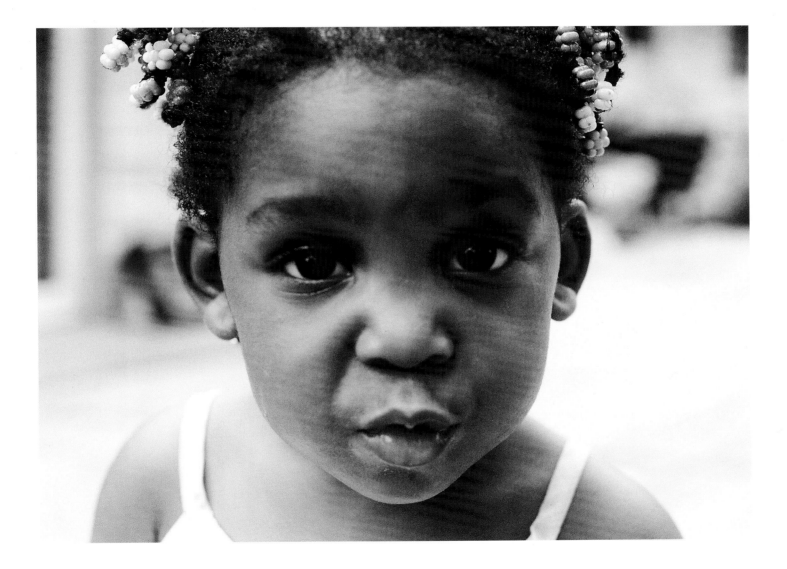

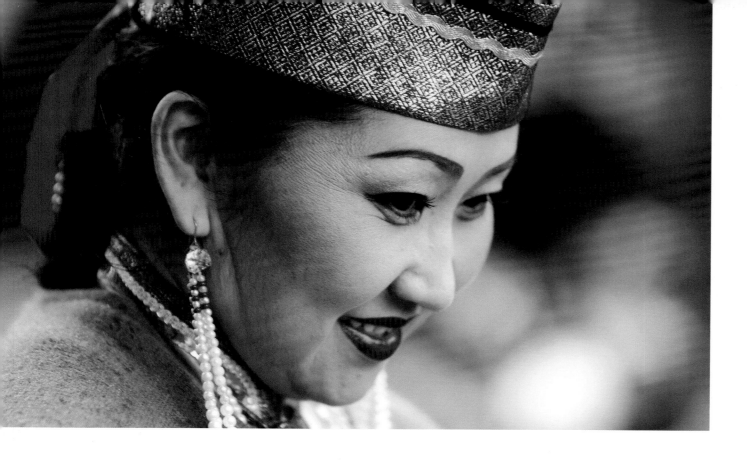
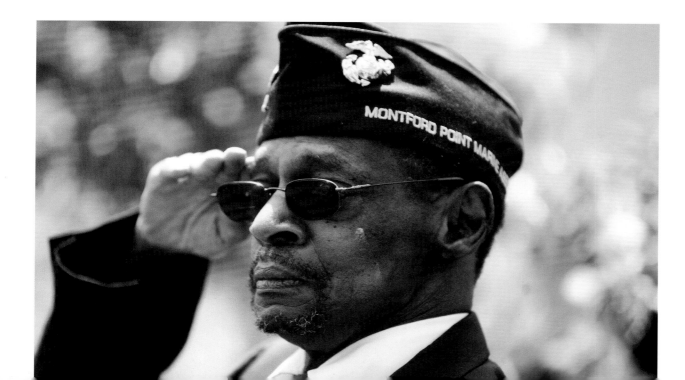

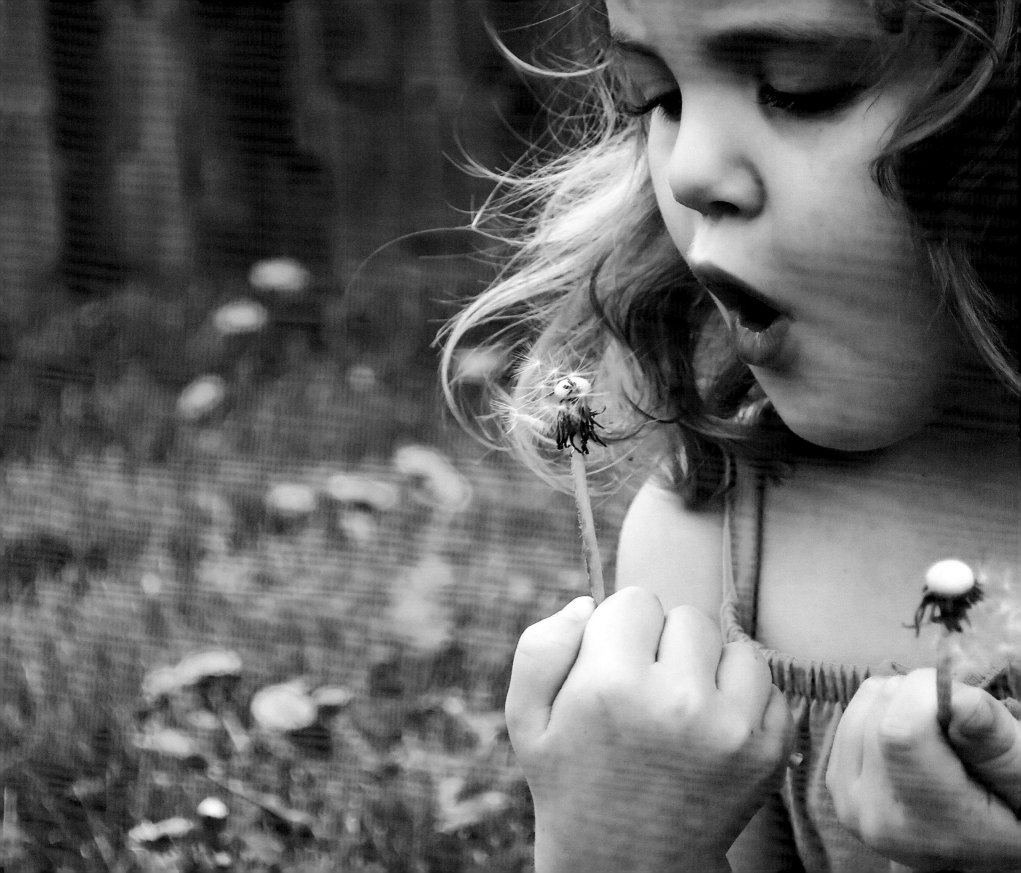

Scapes of All Sorts

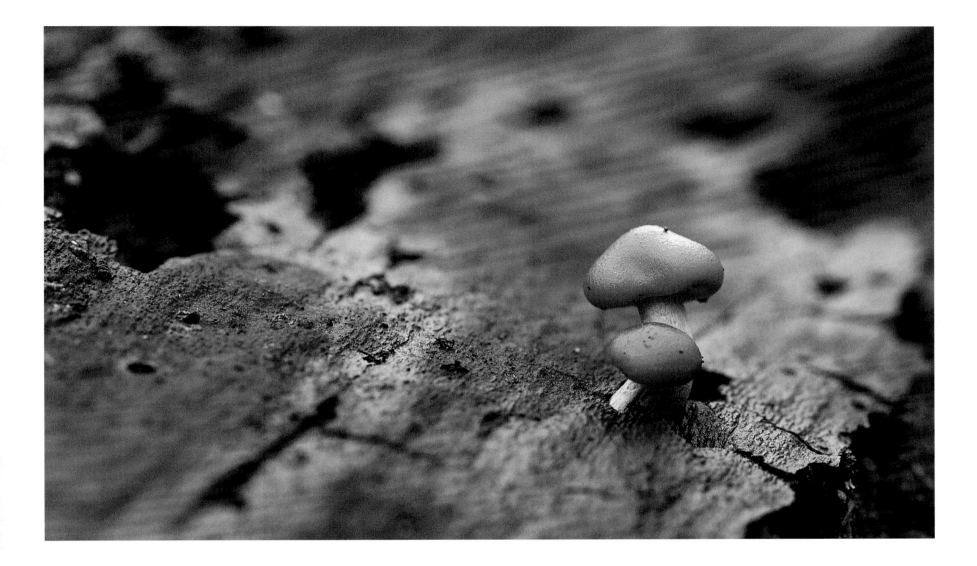

" On a blustery day in January, I threw the camera in the car and headed off across the frozen fields to look for an image that defined central Indiana. This was as close as I could come to it. — BRET ROBINSON / FRIGID WINDMILL

FRIGID WINDMILL *(right)*
West of Pittsboro
📷 BRET ROBINSON

INDIANAPOLIS COUNTRYSIDE *(below)*
Not far from 146th St. and Michigan Rd.
The Indianapolis area has some beautiful countryside to offer.
📷 KEVIN MILLER

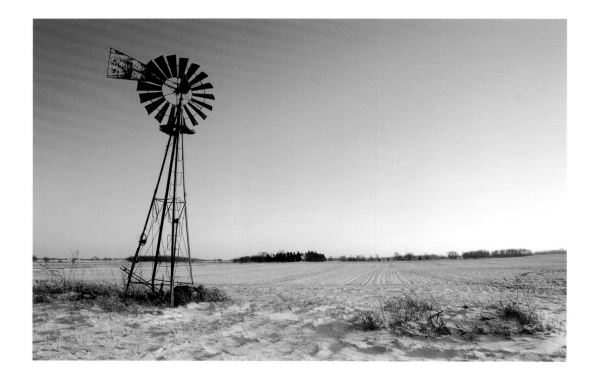

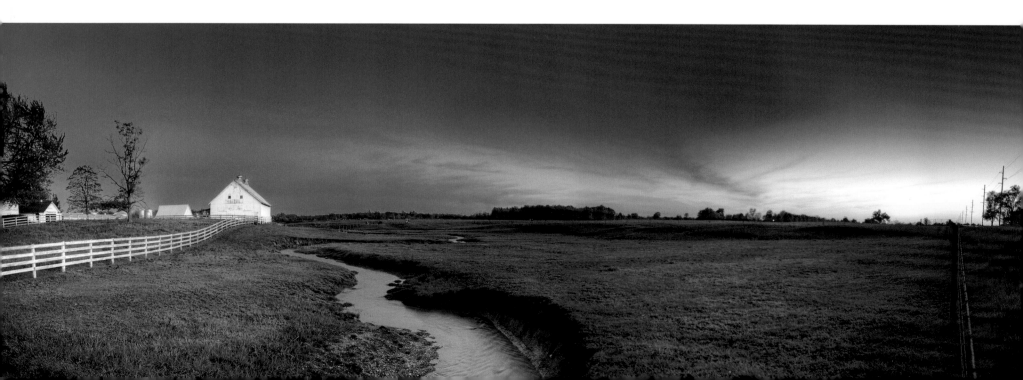

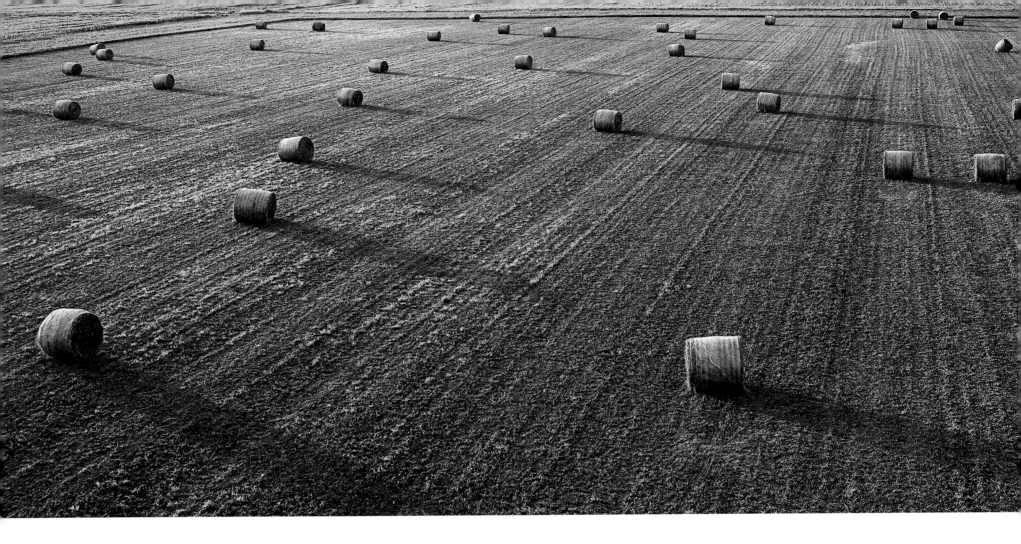

HAY ROLLS *(above)*
Greenwood, Indiana
Hay rolls decorate a field in Greenwood,
Indiana. 📷 **T. JASON WRIGHT**

FIELD OF WHEAT *(left)*
Indianapolis, Indiana
Spending time in the country just out-
side the city on a breezy Indiana day.
📷 **MATTHEW YEOMAN**

WHEAT SUNSET *(following left)*
Westfield
Scenic sunset over a farm in Westfield, Indiana. Only one mile
south new subdivisions of Carmel sprawled over former corn fields.
📷 **ALEXEY STIOP**

NATURE'S ART AT THE IMA *(following right)*
Indianapolis Museum Of Art
Beautiful Sugar Maple tree shows its Autumnal blush on the grounds
of The Indianapolis Museum Of Art. 📷 **WILLIAM DAWSON**

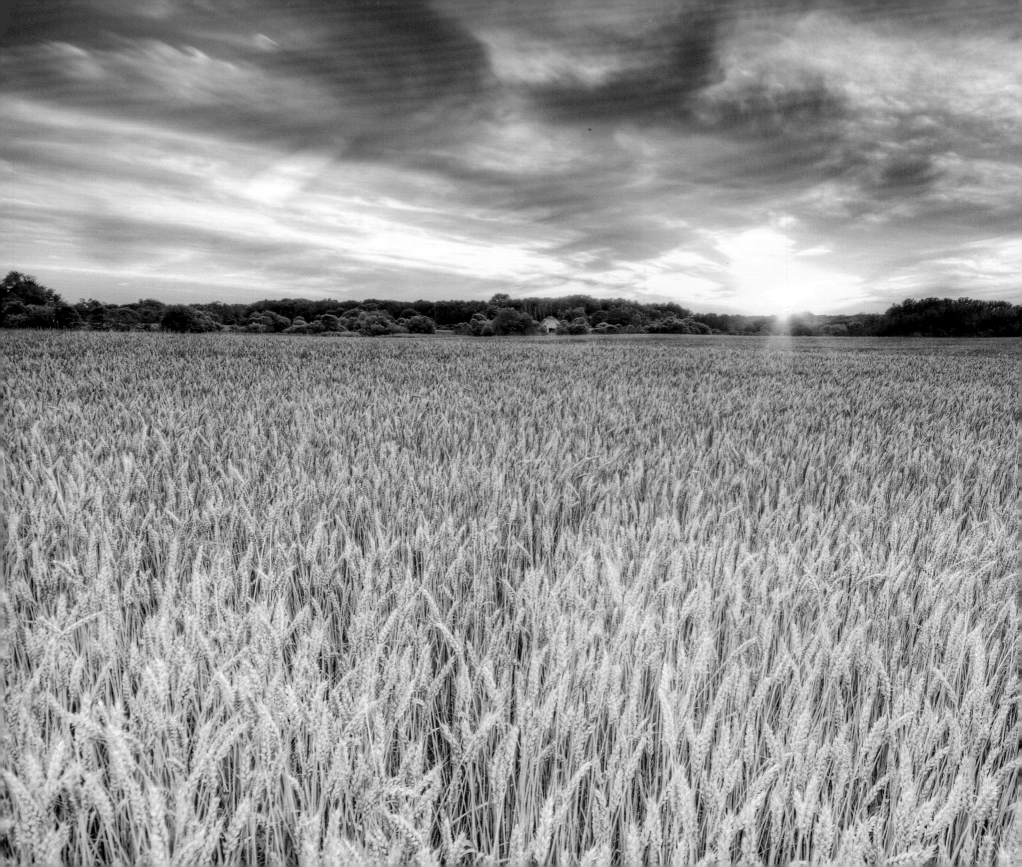

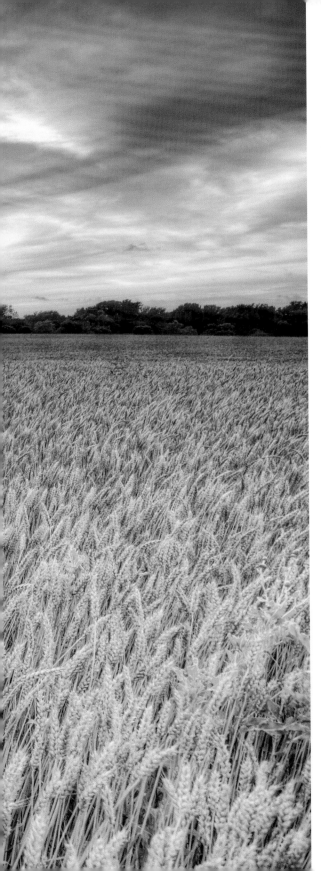

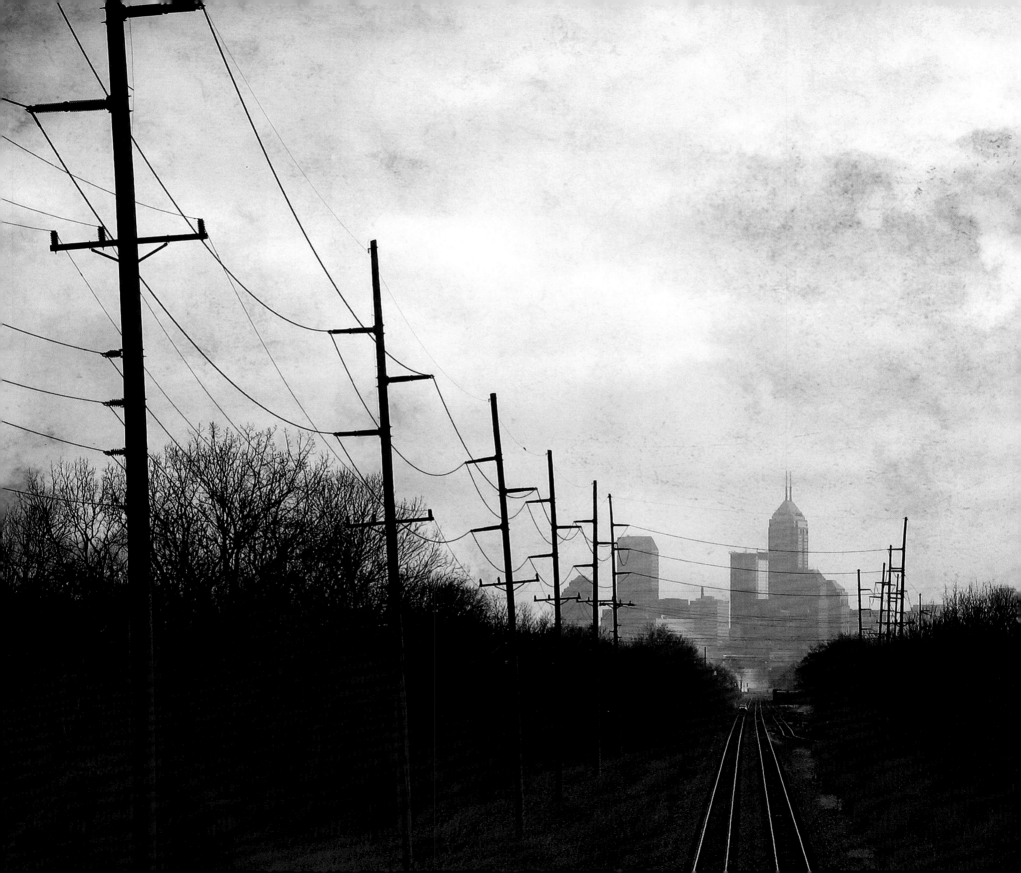

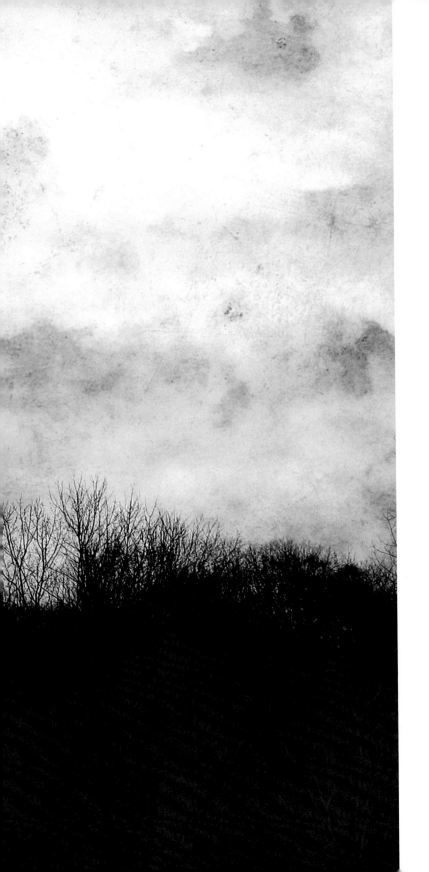

> **❝** I've driven past this many times and always say I'm gonna stop but never have time. But, this time I did, and here is the final result.
>
> — AGNIS FLUGEN / VANISHING POINT

VANISHING POINT *(left)*
Holt Road near West Washington Street
This was taken on an overpass off of Holt Road. 📷 **AGNIS FLUGEN**

UNTITLED *(following left)*
Meridian Street, Monument Circle 📷 **JOSHUA HOLLANDSWORTH**

UNTITLED *(following right)*
Abandoned Indianapolis. 📷 **GARY MEAD**

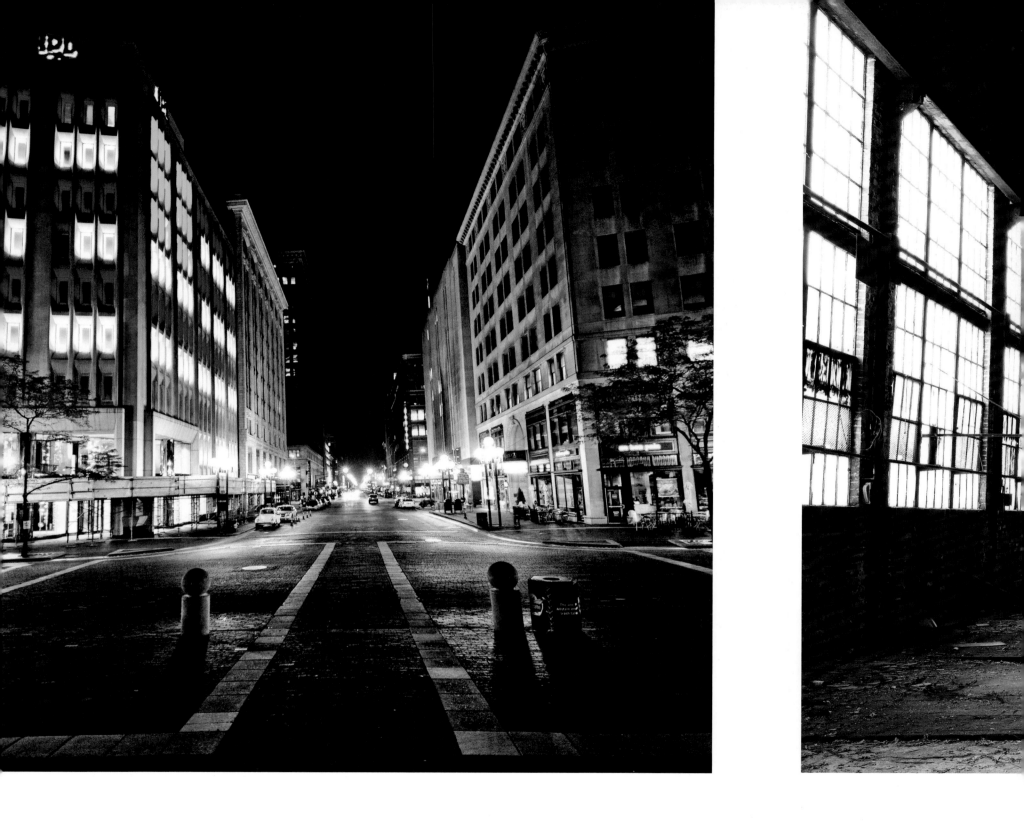

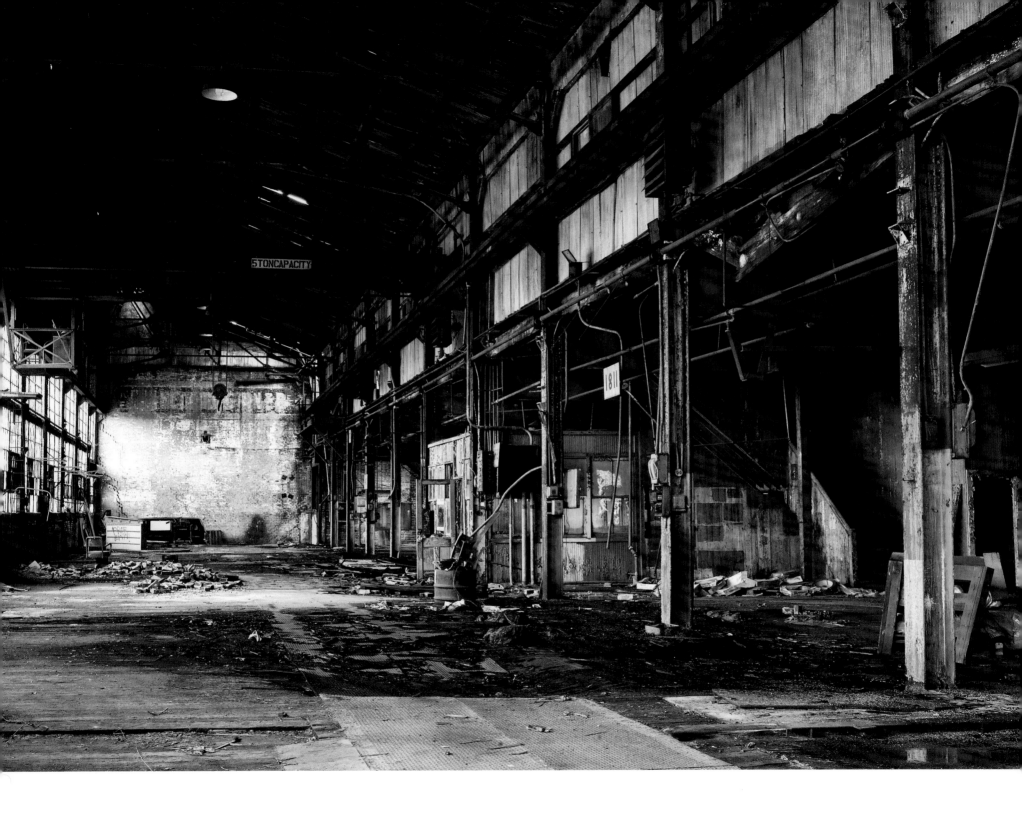

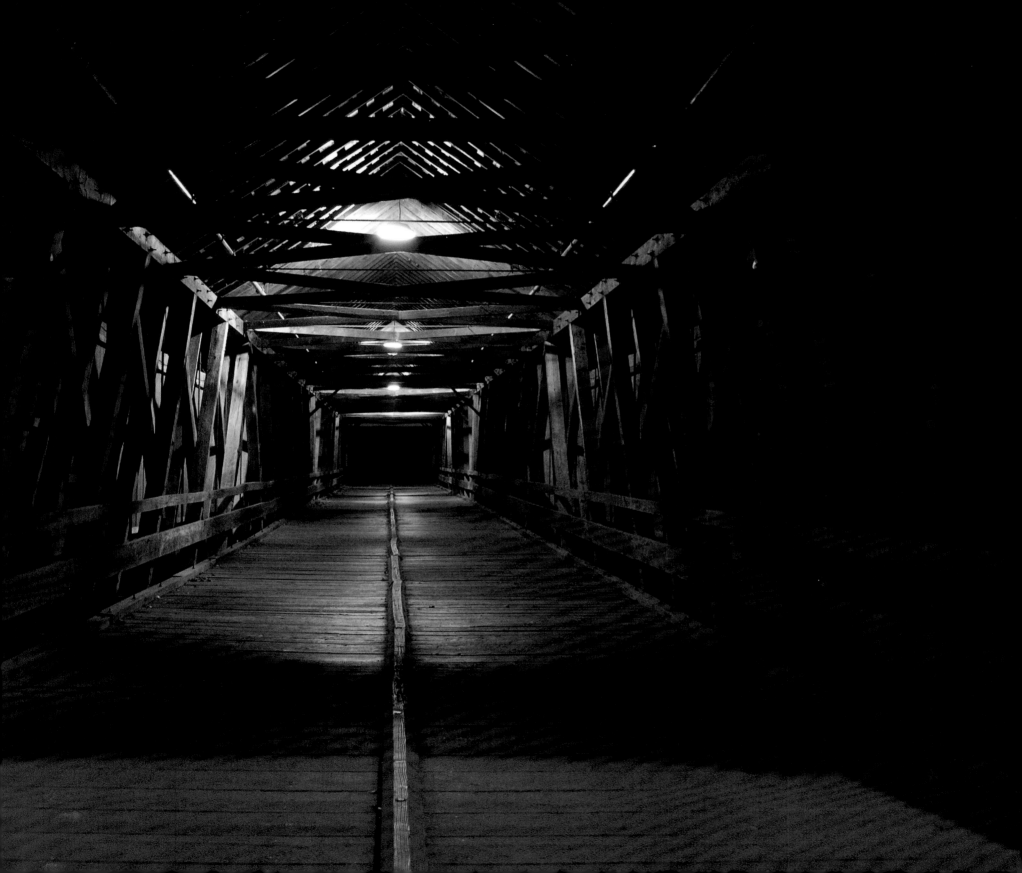

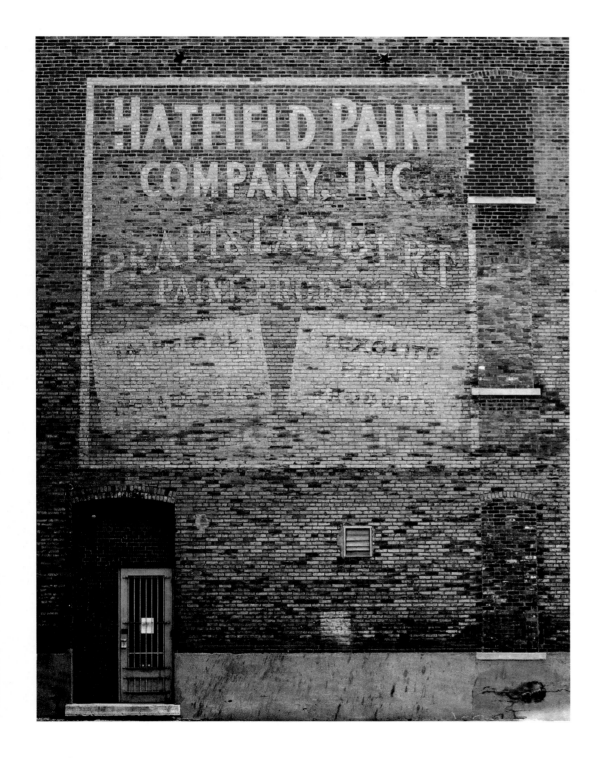

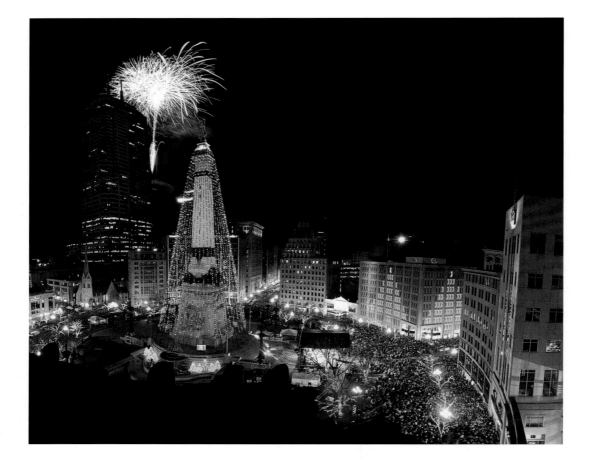

CIRCLE OF LIGHTS (above)
Downtown Indianapolis
Indianapolis Circle of Lights festival 2008
📷 **MARC LEBRYK**

★ **FOURTH OF JULY** (right)
Fireworks reflect in the White River in
downtown Indianapolis on the Fourth of July.
📷 **ALEXEY STIOP**

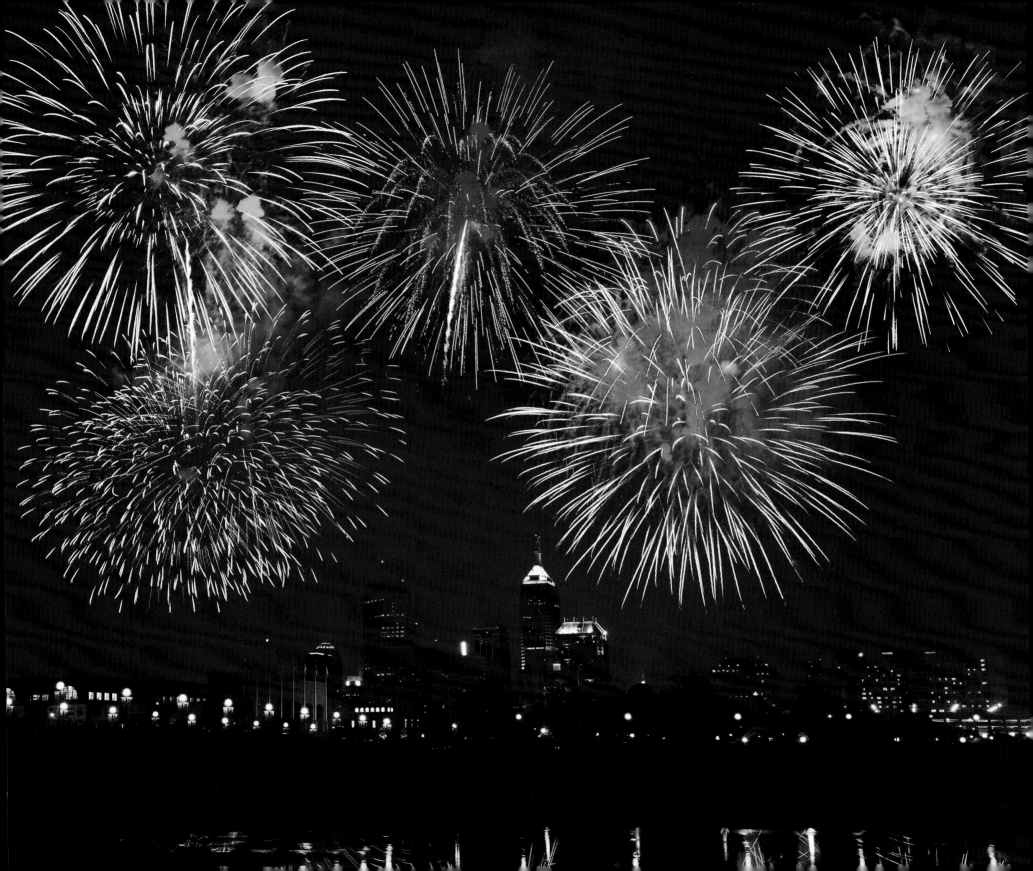

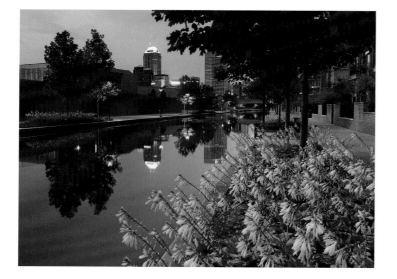

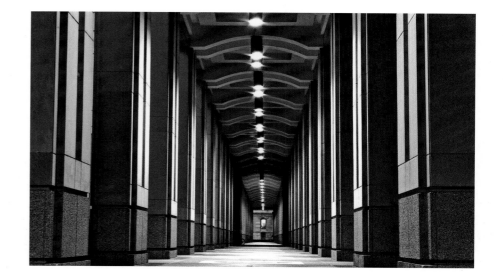

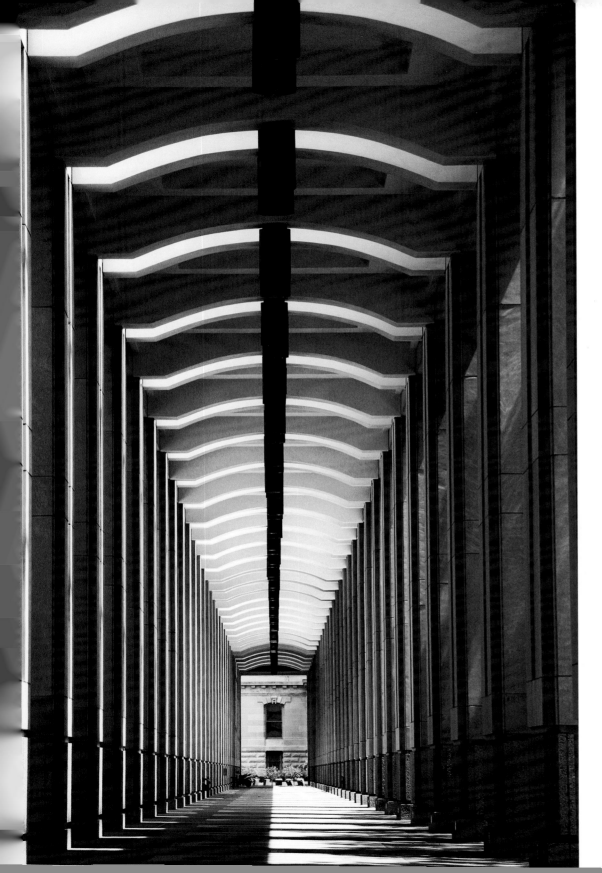

**THE INDIANA GOVERNMENT
CENTER WALKWAY** *(left)*
402 W. Washington St., Indianapolis
Take a thoughtful stroll among shadows and light. 📷 **SALLIE PEELER**

VIEW TO THE SOUTH *(opposite top)*
Looking south from the exact center of downtown, from the top of
Soldiers and Sailors Monument. 📷 **DUANE DART**

CENTRAL CANAL, DAWN *(opposite bottom left)*
Indianapolis Canal Walk
Indianapolis Central Canal at dawn. 📷 **PHILIP JERN**

**INDIANA STATE
GOVERNMENT CENTRE** *(opposite bottom right)*
Indianapolis
Love the long hallway and pillars. 📷 **HOOI KUAN TAN**

CANAL IN THE DARK *(following left)*
Canal Walk next to Indiana State Museum
An early morning view looking east from the canal walk.
📷 **DAVID STEPHENSON**

★ **INDY CANAL SUNRISE** *(following right)*
Sunrise over the Indianapolis Canal. 📷 **STEVE STANDIFER**

33

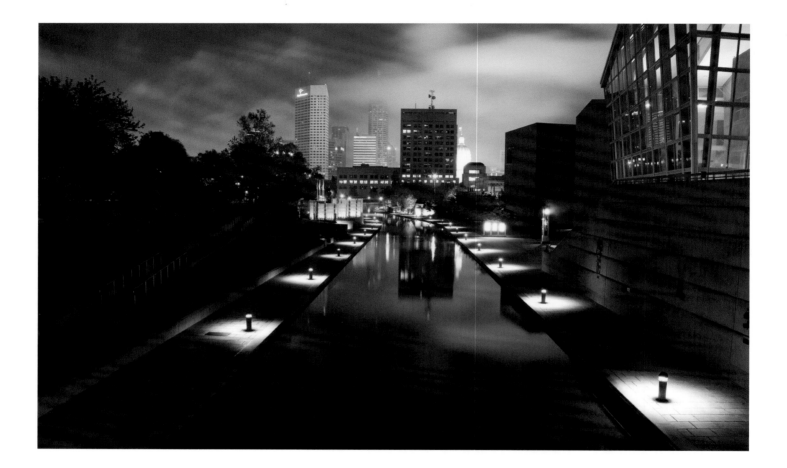

"The long exposure helped give the clouds an interesting look. This photo was taken at 4:30 am, May 2009. — DAVID STEPHENSON

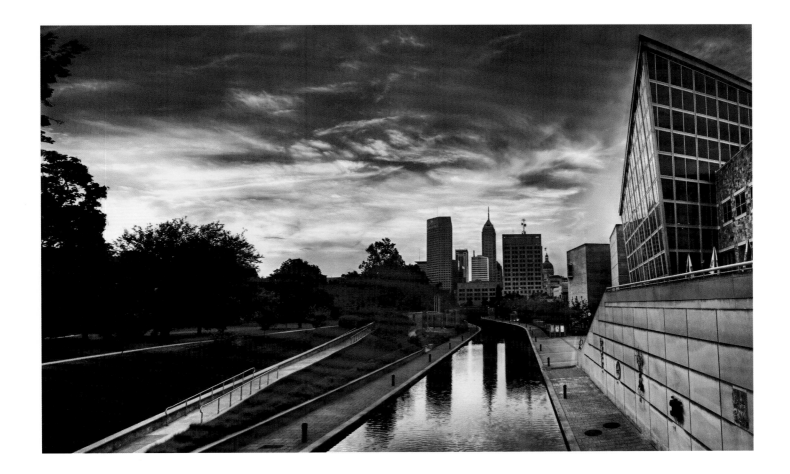

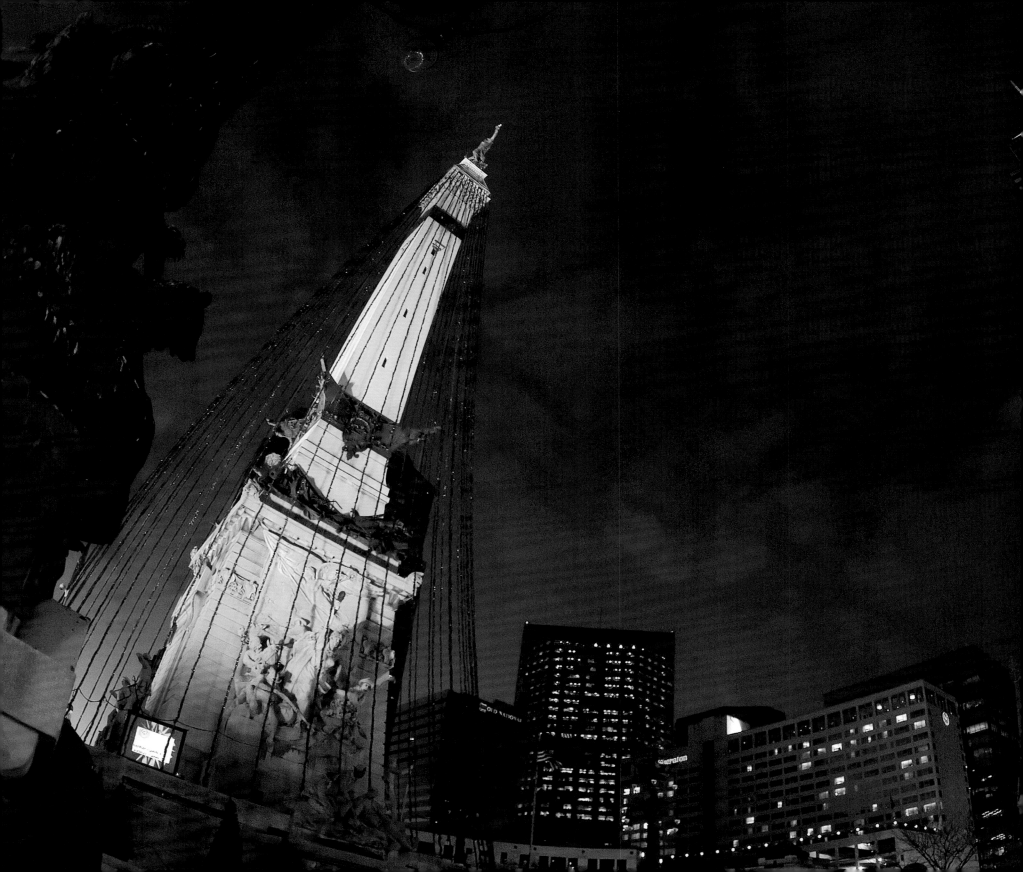

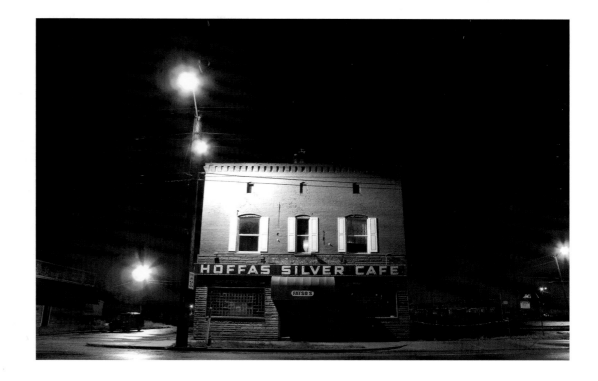

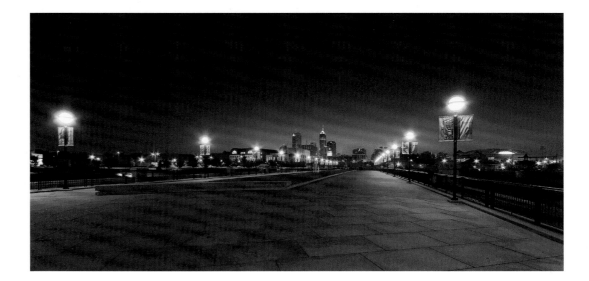

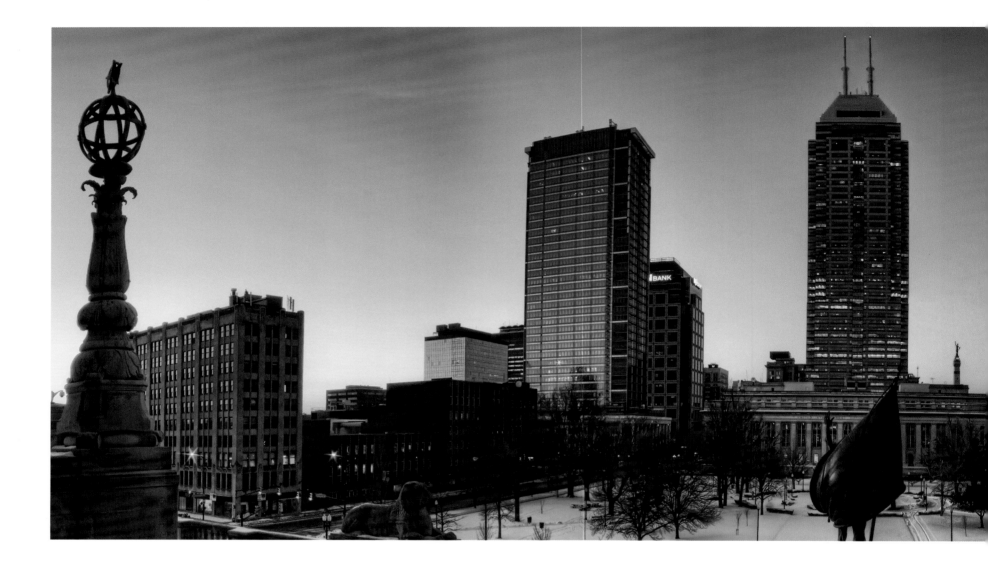

UNTITLED *(previous left)*
Downtown Indianapolis
Monument Circle before the start of the Circle
of Lights Festival. 📷 **MARC LEBRYK**

HOFFAS SILVER CAFE *(previous right top)*
West Indianapolis on Oliver Street
This bright gem shines in the night in west
Indianapolis. 📷 **CURTIS BILLUE**

BRIDGE AT DAWN *(previous right bottom)*
White River State Park, Indianapolis
The pedestrian mall over the White River at
dawn. 📷 **PHILIP JERN**

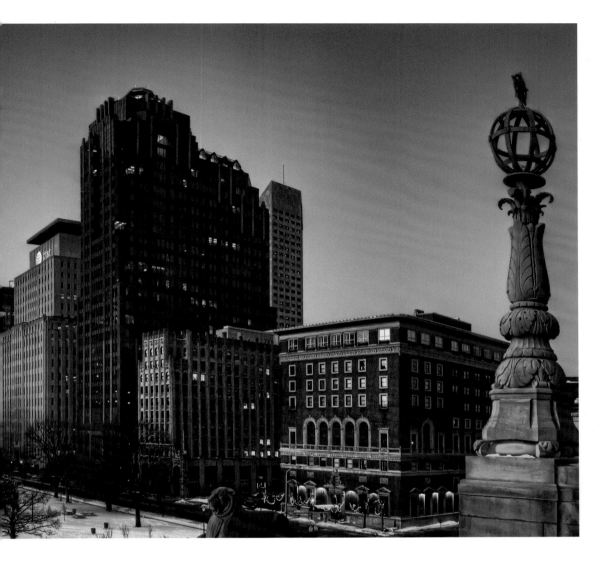

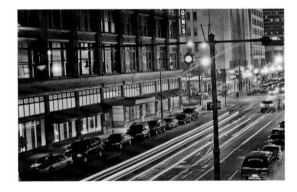

SUNRISE IN THE CITY *(above)*
Sunrise on the downtown skyline, shot
from the steps of the War Memorial.
📷 **CARL VAN ROOY**

**MERIDIAN STREET
LIFELINE** *(right top)*
Meridian Street, Downtown Indianapolis
The vein that keeps the city of Indianapolis'
heart beating. 📷 **ROBERT HAAG**

A NIGHT ON THE TOWN *(right bottom)*
Downtown Indianapolis
The view from a downtown parking garage.
📷 **ALLY MCNUTT**

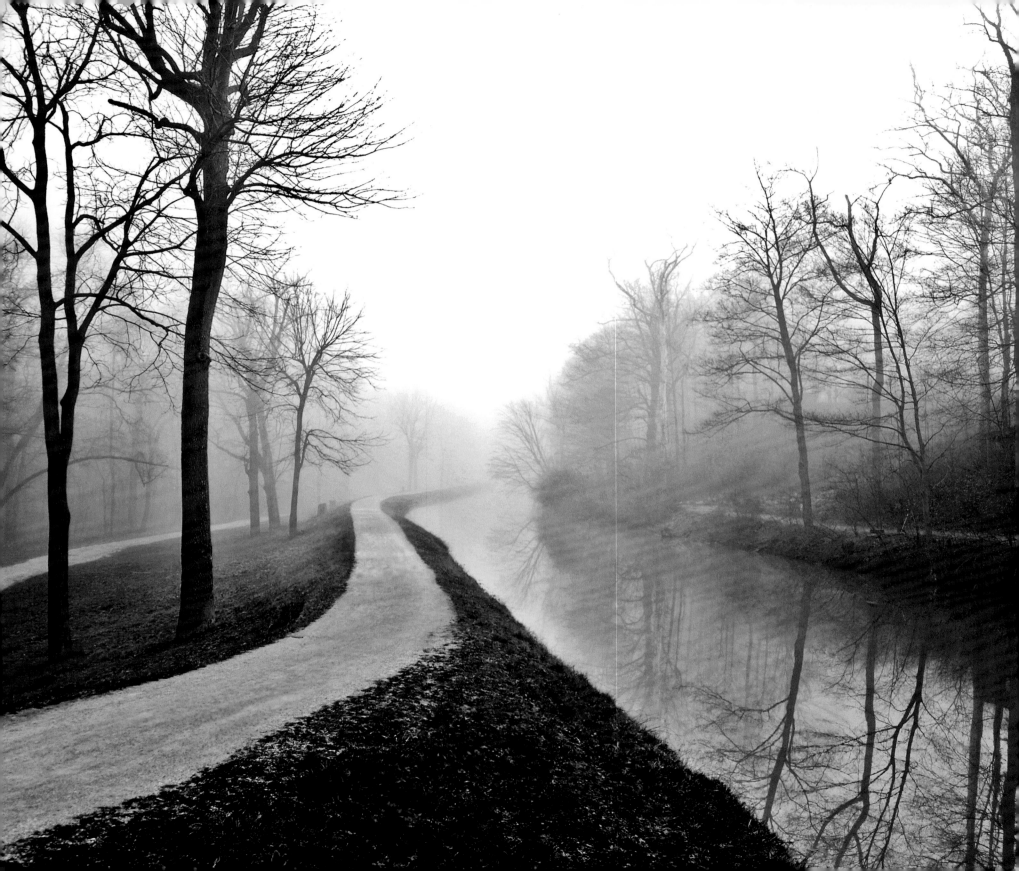

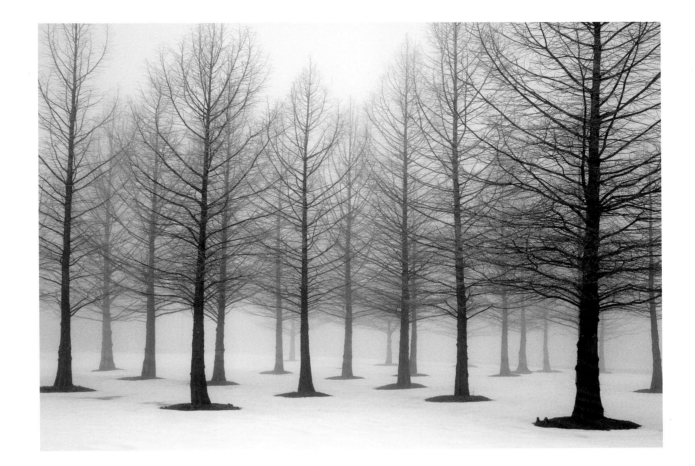

TREES IN FOG *(above)*
A small grove of snowbound trees on Indy's north side takes on an eerie appearance in early morning fog. 📷 **PAUL ANDERSON**

MORNING MIST *(left)*
Foggy morning on the canal behind the Indianapolis Museum of Art. 📷 **LESLEY ACKMAN**

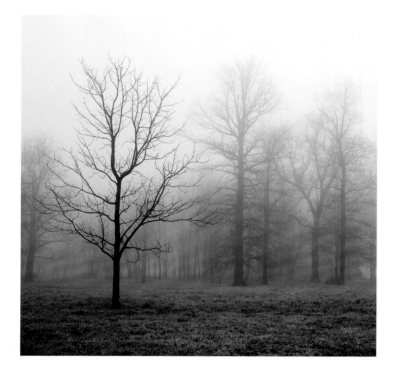

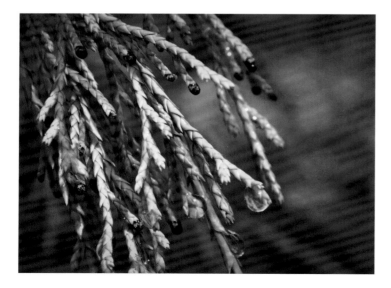

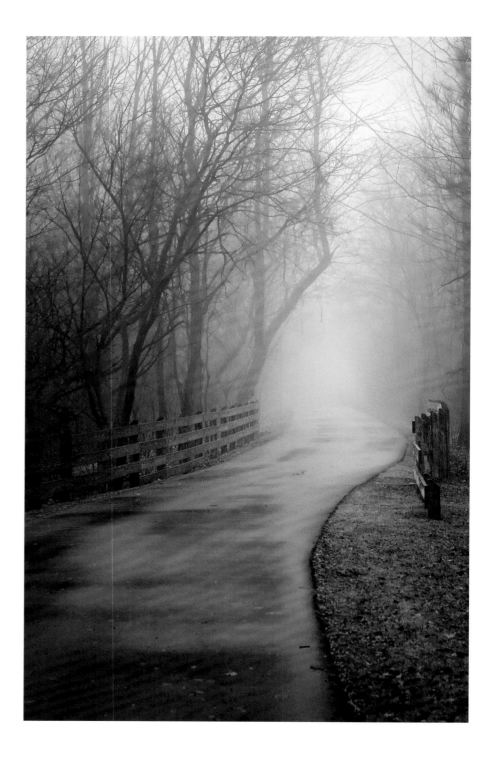

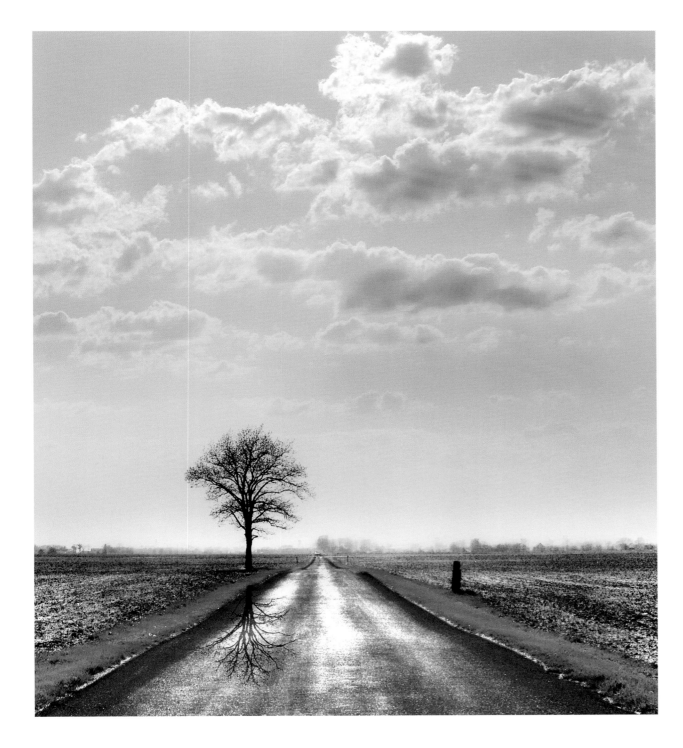

THE ROAD TO INFINI (left)
West of Kokomo
The long farm roads of rural Indiana.
📷 **DARIO INFINI**

EARLY MORNING FOG (opposite left top)
Hamilton County, Indiana
A stand of trees in the early morning fog.
📷 **WENDY KAVENEY**

DEW DROPS (opposite left bottom)
Indianapolis Museum of Art
Dew drops cling to the tree as the sun rises in
the morning sky. 📷 **LESLEY ACKMAN**

THE TRAIL (opposite right)
Plainfield, Indiana
One of the first damp days of winter along the
newly paved walking trail that used to be a
train track. 📷 **DAN WINSHIP**

★ **FOGGY MORNING**
COUNTRYSIDE (following)
Greenwood, Indiana
Fog covers the landscape on this morning in
Johnson County, Indiana. 📷 **T. JASON WRIGHT**

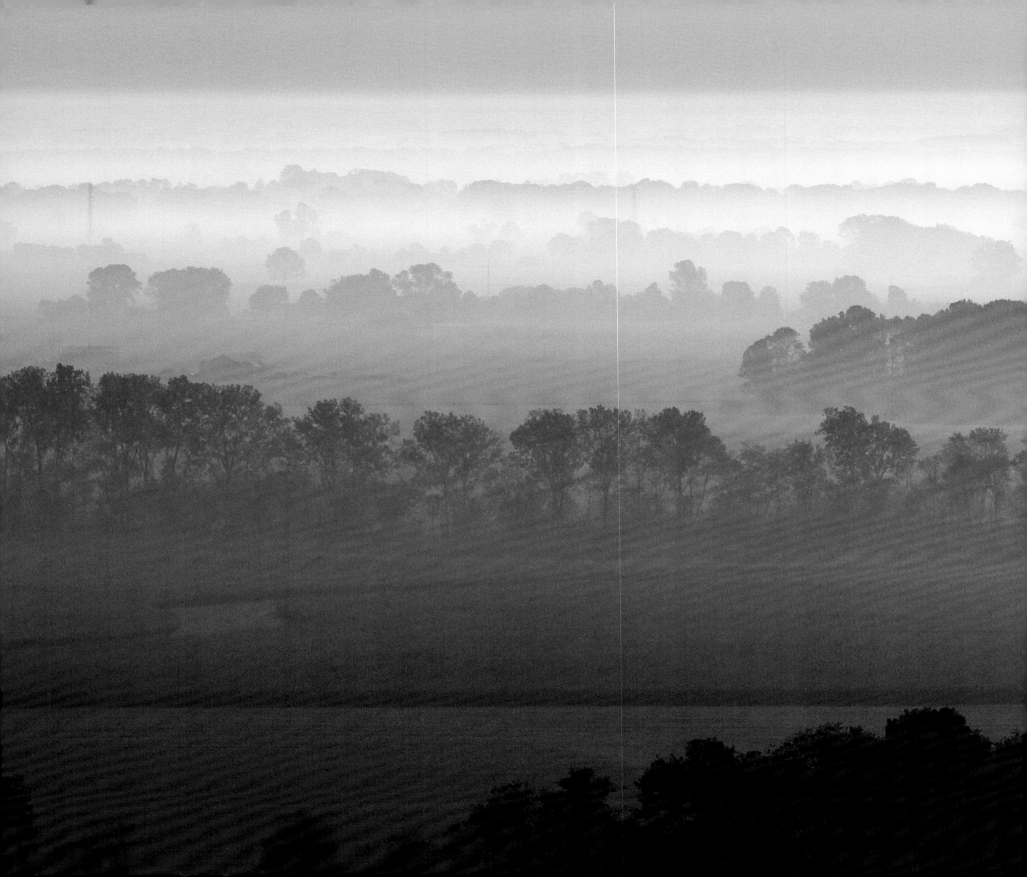

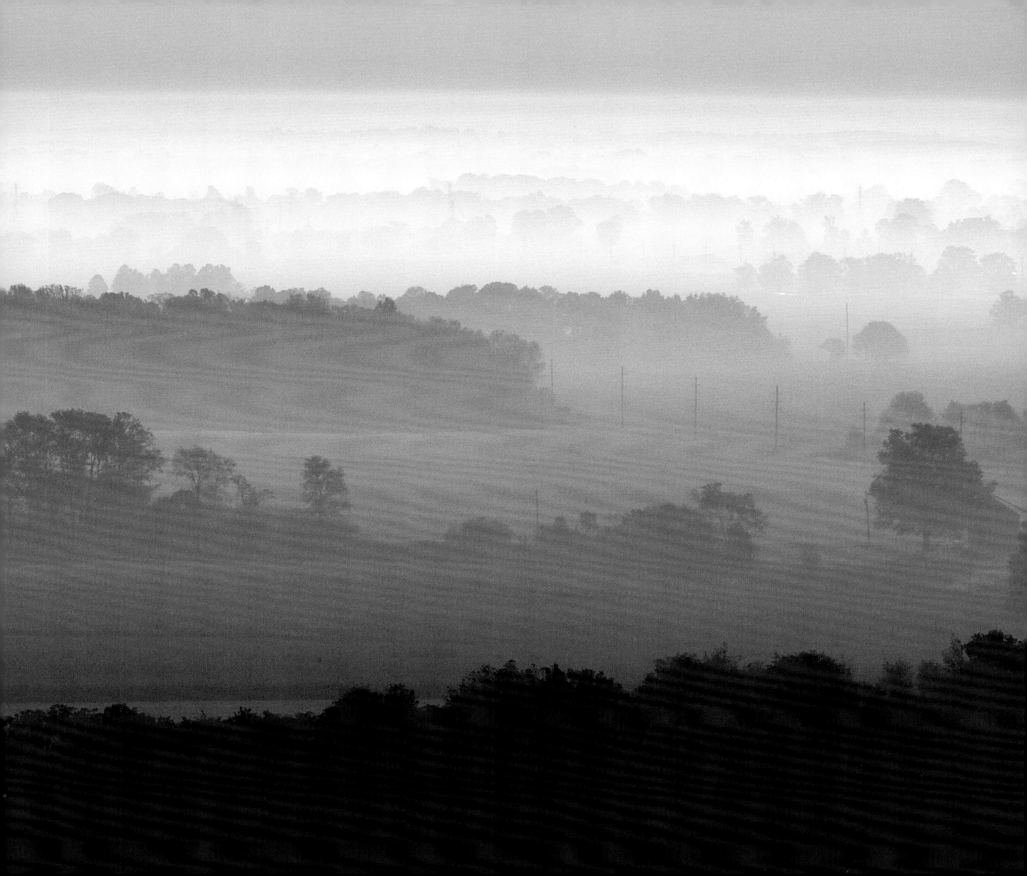

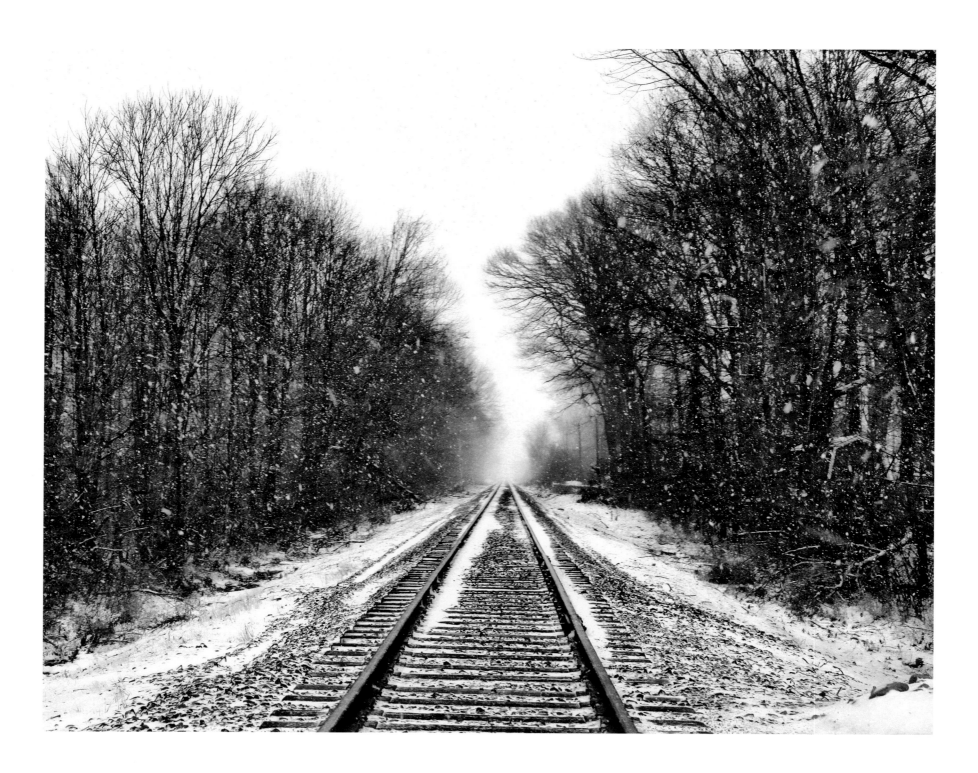

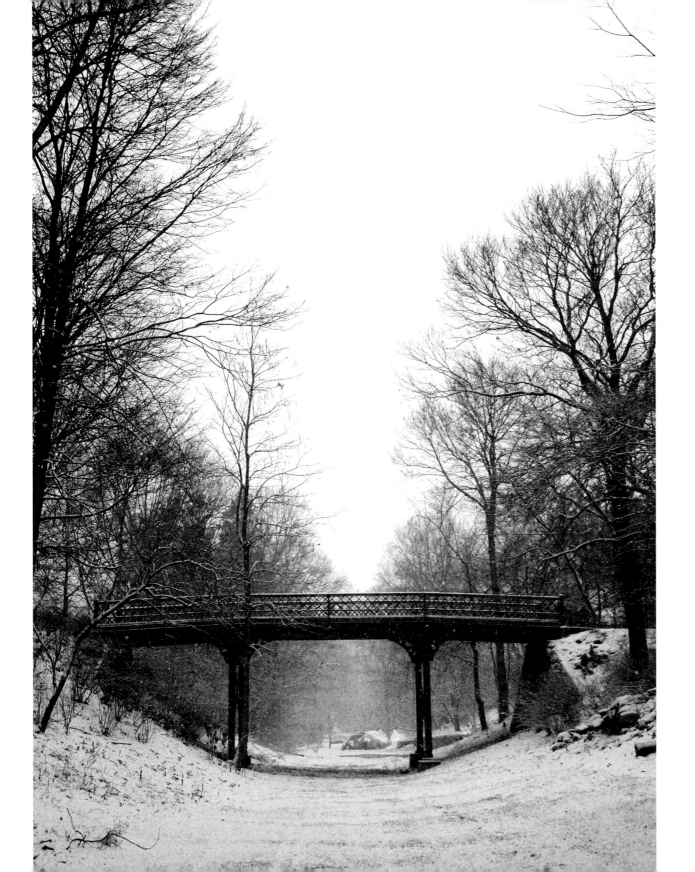

BRIDGE AT IMA *(left)*
📷 **DANIEL BURROUGHS**

THE SNOWS A FLYING *(opposite)*
Off of Post Road
Taken while driving in a slight snow storm on slick roads. Stopped on rail road tracks with a car behind me blowing his horn! Do I love taking photos or what? 📷 **LISA HANNAH**

47

GOLDEN STREETS *(right)*
Bargersville, IN
The sunset lit the streets up like they were on fire this night. Taken while piloting an ultralight aircraft. 📷 **T. JASON WRIGHT**

EARLY RIDER *(opposite)*
Early morning fog (and the photographer's bicycle and camera bag) at Fort Harrison, on the northeast side of Indianapolis. 📷 **JOHN DAILY**

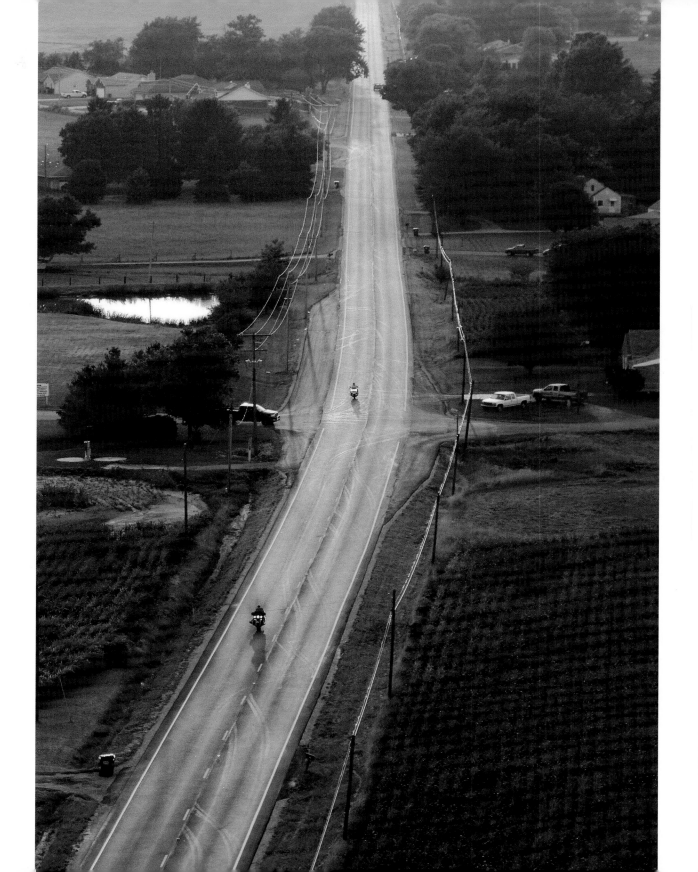

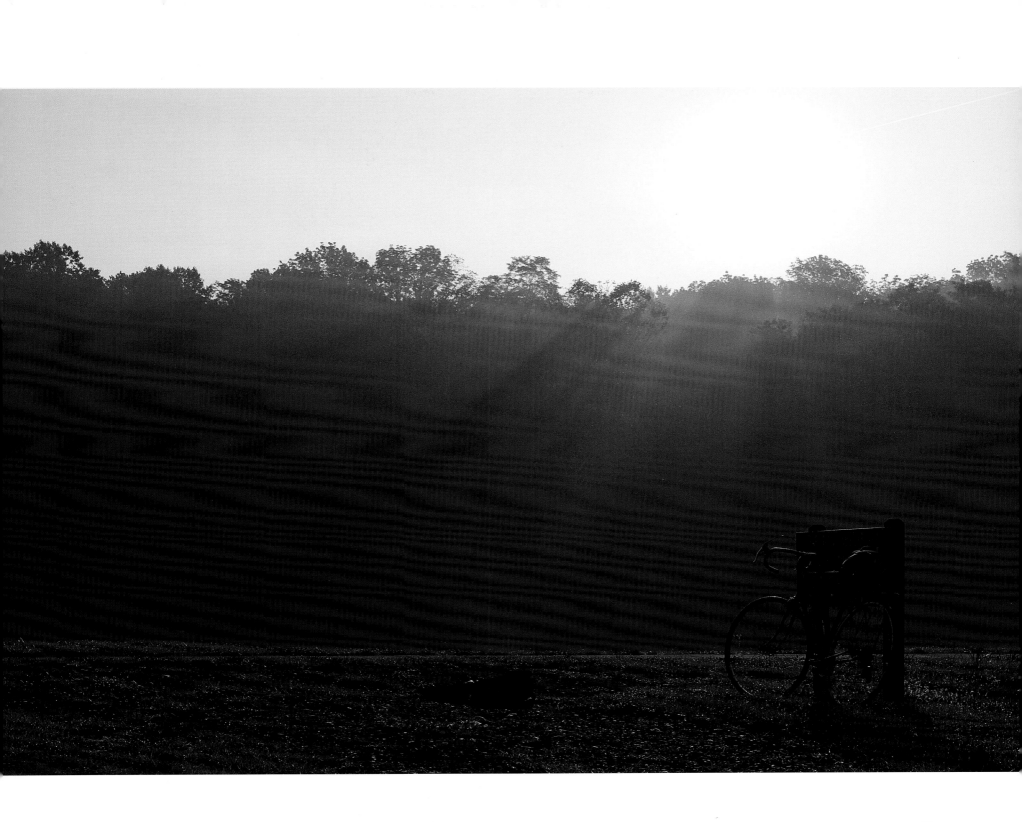

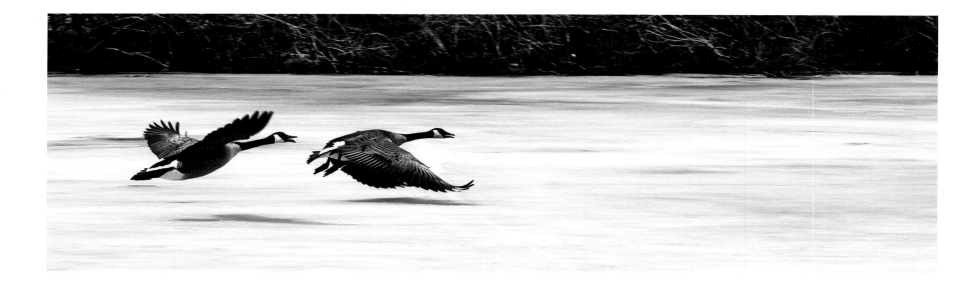

CLEAR THE RUNWAY! *(above)*
Eagle Creek State Park
Honking loudly, two Canada geese take flight over an icy pond at Eagle Creek State Park in Indianapolis. 📷 **PAUL ANDERSON**

CHIPPY *(right)*
Eagle Creek
This Chippy calls the bird sanctuary at Eagle Creek home. Plenty of food for the taking at this spot. 📷 **DAN WINSHIP**

LONELY BUOY *(opposite)*
Eagle Creek Park Reservoir
As evening approaches on Eagle Creek Reservoir, a lone buoy stands silent and still. 📷 **DOUGLAS HART**

FALLEN LEAVES *(following left top)*
A panoramic taken while laying on my stomach in my back yard.
📷 **AGNIS FLUGEN**

INDIANA SUNSET *(following left bottom)*
As storms roll through Indiana a blazing sunset pokes through the clouds. 📷 **MICHELLE PEMBERTON/INDYSTAR.COM**

THE EVENING SHADE *(following right)*
Indianapolis Museum Of Art
At times, the beautiful fall foliage on the grounds of the Indianapolis Museum of Art can rival many of the man-made creations maintained by the museum. 📷 **WILLIAM DAWSON**

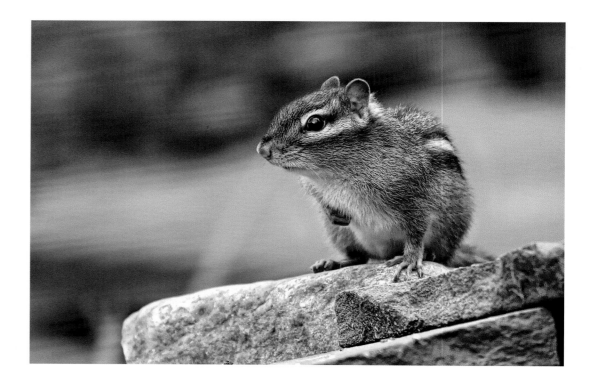

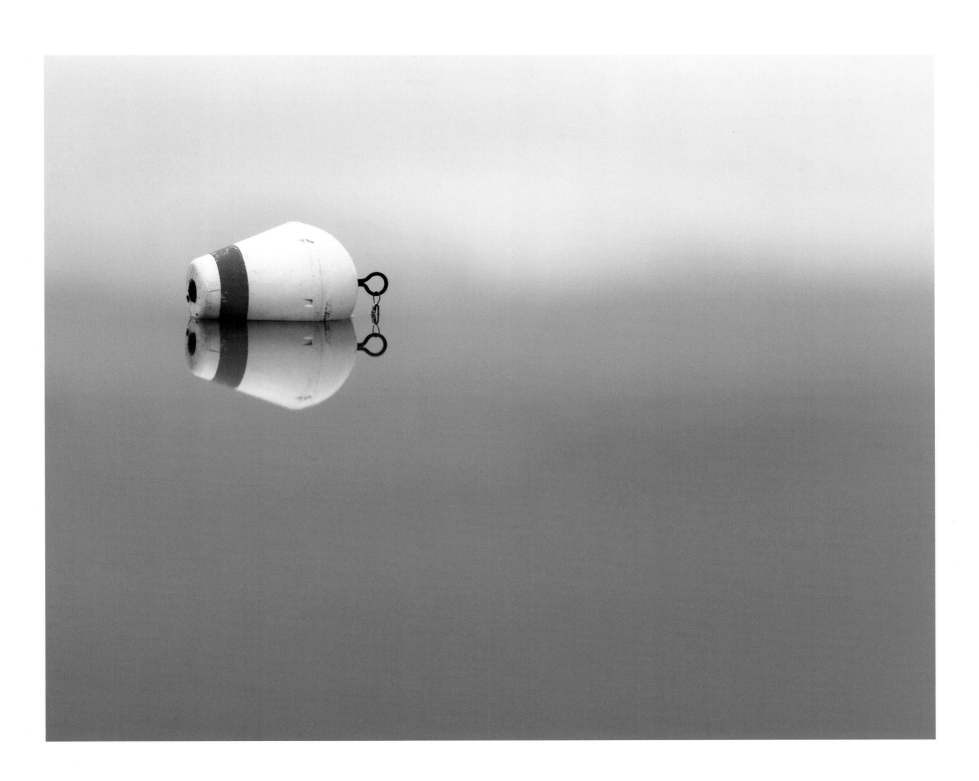

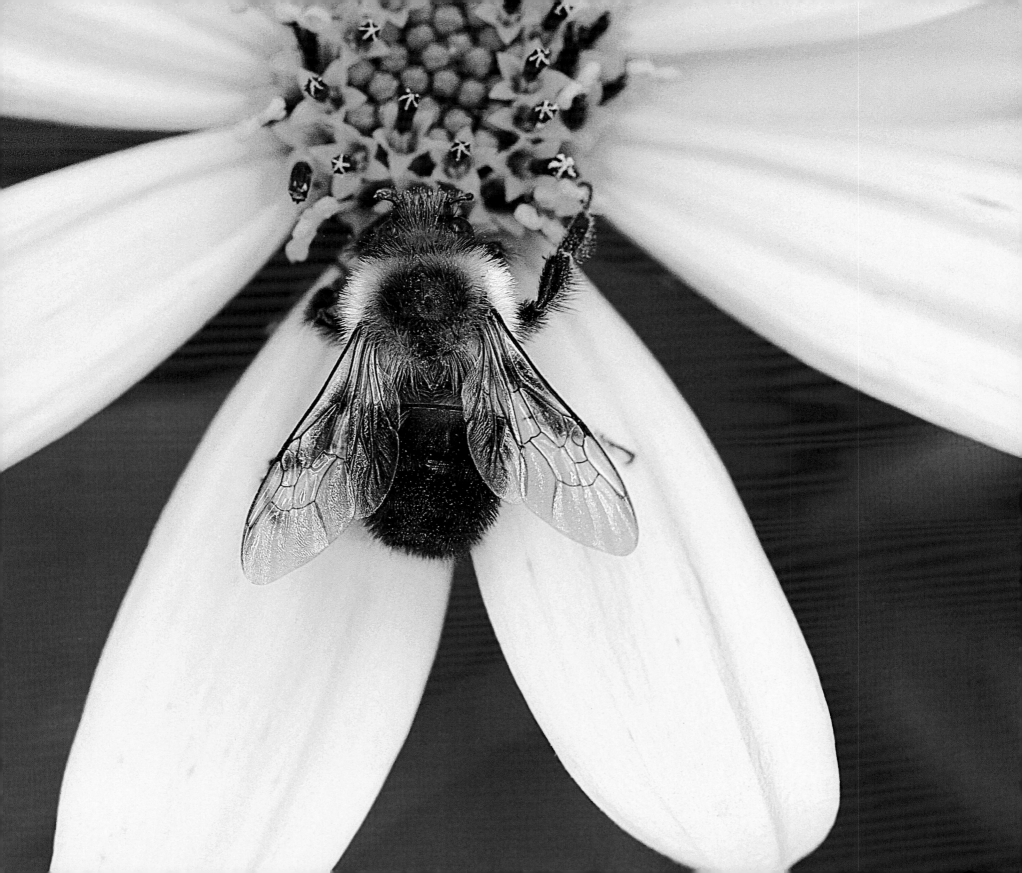

" Perfect timing on this one. I was setting up the camera on a tripod for a flower shot when the bee decided to pose for me.
— DAN WINSHIP / BEE ON FLOWER

BEE ON FLOWER *(left)*
Indianapolis Park 📷 **DAN WINSHIP**

BUG INVASION *(below)*
Indianapolis Museum of Art
A small reminder of how important a single blade of grass can be. 📷 **JIN KONG**

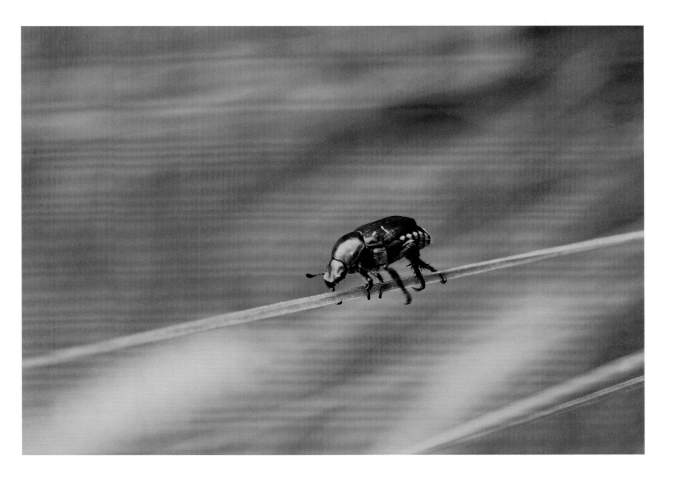

Newsworthy

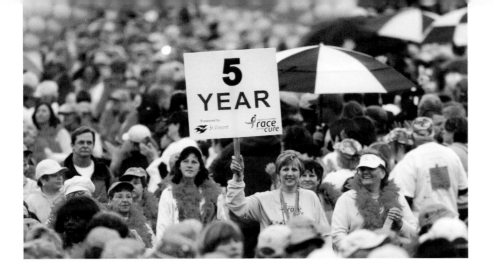

UNTITLED (left)
Breast cancer survivors walk in the Pink Parade during the opening cermonies for the 2008 Komen Indianapolis Race for the Cure at IUPUI. 📷 **JOE VITTI/INDYSTAR.COM**

MAKING A CONNECTION (below)
Madison Avenue and Pleasant Run Parkway
Volunteers from Lilly paint part of a paint-by-number mural that is the longest in the world, a new Guinness Book record. 📷 **TONY GARDNER**

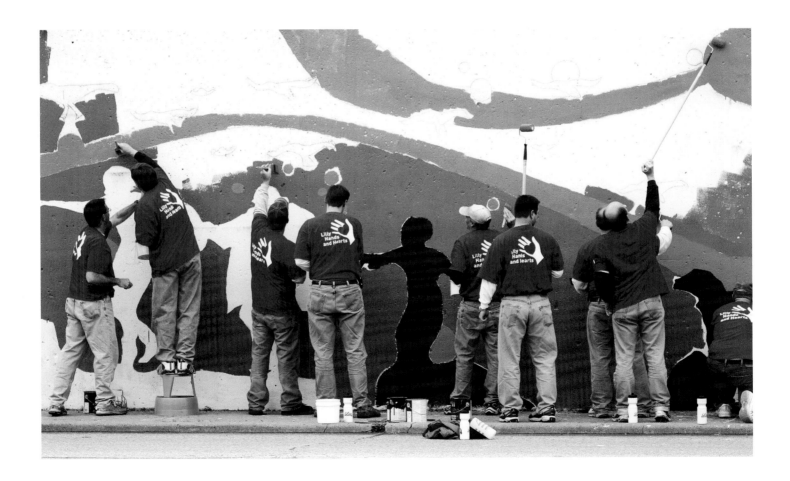

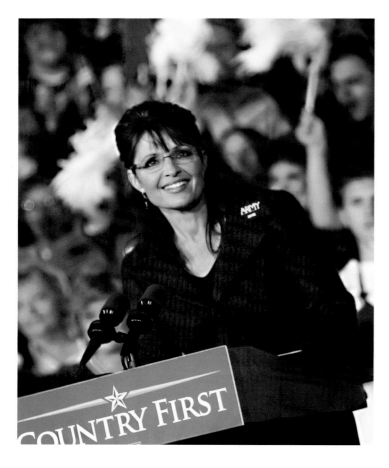

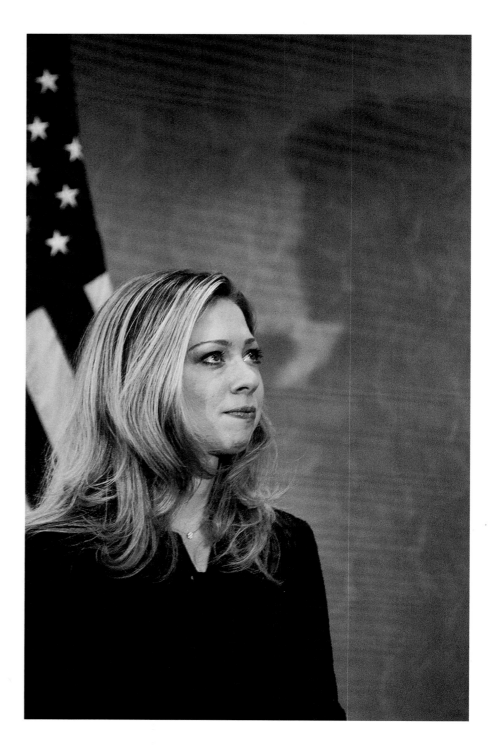

PALIN CAMPAIGN (above)
Verizon Music center
Sarah Palin stumping the campaign trail. 📷 **RON SANDERS**

IN HILLARY'S SHADOW (right)
Brownsburg, Indiana
Chelsea Clinton watches her mother, Hillary Clinton, give a speech at the Brownsburg Town Hall in May of 2008. 📷 **BECKIE KERN-JEFFREY**

CHANGE WE NEED (opposite)
American Legion Mall, Downtown Indianapolis
Barack Obama campaign rally, October 2008. 📷 **DAVE DAWSON**

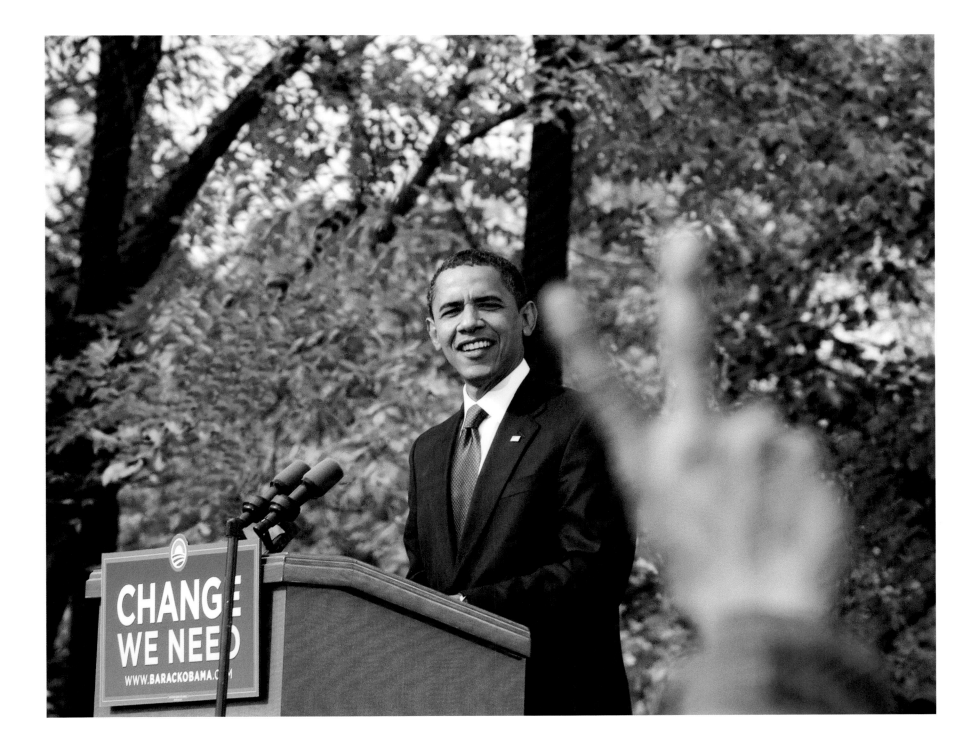

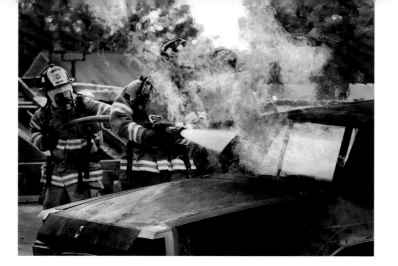

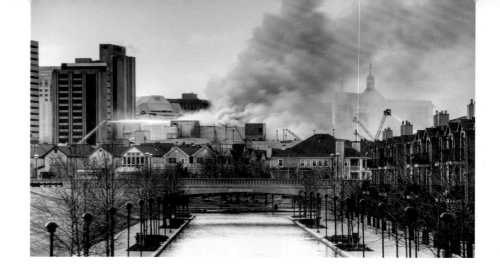

LEARNING ABOUT FIRE *(top left)*
Ken Kingshill (far left), President of the West-field City Council, and Darren Murphy (middle), Legal Department for City of Noblesville, fight flames pouring from a vehicle at the Fire Ops 101 in Fishers. ☞ **DANESE KENON/INDYSTAR.COM**

★ **FIRE ATTHE CANAL** *(top right)*
10th Street at the Canal
Cosmopolitan building fire taken from the 10th Street canal seven hours fire fighters first responded to Indy's largest fire in over 20 years. ☞ **GREG HANSEN**

★ **WORKING ALL DAY LONG** *(right)*
Cosmopolitan on the Canal
The fire on March 12, 2009 at the Cosmo-politan on the Canal condos that were under construction. These fireman worked all day long to extinguish the flames. The fire started early in the morning and this photo is taken at about 1 pm. ☞ **CARL VAN ROOY**

UNTITLED *(opposite)*
A Cessna airplane, piloted by Babar M. Sulema of Plainfield, uses the east bound lanes of I-70 to take off west bound. Suleman lost power and landed on the interstate between the rest stop and the Knightstown exit.
☞ **JERI REICHANADTER/INDYSTAR.COM**

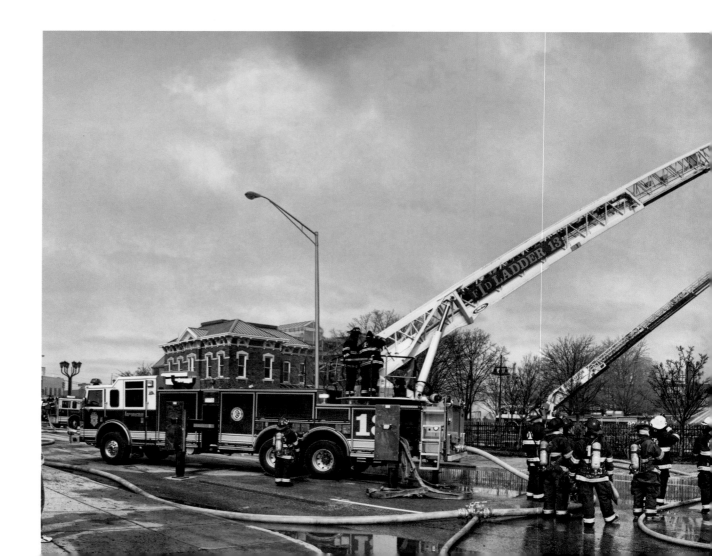

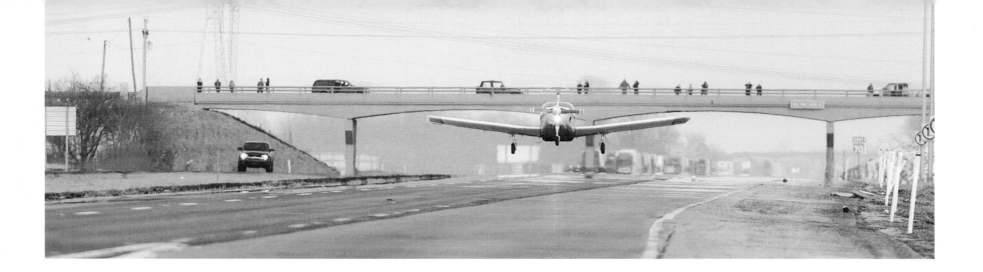

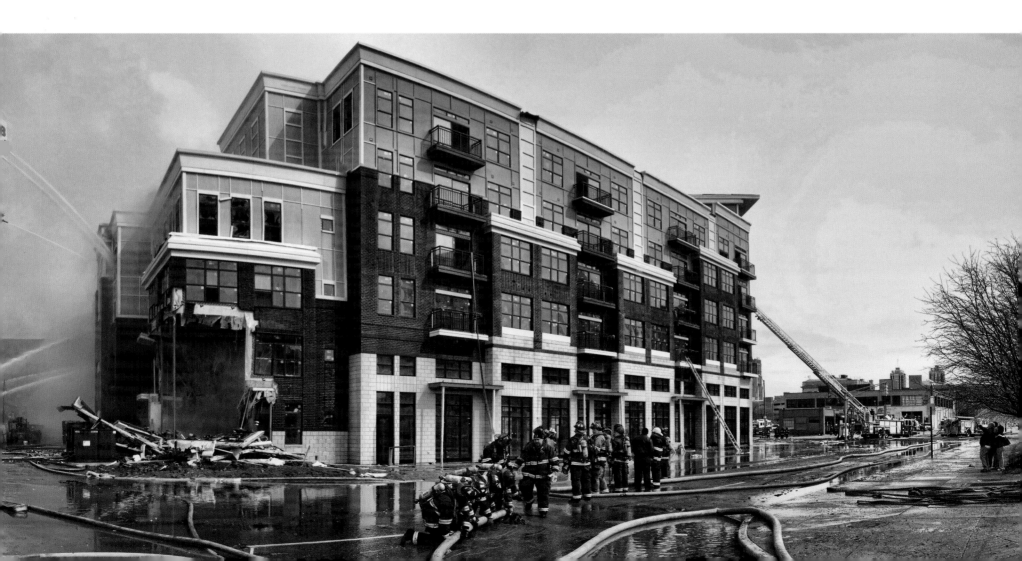

Landmarks

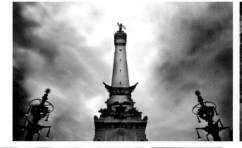

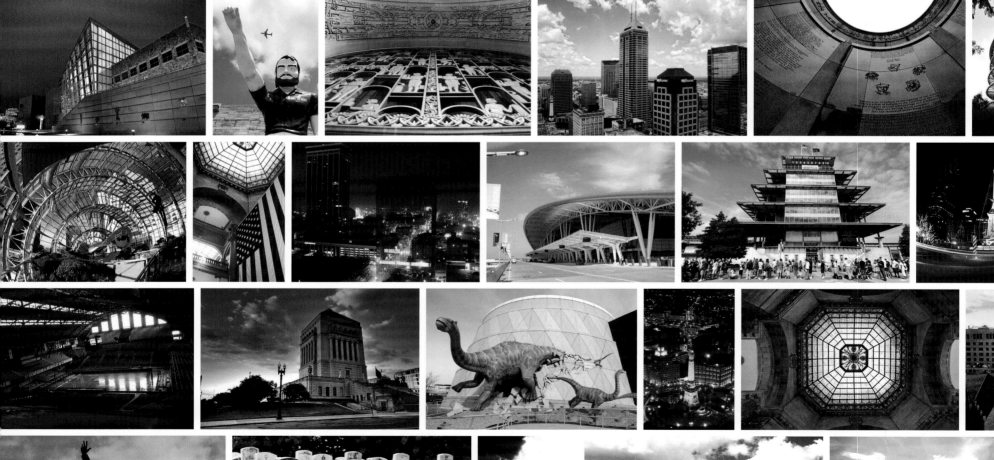

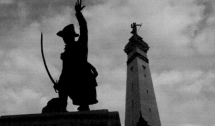
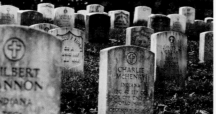

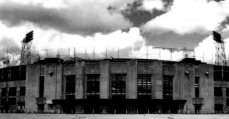

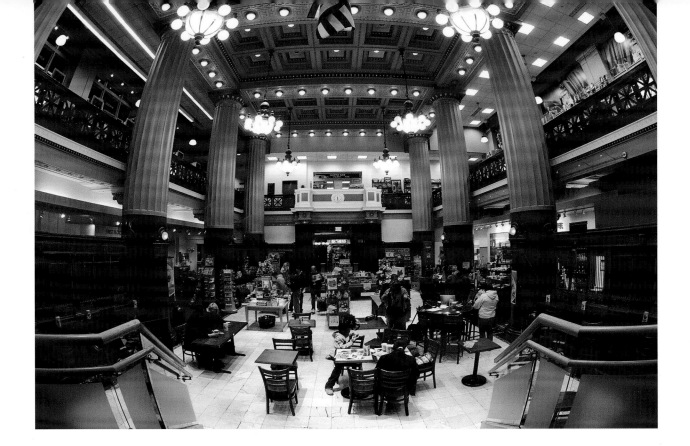

PAUL HARRIS BUILDING *(left)*
Indianapolis, Indiana
A historic building that used to be one of the old stores for Paul Harris on the corner of Washington and Meridian. Now a Borders Book Store and Cafe. **SERGE MELKI**

OLD GLORY *(bottom left)*
War Memorial Museum, Indianapolis
An inspirational American flag hangs in the Shrine Room at the Indiana War Memorial. Truly magnificent! 📷 **STEVE STANDIFER**

MONUMENTAL PATRIOTISM *(bottom right)*
Monument Circle
This is a shot of one of the statues on the east side of the Soldiers & Sailors Monument. The IPL building is in the background, decorated for the 4th of July. 📷 **CARL VAN ROOY**

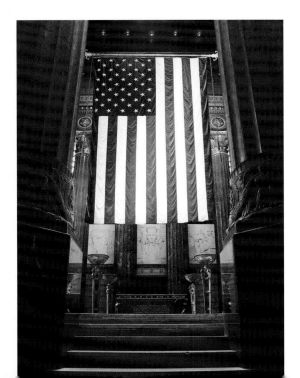

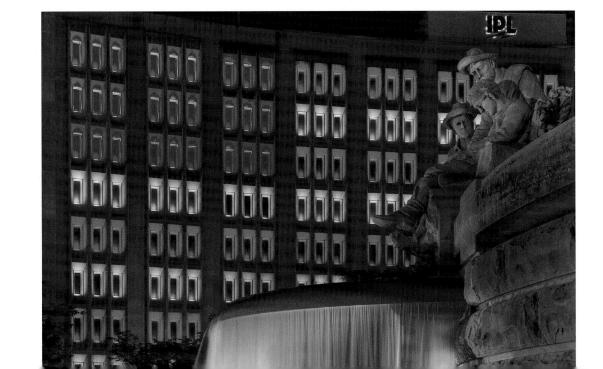

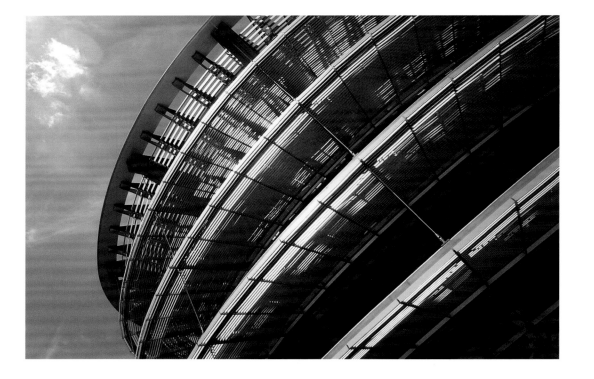

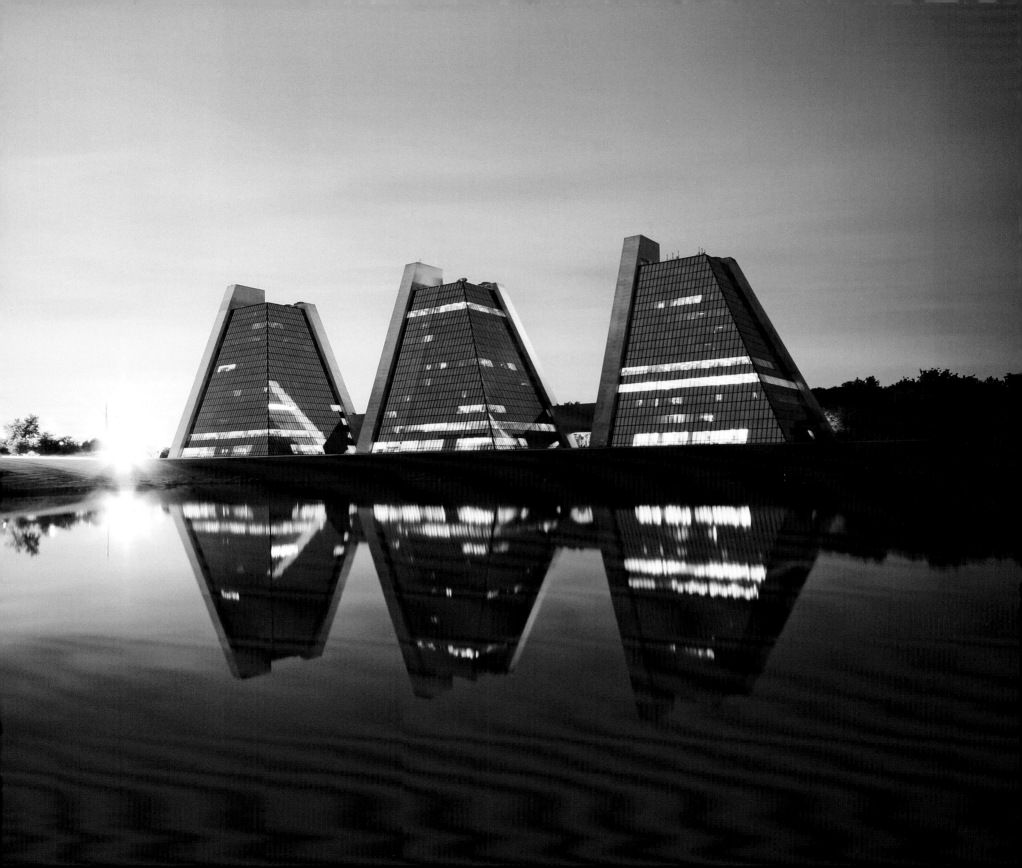

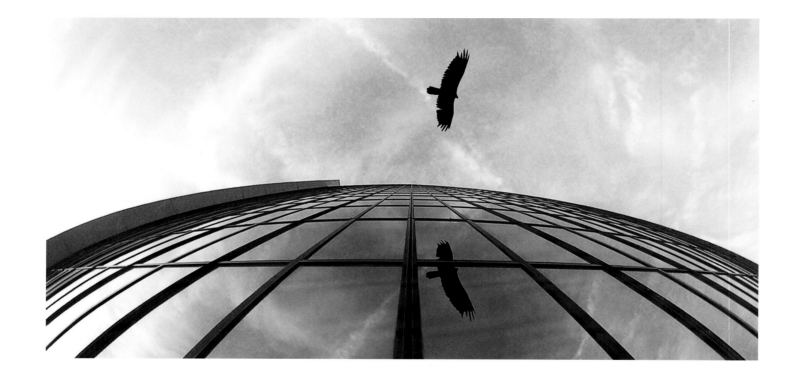

MIRAGE *(above)*
Hawk reflected in the structure of the Indiana pyramids ▣ **DARIO INFINI**

FRAGMENTED *(previous left top)*
Sculpture at small park on Mass Avenue.
▣ **KEVIN KIRSCHNER**

CONTRAST *(previous left bottom)*
Indianapolis Museum of Art
An upward view of a wall of the Indianapolis Museum of Art. ▣ **LIZ NICOL**

★ **EVENING PYRAMIDS** *(previous right)*
Just after sundown at the Indianapolis Pyramid Office Park ▣ **KEVIN MILLER**

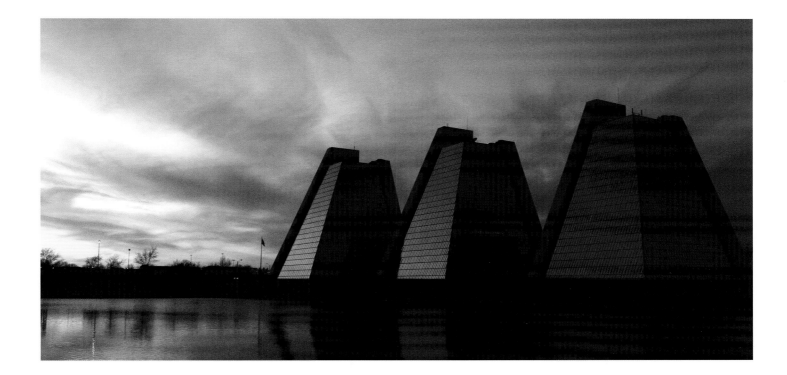

PYRAMIDS AT SUNSET *(above)*
The sun sets behind the iconic Pyramids office complex on Indy's north side.
📷 **PAUL ANDERSON**

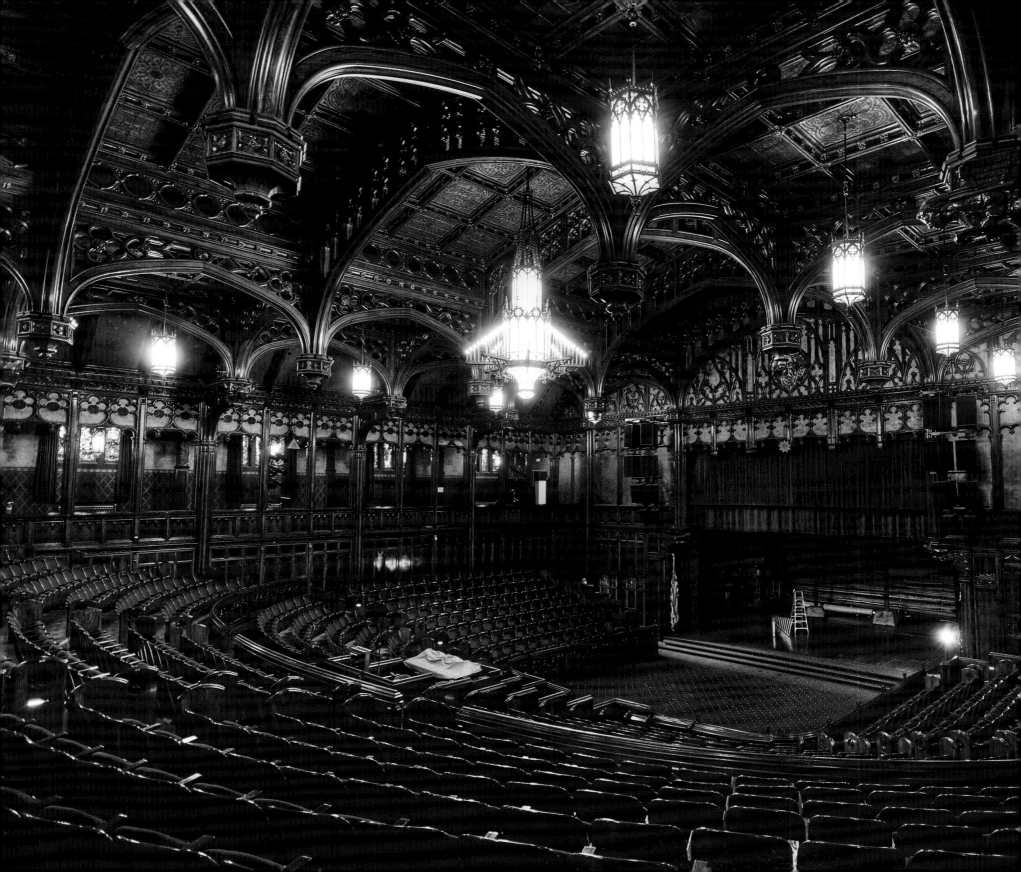

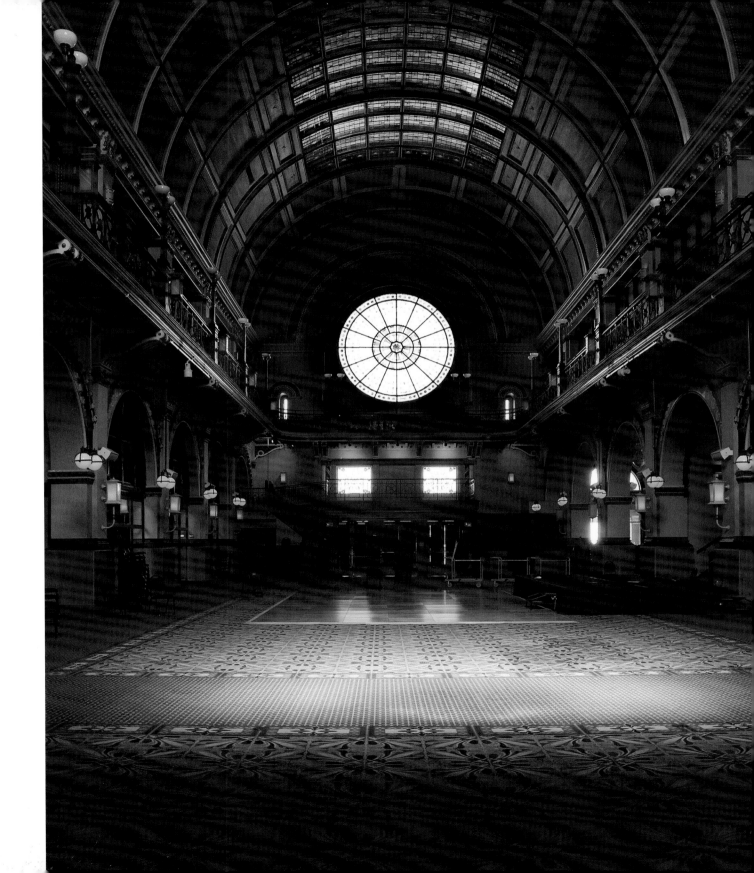

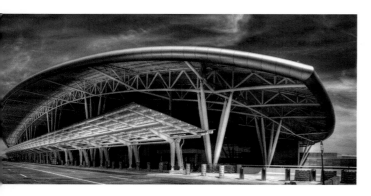

INDIANAPOLIS AIRPORT MIDFIELD TERMINAL *(above)*
The new Indianapolis Airport Midfield Terminal near completion. This terminal was a long time coming. It is a beautiful work of art and a great addition to our growing city. 📷 **CARL VAN ROOY**

THEATER *(previous left)*
Theater inside the Indianapolis Scottish Rite Cathedral. 📷 **ALEXEY STIOP**

★ **GRAND** *(previous right)*
Indianapolis, IN
The old Indianapolis Union Station gallery, now a hotel ballroom.
📷 **PHILIP JERN**

SCOTTISH RITE CATHEDRAL *(right)*
Downtown Indy
Looking up at the Scottish Rite Cathedral. 📷 **JON HERING**

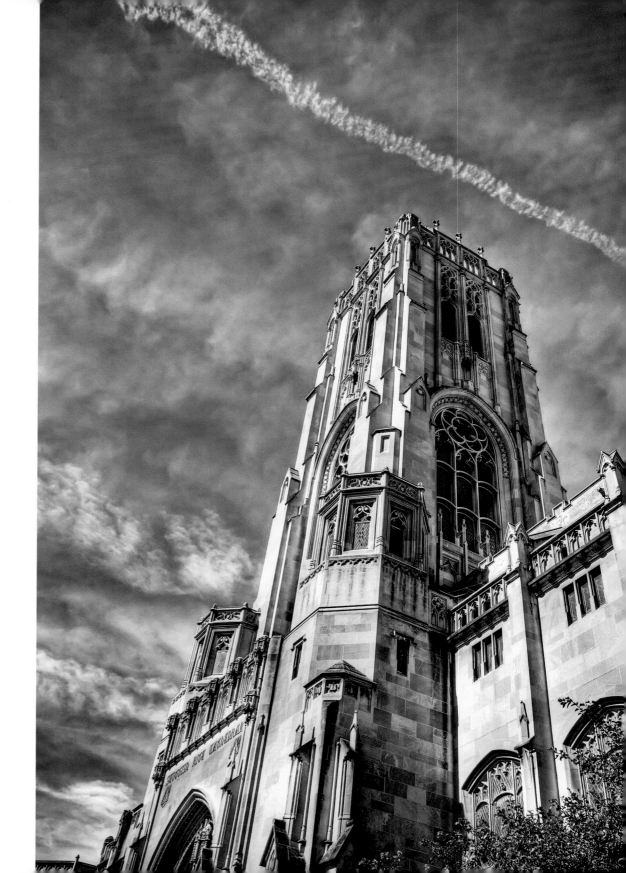

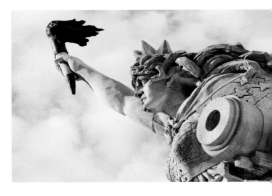

**FLOWERS AND
MEDAL OF HONOR MEMORIAL** *(above)*
Indianapolis Canal Walk
Taken with the fisheye lens. 📷 **SERGE MELKI**

YOUNG LOVE *(right top)*
A young couple at the IMA LOVE sculpture. 📷 **REBECCA BRETZINGER**

VICTORY *(right bottom)*
Monument Circle – East side
Soldiers & Sailors Monument. 📷 **DUANE DART**

GOD BLESS AMERICA *(following left)*
Indianapolis
Doors located on the north side of the Indiana War Memorial. Sitting in the shade, the doors reflect beautiful colors. The symbols represent the American spirit of freedom and democracy, and honor those who gave their lives defending it. 📷 **BOB NOEL**

GOTHIC GATE *(following right)*
Crown Hill Cemetery's Gothic Gate, one of the entrances to the large Indianapolis cemetery. 📷 **KEVIN MILLER**

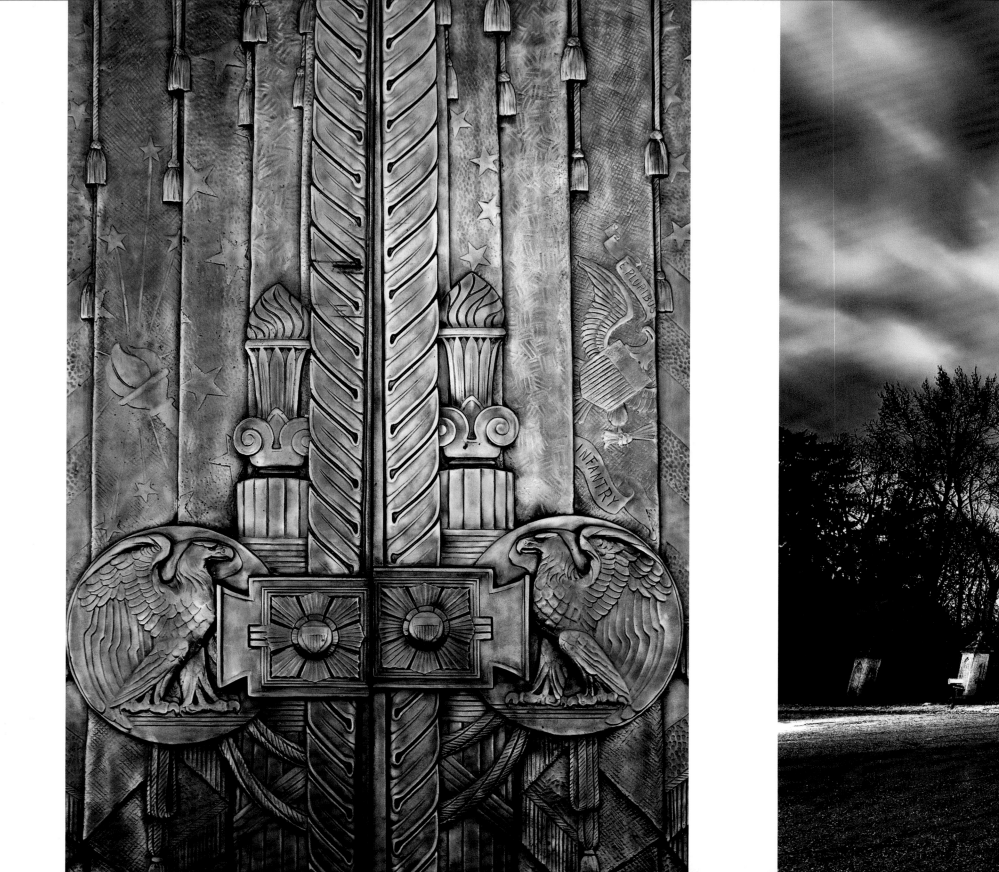

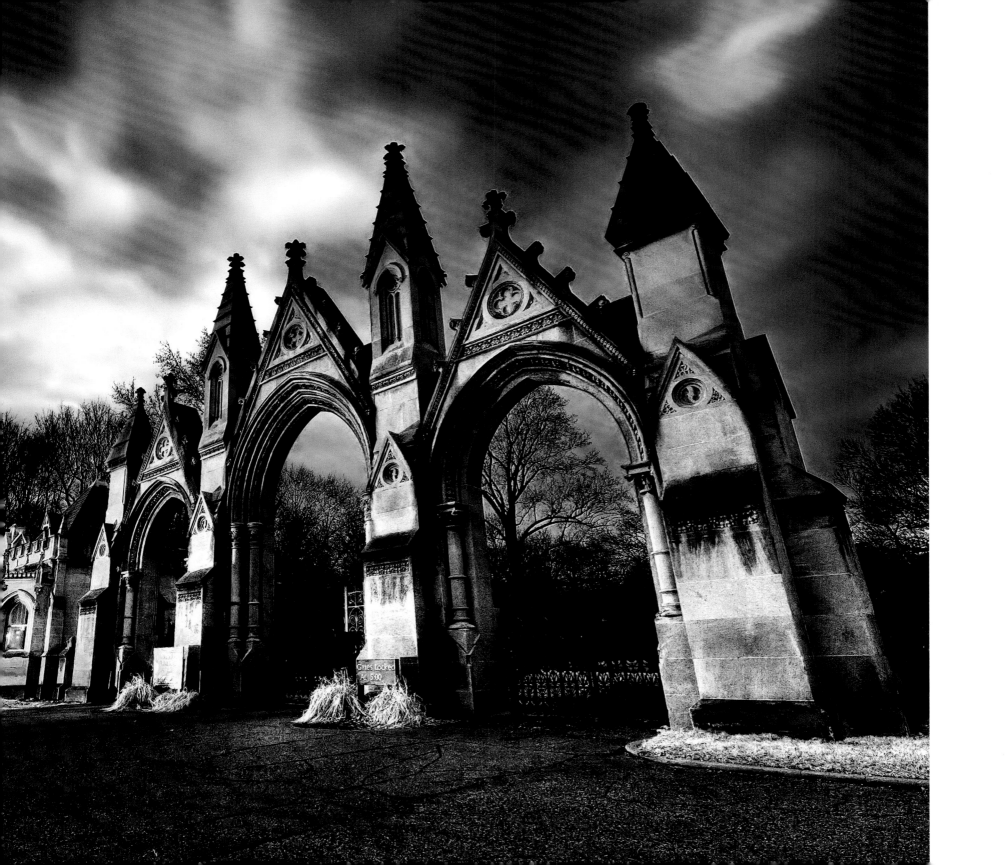

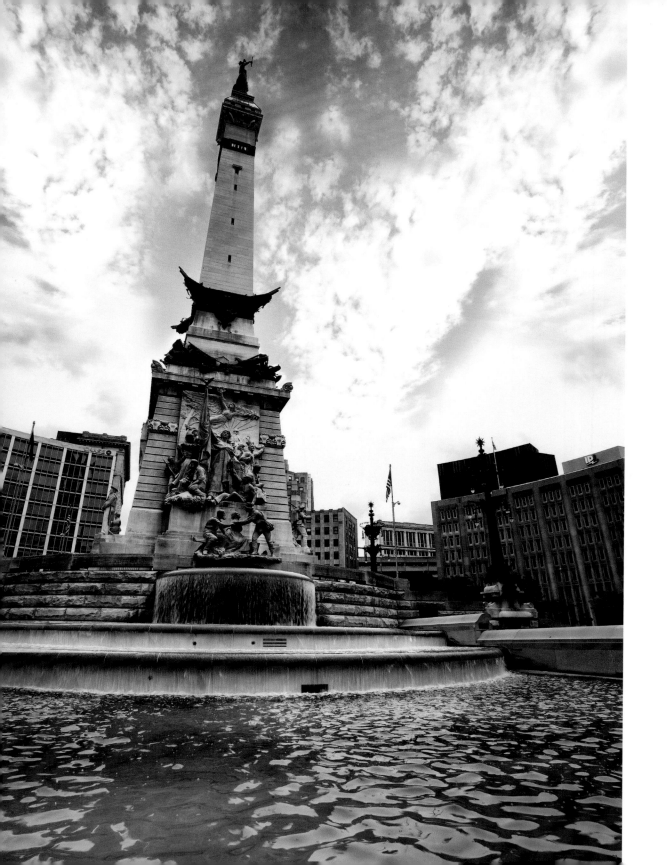
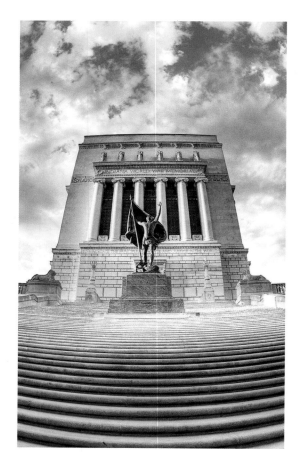

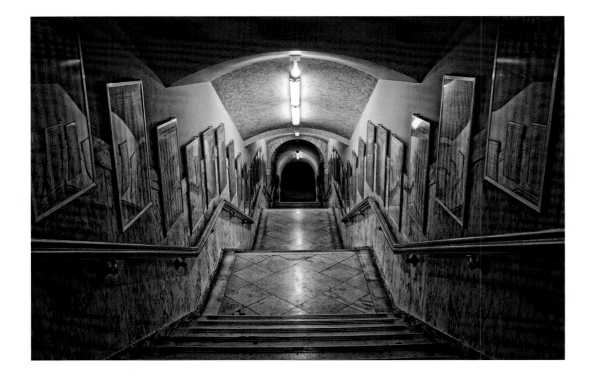

NOSEBLEED SECTION *(above)*
Lucas Oil Stadium
View through the sliding glass window at Lucas Oil Stadium.
Photo taken from the cheap seats. I think we were in the top row.
📷 **RYAN BURWELL**

A JOURNEY THROUGH TIME *(left)*
War Memorial
The staircase leading to the War Memorial Shrine Room.
📷 **CARL VAN ROOY**

MONUMENT CIRCLE *(opposite left)*
Monument Circle, downtown Indy. 📷 **T. JASON WRIGHT**

WAR MEMORIAL *(opposite right top)*
Indiana War Memorial at the downtown mall. 📷 **KRIS ARNOLD**

LOOKING UPWARDS *(opposite right bottom)*
Monument Circle
Looking up the light skirt on Monument Circle on a misty evening during the Festival of Lights. 📷 **PHILIP JERN**

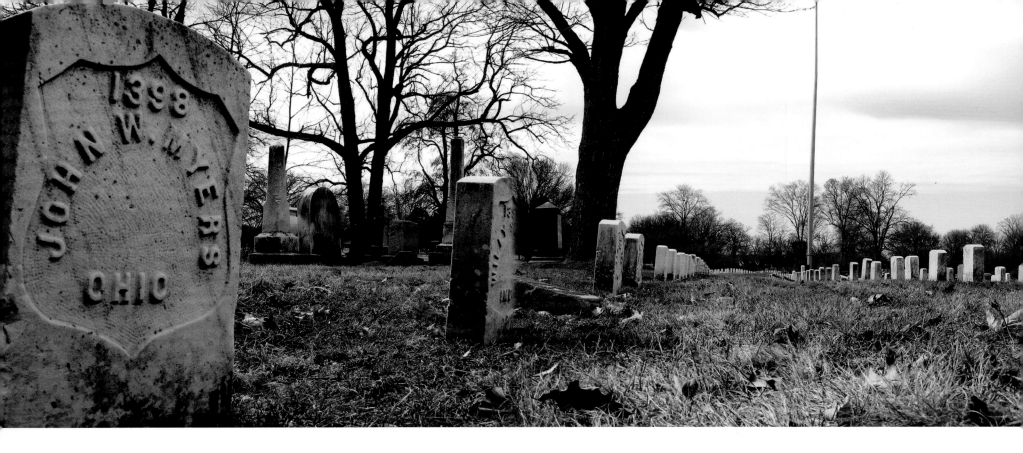

THE EPITAPH (above)
Panoramic image taken at Crown Hill Cemetery. 📷 **AGNIS FLUGEN**

DOOR TO INDIANA (right)
State Capital door pull knob on the east entry doors. 📷 **DUANE DART**

GOTHIC CHAPEL AT CROWN HILL (opposite left)
Chapel located at Crown Hill in North Indianapolis. It's beautiful. 📷 **PAUL EVERETT**

LOOK TO THE WEST (opposite right)
Standing on the Circle looking west to the Capitol building. 📷 **DAN WINSHIP**

FIRST LOOK (following left)
Lucas Oil Stadium, Indianapolis
Getting a first look at the new stadium during the open house of Lucas Oil Stadium.
📷 **STEVE STANDIFER**

UNTITLED (following right)
Indianapolis 500
Scoring tower at Indianapolis 500.
📷 **BILL WILLS**

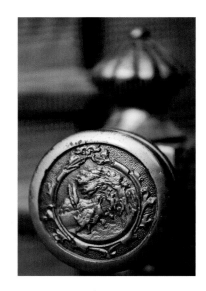

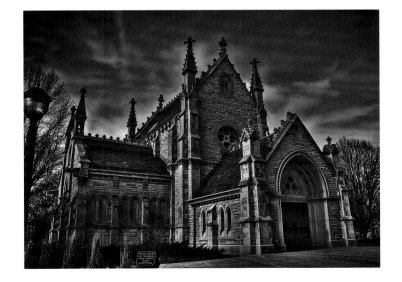

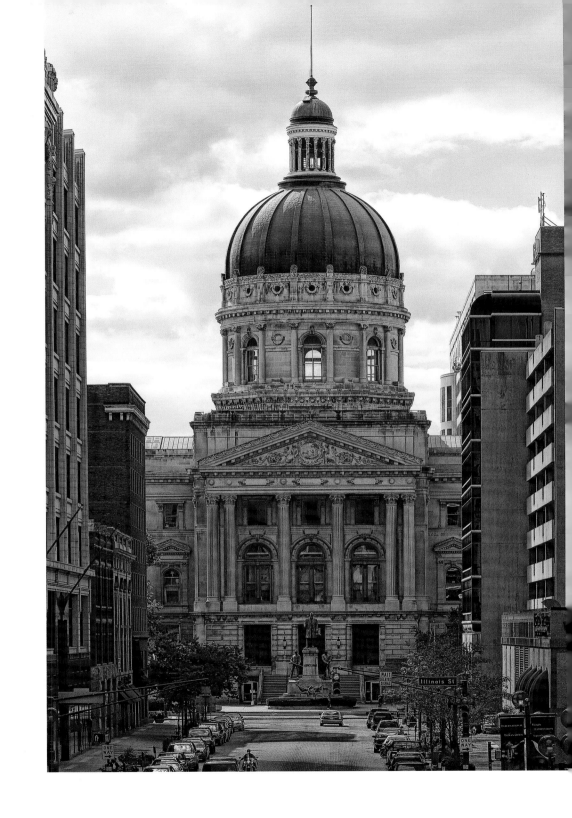

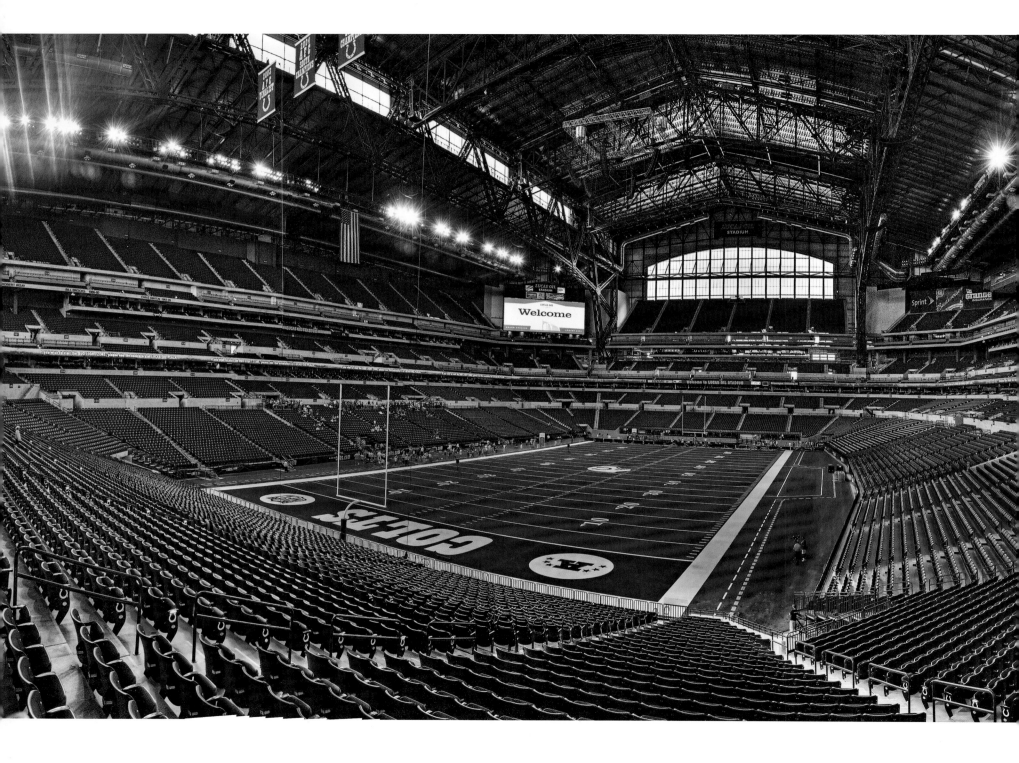

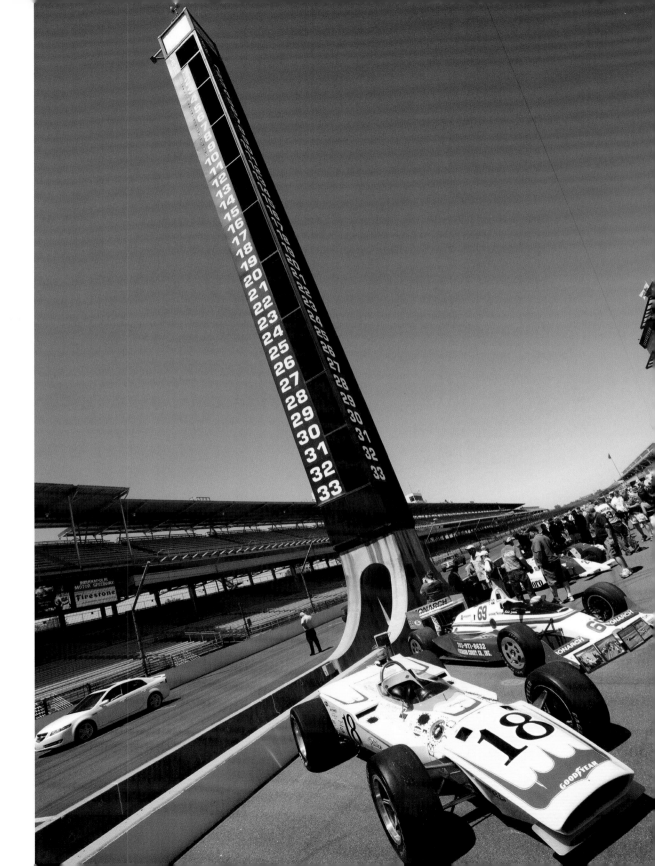

Sports & Recreation

SPONSORED BY MARSH

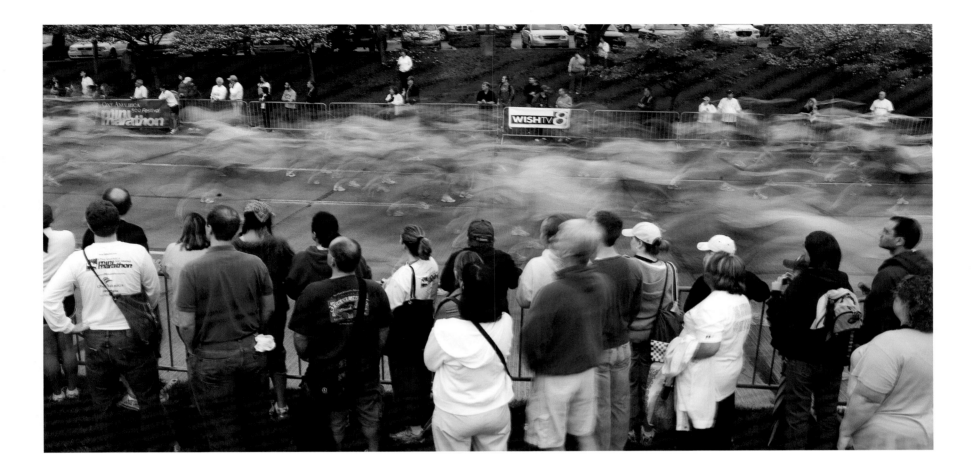

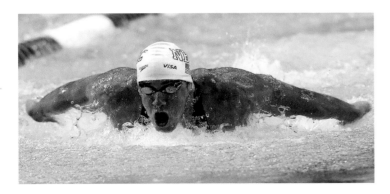

UNTITLED *(above)*
Downtown Indianapolis
Runners in The 500 Festival Mini-Marathon.
☞ **MARC LEBRYK**

MICHEAL PHELPS
SWIMMING INDY *(left)*
Natatorium at IUPUI
Olympic gold-medal winner Micheal Phelps,
competing at the ConocoPhillips USA
Swimming Championships. ☞ **FRED BOYD**

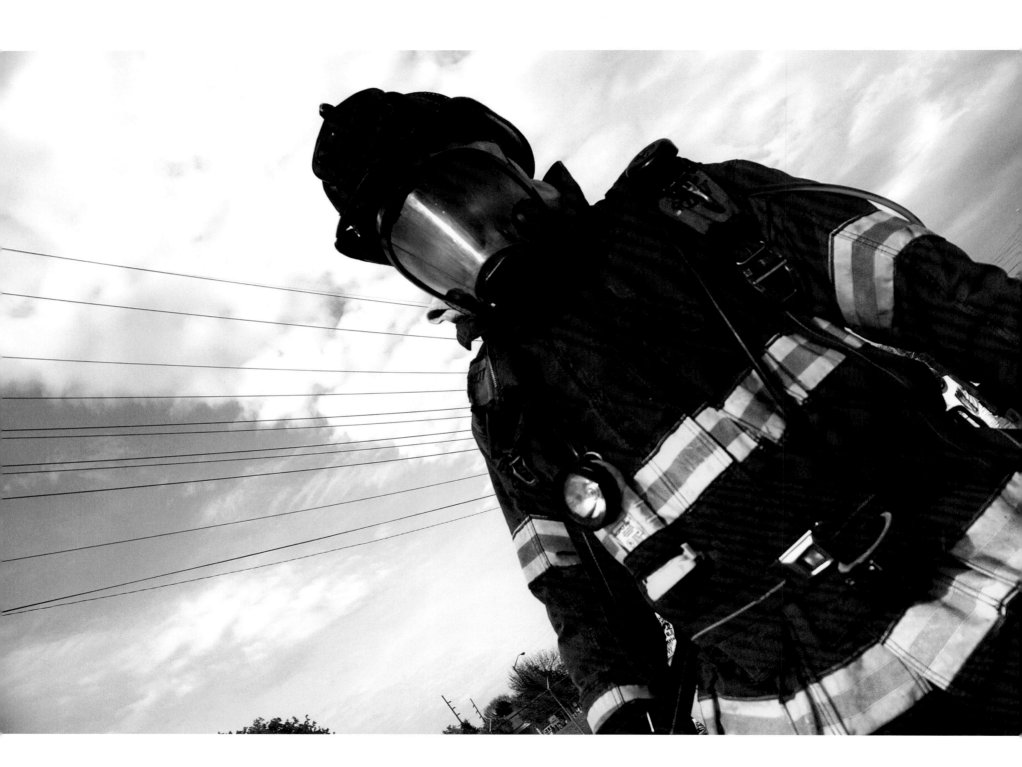

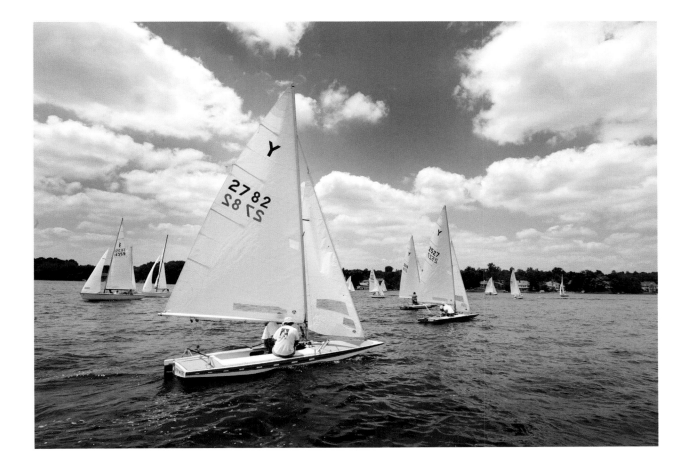

SAILING ON GEIST *(left)*
Sailors jockey to race in the Indianapolis Sailing Club Summer Regatta on Geist Reservoir. 📷 **KELLY WILKINSON/INDYSTAR.COM**

COMING TO A
RESCUE NEAR YOU *(opposite)*
16th Street
Always a friendly face and always to the rescue, this fire fighter walked in the annual 500 Festival Mini-Marathon. 📷 **KYLE PEARSON**

SLEDDING *(bottom left)*
Riverside Golf Club
A fun day of sledding on Riverside Golf Club course. 📷 **ERIC THOMAS**

MORNING FISHERMAN *(bottom right)*
Indianapolis, IN
A man dons waders to get closer to the fish in Eagle Creek Park. 📷 **T. JASON WRIGHT**

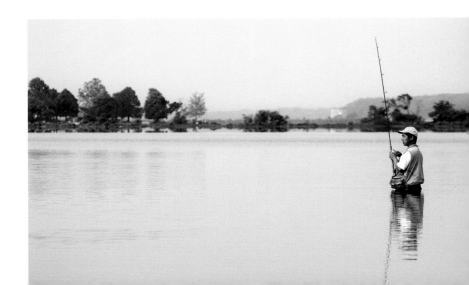

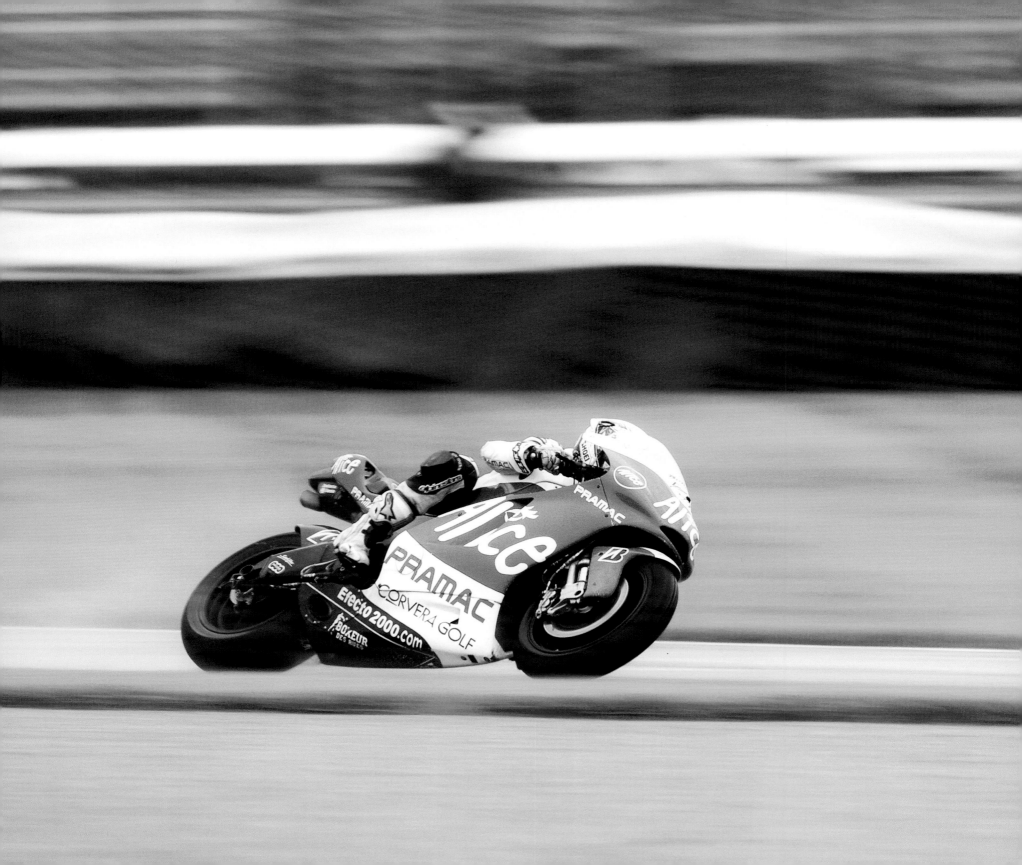

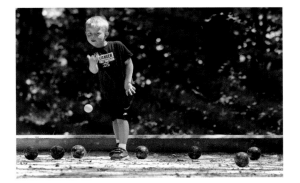
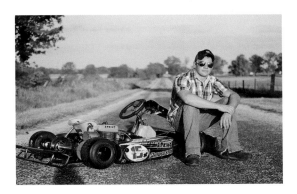
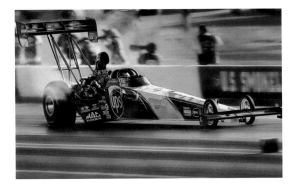

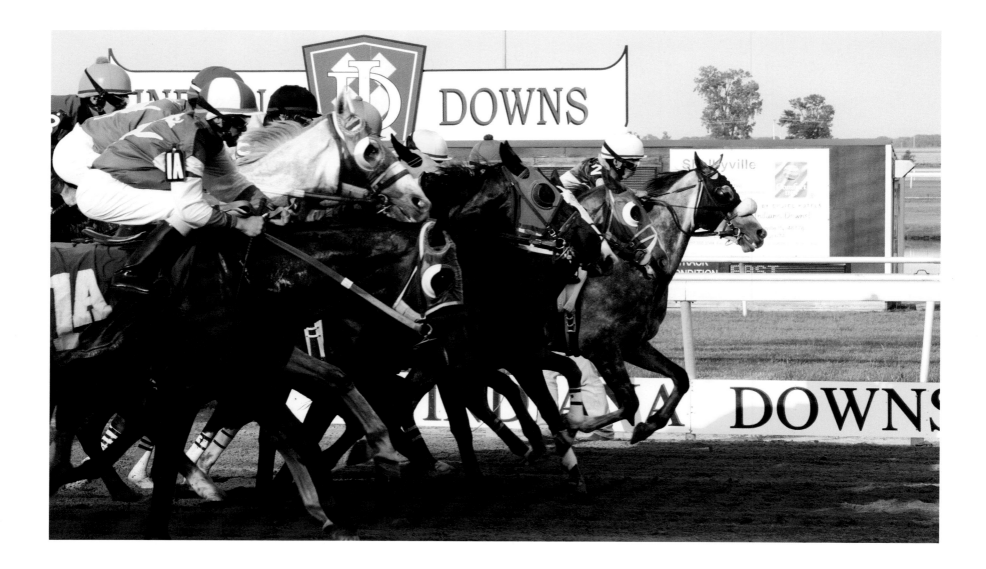

AND THEY'RE OFF! *(above)*
Flying out of the starting gates at Indiana
Downs. ◉ **EVAN SMOGOR**

TONI ELIAS DUCATI *(previous left)*
Indianapolis Motor Speedway
Spanish rider Toni Elias rides his #24 Ducati in
practice for the inaugural Red Bull Indianapolis
MotoGp. Toni finished in 12th place in the race.
◉ **T. JASON WRIGHT**

BOCCE BALL *(previous top)*
Jekub Resler, 5, throws the pallino to start a
bocce ball game at Slovenefest, on the Slo-
venian National Home picnic grounds in Avon.
◉ **MATT KRYGER/INDYSTAR.COM**

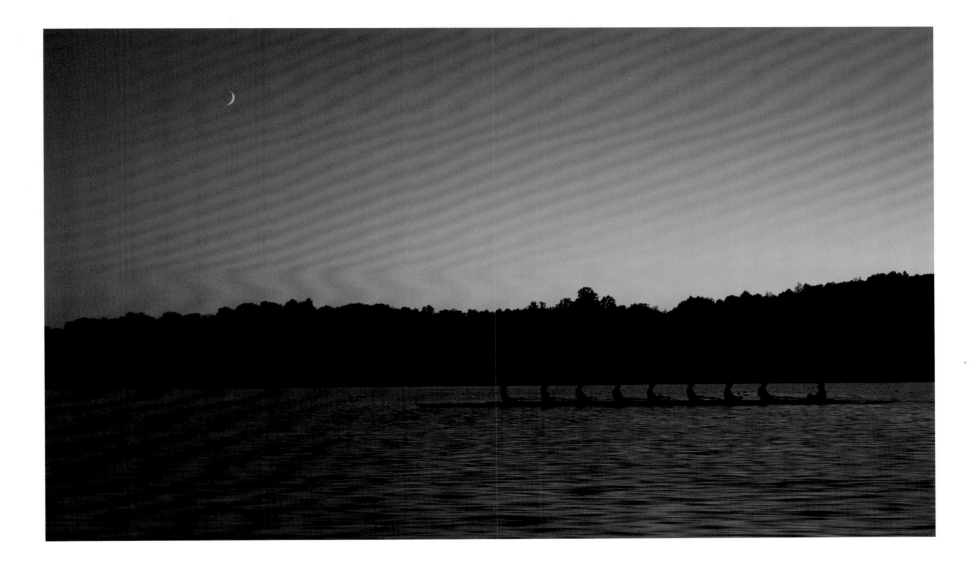

RATHER BE RACING *(previous middle)*
Josh Call poses with his true love a week after ditching his prom date to compete in a race.
📷 **RACHEL BRAU**

**KICK THE TIRES AND
LIGHT THE FIRES** *(previous bottom)*
O'Reilly Raceway Park, Indianapolis
UPS hauling the freight ... 320 miles per hour.
📷 **DAN WINSHIP**

**SUNSET
ROWING** *(above)*
Eagle Creek Resevoir
📷 **LINDSAY AMORE**

"Indy Rowing practices at all hours!
— LINDSAY AMORE / SUNSET ROWING

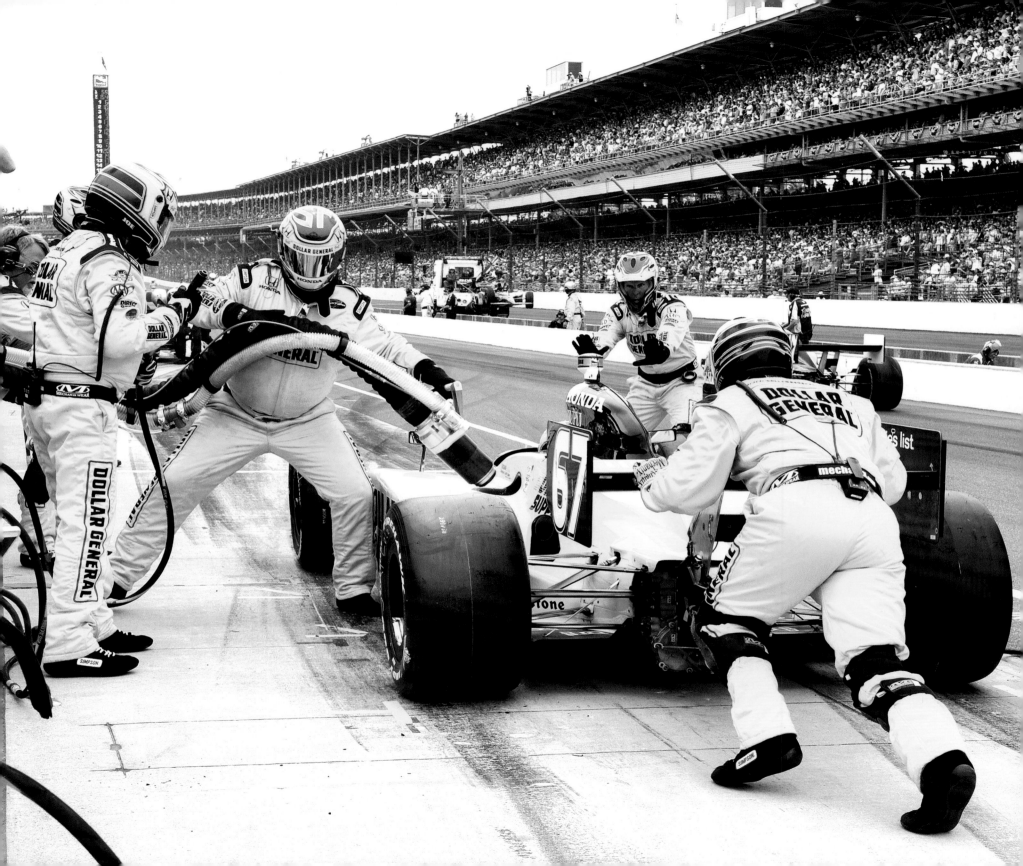

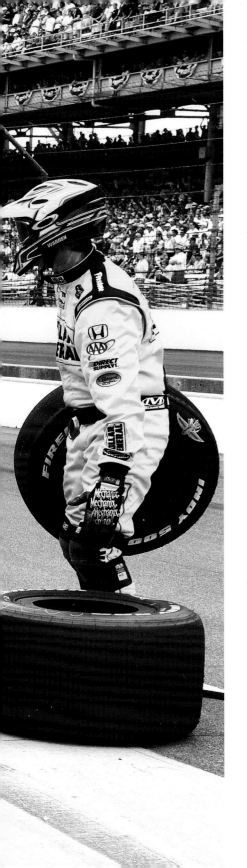
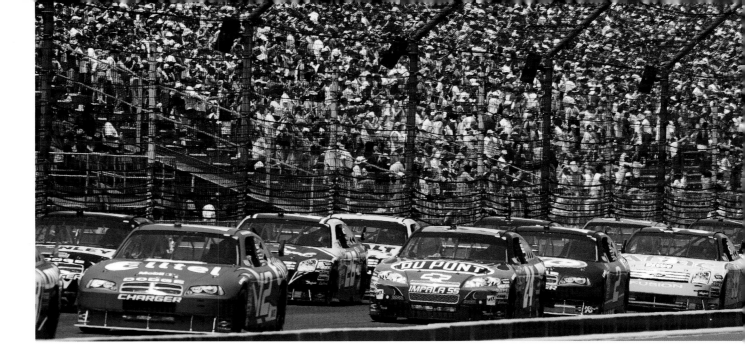
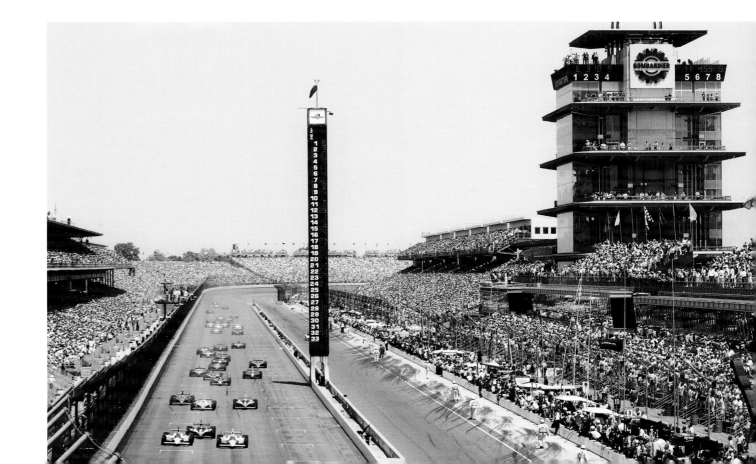

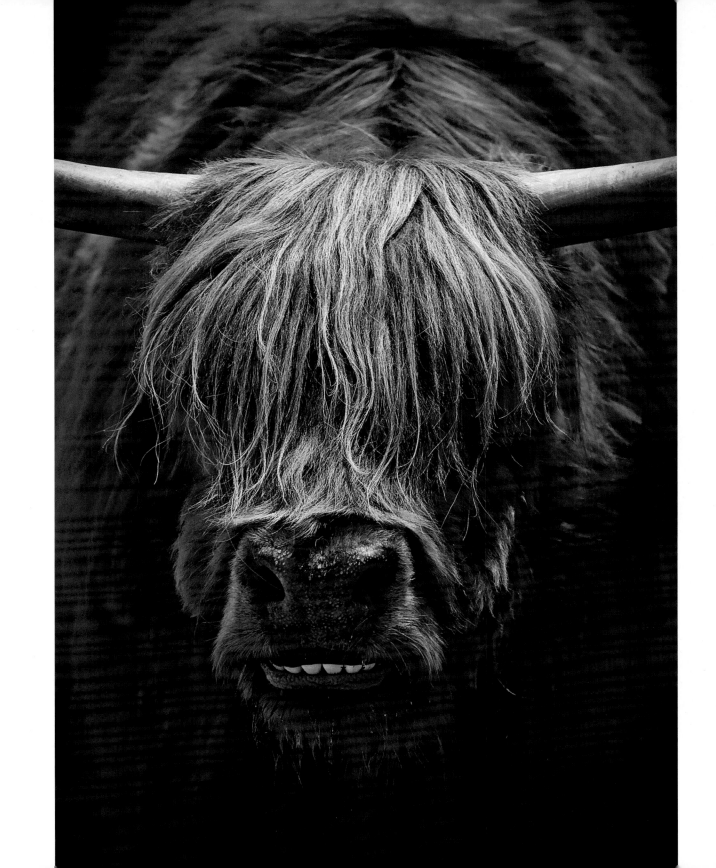

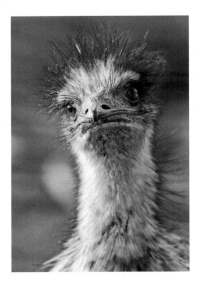

BAD HAIR DAY *(above)*
Bad hair day at the Indianapolis Zoo
📷 **EMILY WINSHIP**

HAIRY COW *(right)*
A hairy cow at the Indianapolis Zoo.
📷 **RYAN BURWELL**

THE DOLPHIN DOME *(opposite)*
Spectators, both young and old, enjoy the one-of-a-kind Dolphin Adventure Viewing Dome.
📷 **WILLIAM DAWSON**

★ **FILL 'ER UP!** *(previous left)*
Pretty important guy: the fuel man!
📷 **MICHAEL DELANEY**

GREEN FLAG! *(previous right top)*
Indianapolis Motor Speedway
Forty-three drivers take the green flag to start the 2008 Brickyard 400 at the Indianapolis Motor Speedway. 📷 **PAUL ANDERSON**

**A VIEW FROM
TURN ONE** *(previous right bottom)*
The starting field of the Indianapolis 500 field heads toward turn one after taking the green flag. 📷 **CHARLIE NYE/INDYSTAR.COM**

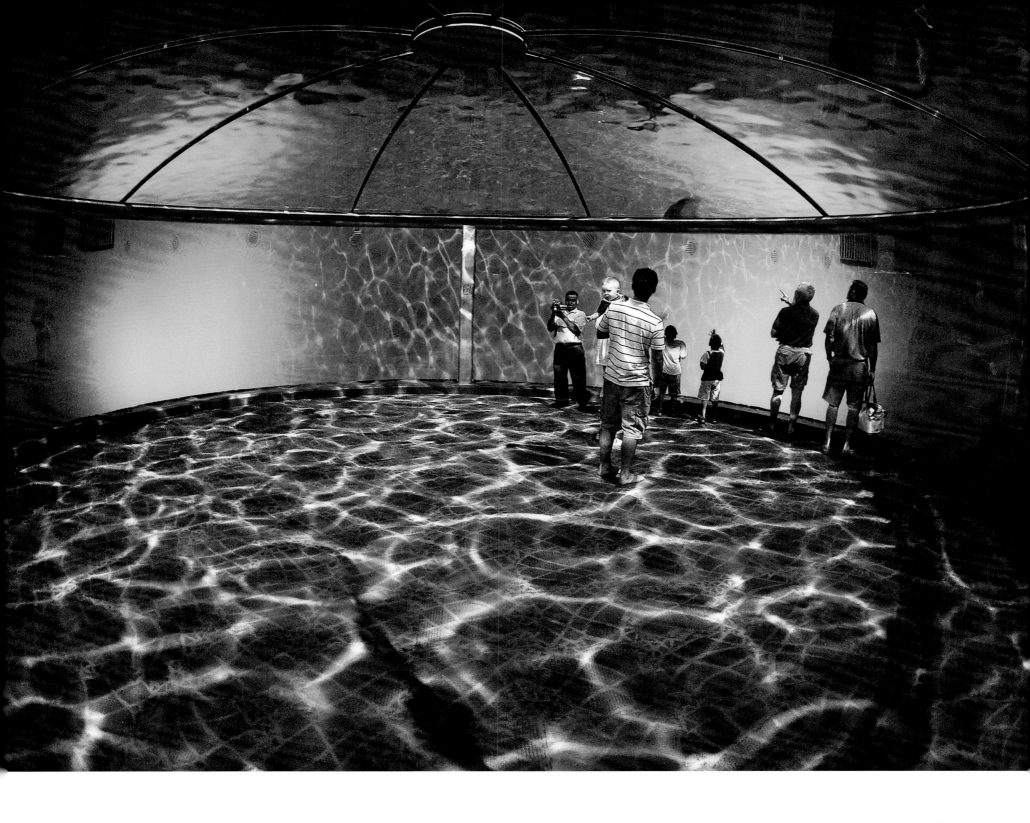

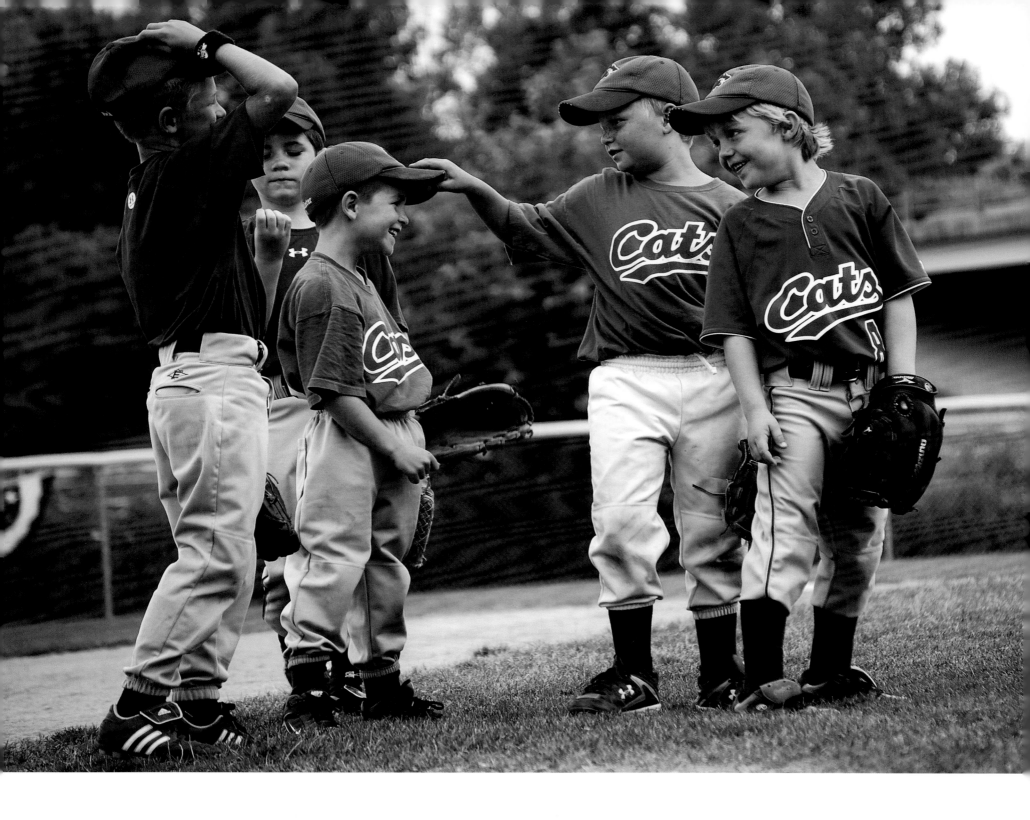

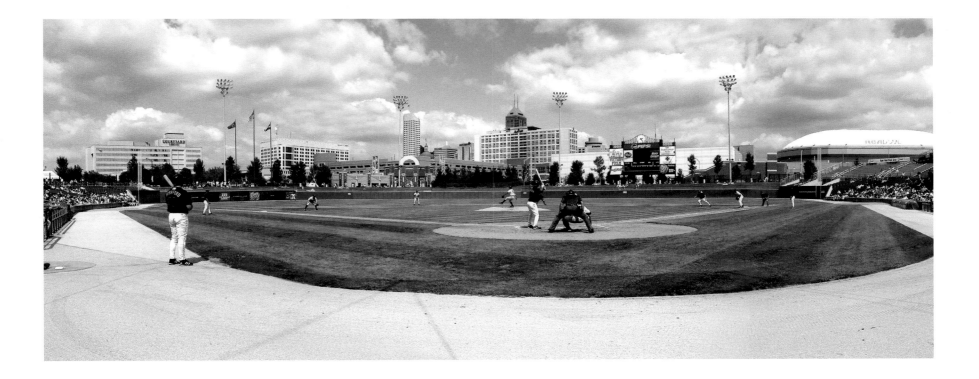

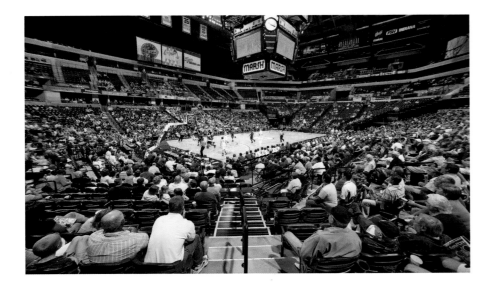

A PLACE IN THE SUN *(above)*
From here you can hear the crisp hum of a 90-mile-per-hour slider and the crack of white ash on cowhide. There's no better spot than a seat right behind home plate to enjoy our Indianapolis Indians at Victory Field – the best ballpark in America. 📷 **BILL FULTON**

UNTITLED *(left)*
Conseco Fieldhouse during the 2008 Indiana All Star Basketball Games vs Kentucky.
📷 **MARC LEBRYK**

CATS *(opposite)*
Billericay Park in Fishers
The Cats baseball team enjoying a moment during practice. From left: Samuel Finefrock, Tommy Wahlstrom, Ty DeSplinter, Mason Cooley and Dylan Gray. 📷 **KIM GRAY**

COURT UNDERWATER *(following left)*
Carmel, Indiana
A basketball court in our neighborhood after a storm. 📷 **KATHY SHREVE**

NICE PUTT *(following right)*
This shot was taken during a round of golf at Bear Slide Golf Course just north of Indianapolis.
📷 **AARON DRAKE**

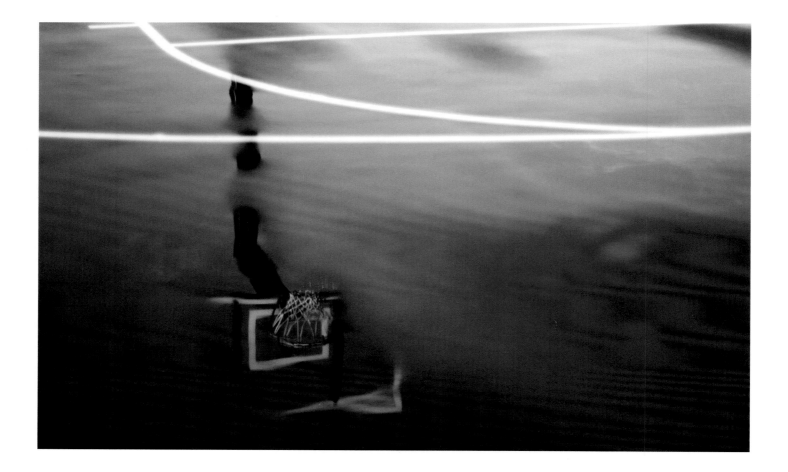

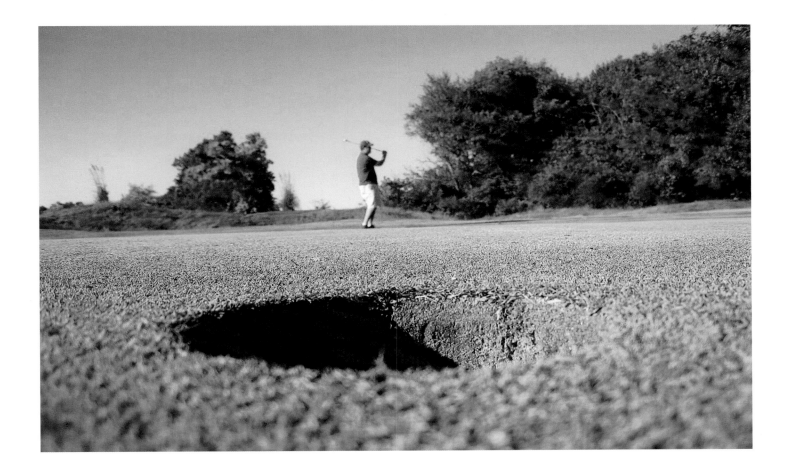

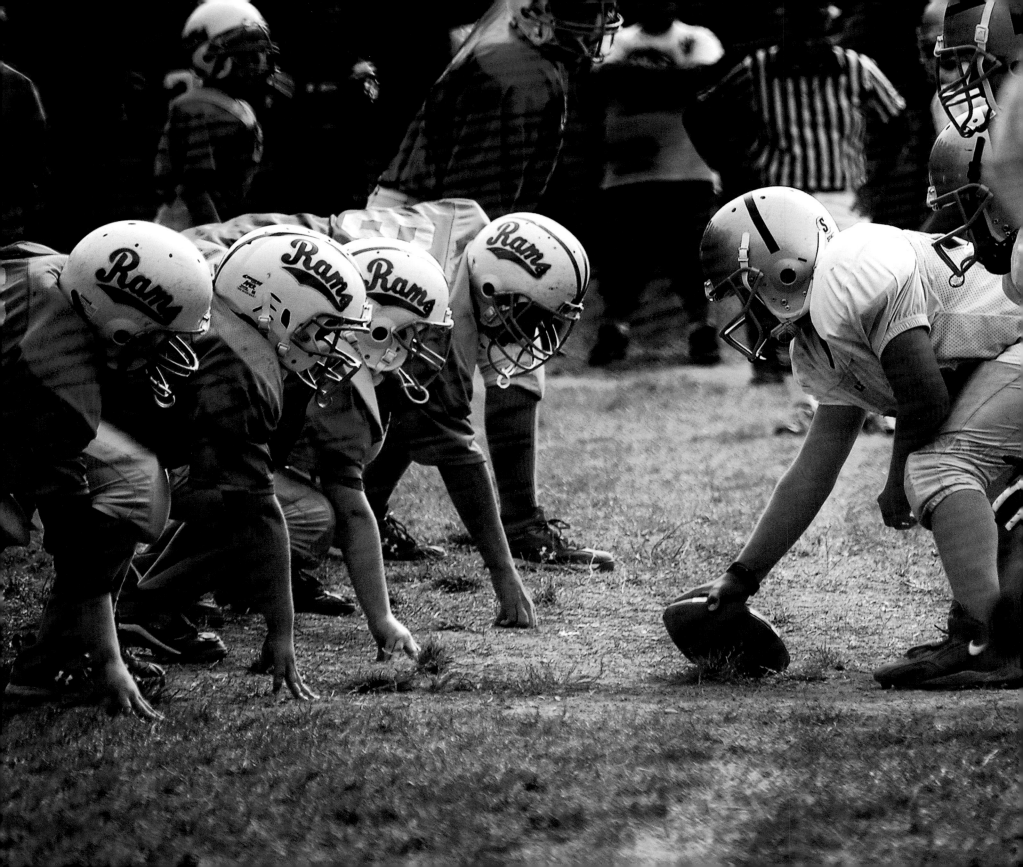

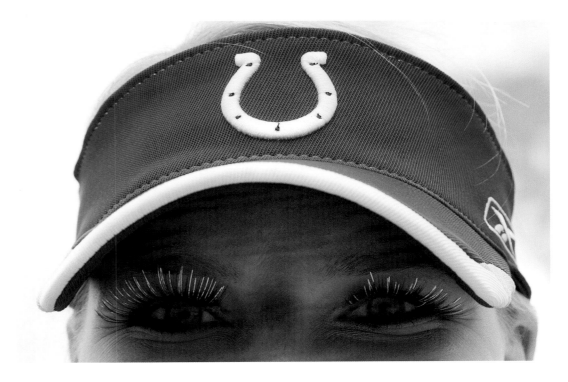
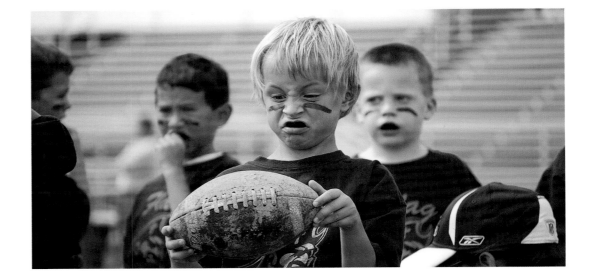

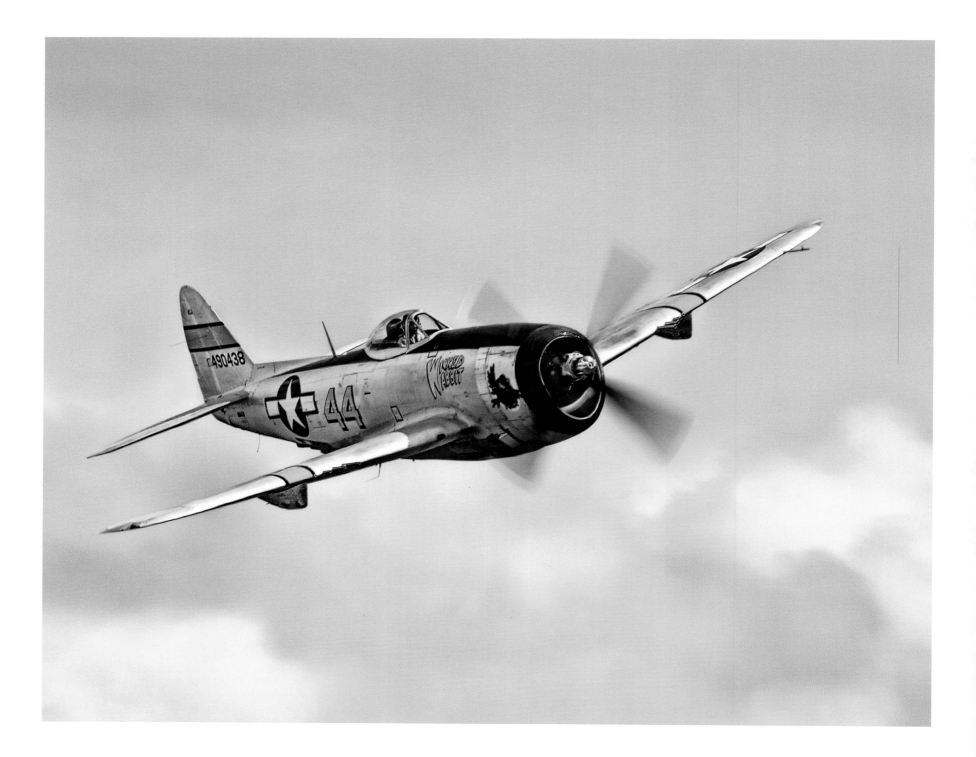

LINE OF SCRIMMAGE *(previous left)*
Ellenberger Park
Teams practice for the big game. 📷 **SCOTT O'FARRELL**

COLTS FAN *(previous right top)*
Indianapolis, IN
A Colts fan sporting eyelashes in the team's colors. 📷 **WENDY KAVENEY**

FLAG FOOTBALL *(previous right bottom)*
Carmel, IN
Football is a dirty sport. 📷 **SUSAN DORSEY**

THE JUG P-47 *(opposite)*
Indianapolis Airshow
Taken at the Indianapolis Air Show at Mt. Comfort Airport.
📷 **DAN WINSHIP**

MAKING THE SHOT *(left)*
Borrowed a fisheye for the first time during the air show. I'm going to have to get me one of these. 📷 **PAUL D'ANDREA**

AERIAL ACROBATS *(following left)*
Mt. Comfort Airport
Planes demonstrate aerial acrobatics at the Indianapolis Air Show.
📷 **WENDY KAVENEY**

INDIANAPOLIS AIR SHOW *(following right)*
Mt. Comfort Airport
The Indianapolis Air Show, which is held annually in at the Mt. Comfort Airport during early June, sports many aircraft vehicles from helicopters to stealth bombers, all of which perform an array of aeronautical stunts for the public. 📷 **ANTHONY DEAK**

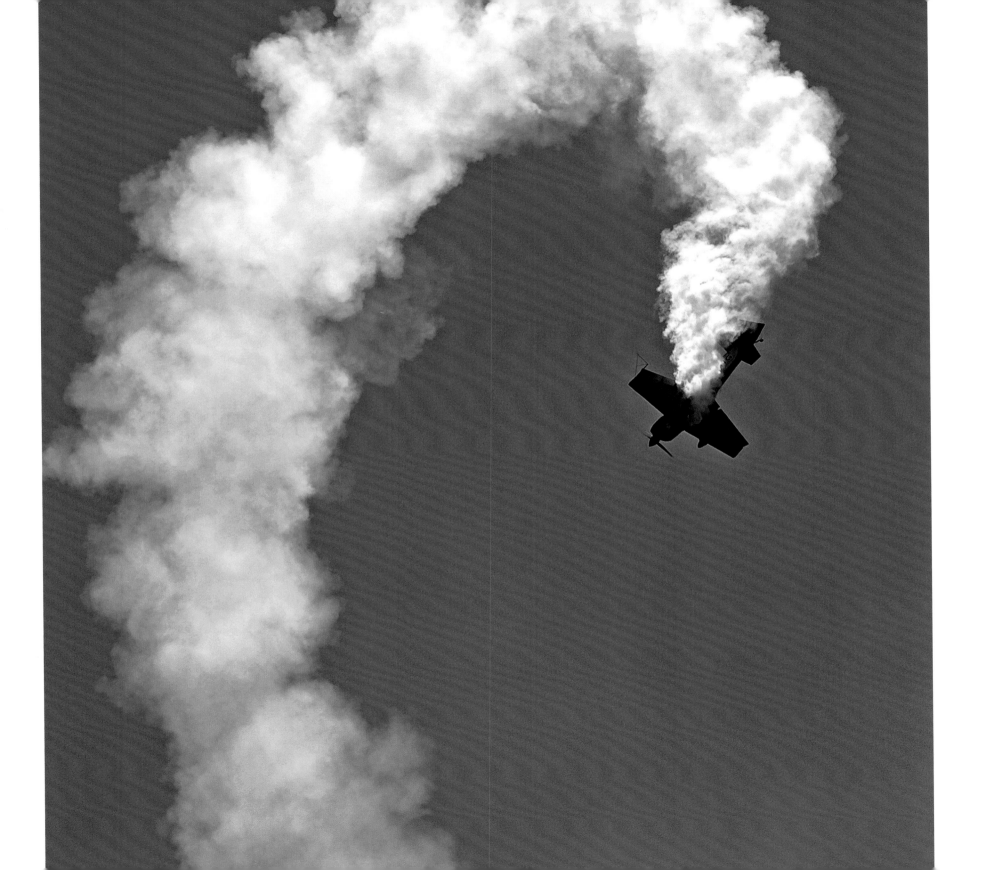

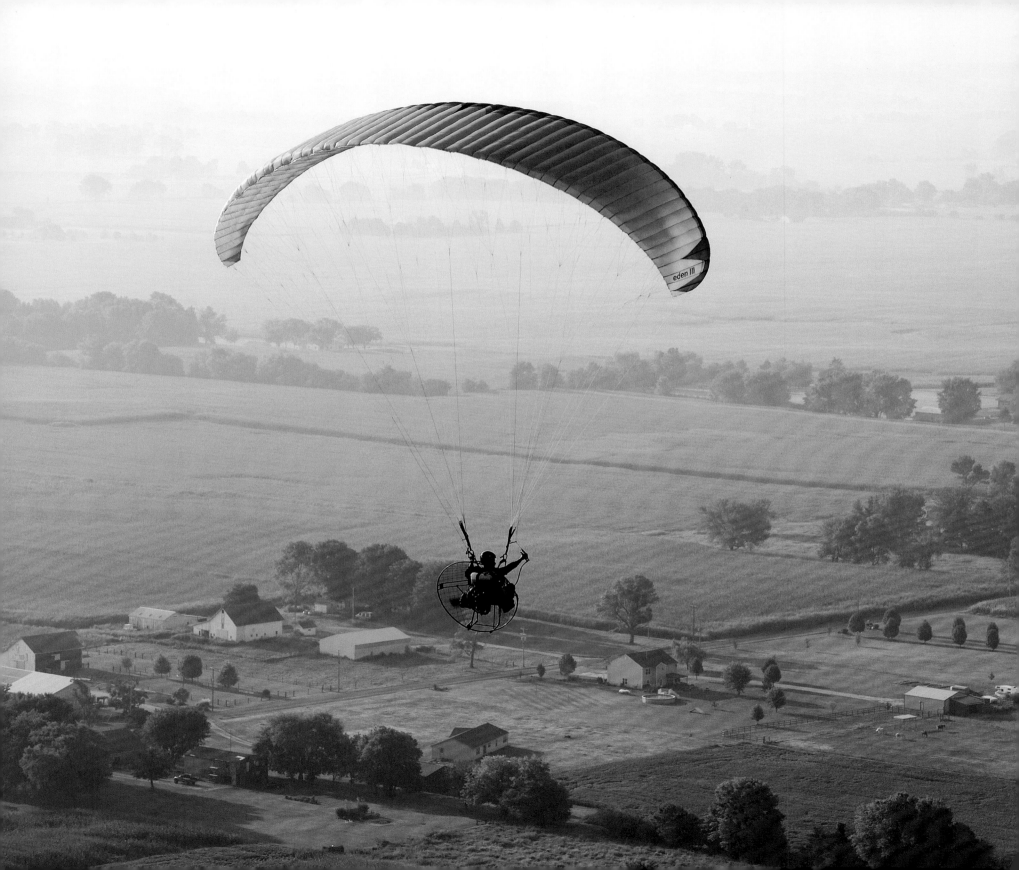

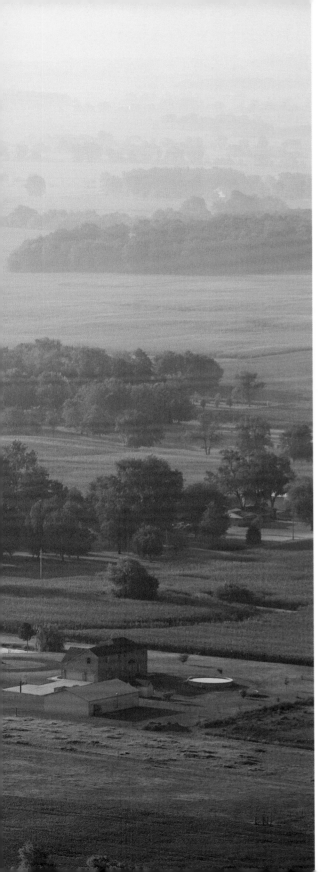

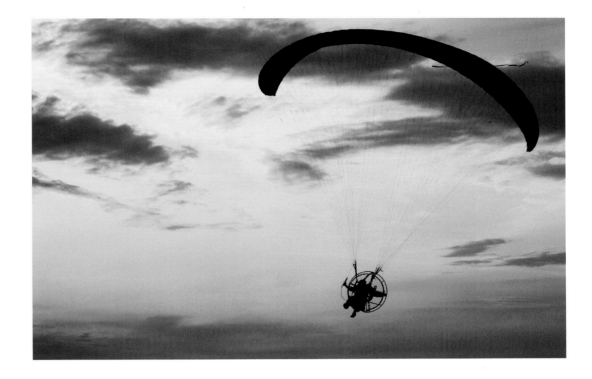

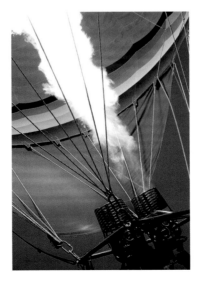

SPACIOUS SKIES *(above)*
A powered paraglider pilot flies in Greenwood, Indiana.
📷 **T. JASON WRIGHT**

LOTS OF HOT AIR *(left)*
Indianapolis
Warming up a hot-air balloon with a propane flame at the annual hot-air balloon "Night Glow" at the Indiana State Fairgrounds. It sounds like a jet engine roaring when it lifts off. 📷 **STEVE BROKAW**

FLYING ON A HAZY MORNING *(far left)*
Indy Air Hog Matt W. sharing a nice morning flight with me. I love flying in the mornings! 📷 **T. JASON WRIGHT**

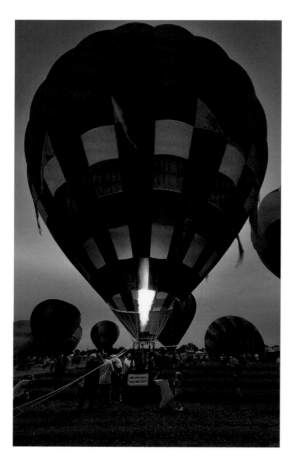

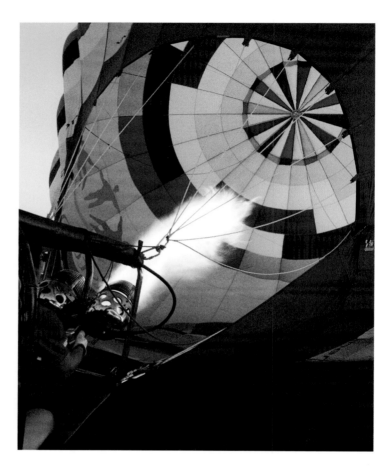

COLORFUL *(above)*
Balloon at the illume the night before the
Indiana State Fair opening. 📷 **PHILIP JERN**

ALL FIRED UP *(above)*
Indianapolis, IN
A balloonist inflates his hot air balloon at
the State Fairgrounds during the an-
nual Balloon Glow event to kick off the fair.
📷 **WENDY KAVENEY**

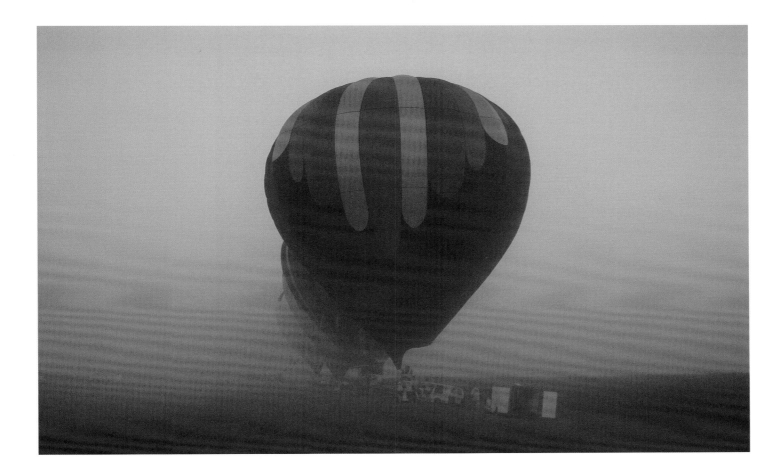

EARLY MORNING INFLATION *(above)*
Early Morning inflation, Indy Air Show
📷 **LYNN MAILLOUX**

★ **FIRE IN THE HOLE** *(following left)*
Mount Comfort Airport
The balloon crew Oompa Loompa prepares
for an early morning flight at Mount Comfort
Airport. This was part of a larger effort at the
Indianapolis Air Show to raise money for Riley
Children's Hospital. 📷 **DAVID STEPHENSON**

EARLY MORNING
FLIGHT *(following right)*
Several hot-air balloons depart Mt. Comfort
Airport for an early morning flight prior to the
Indianapolis Air Show. 📷 **DAVID STEPHENSON**

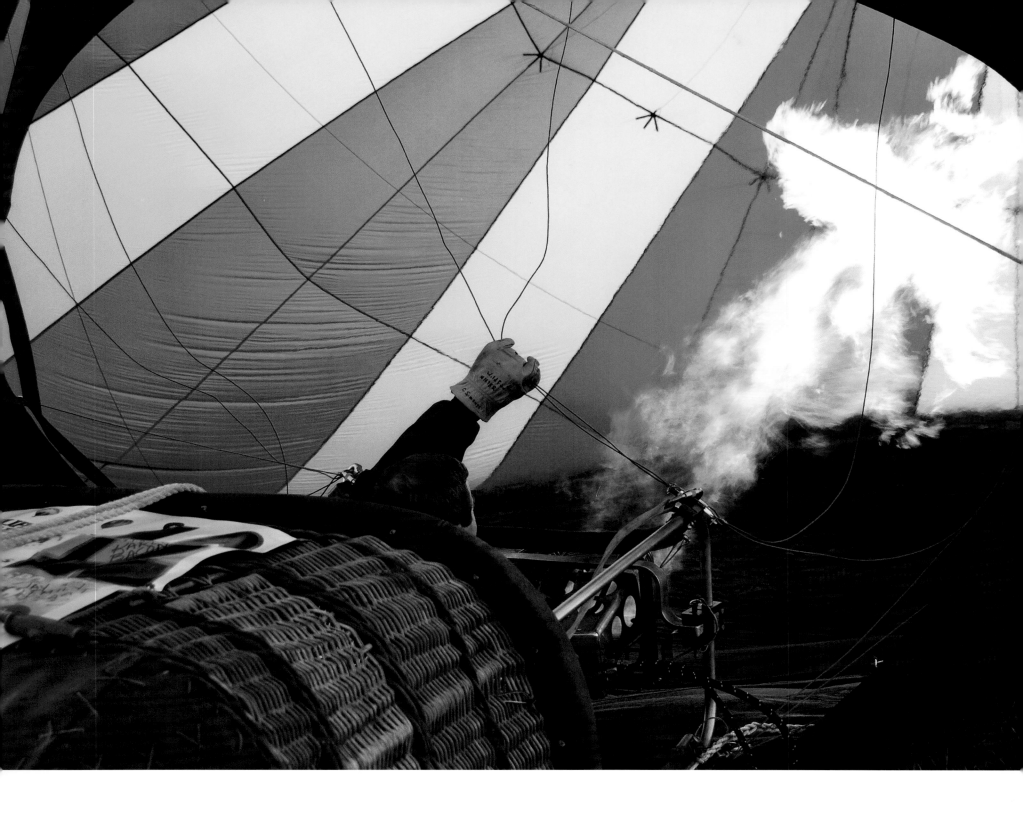

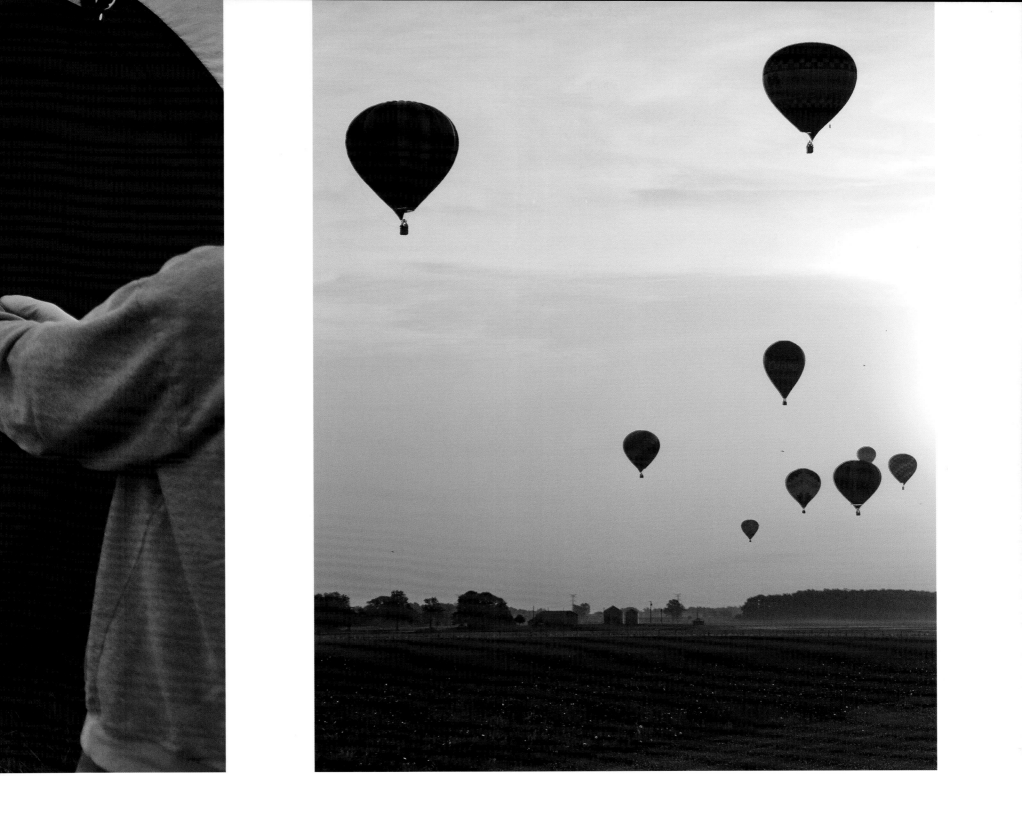

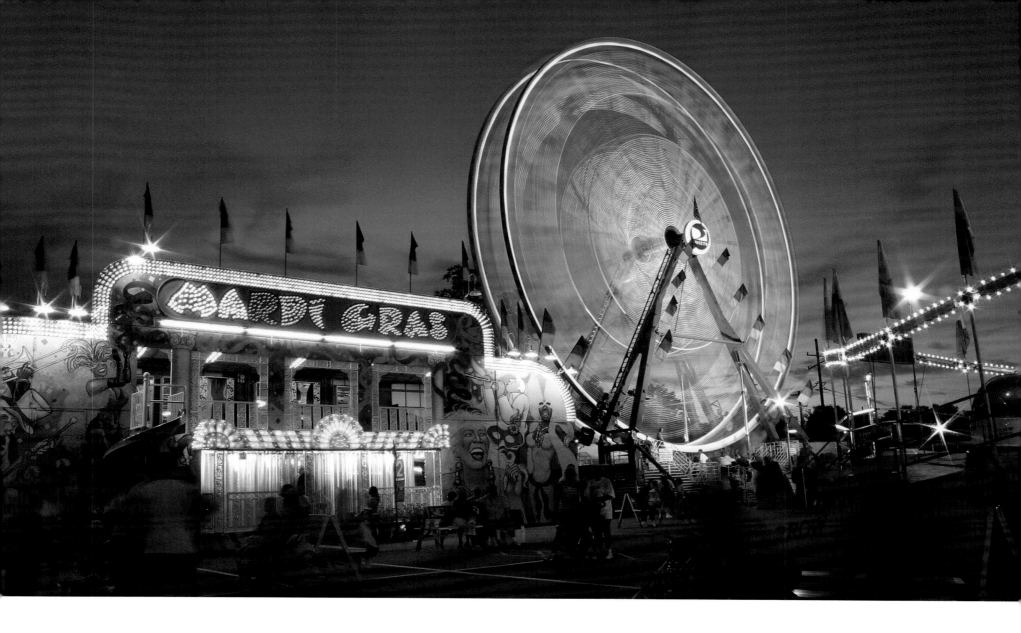

★ **STATE FAIR AT NIGHT** *(above)*
State Fairgrounds 📷 **PAUL ANDERSON**

❝ The Indiana State Fair comes alive in this early evening time exposure.
— **PAUL ANDERSON / STATE FAIR AT NIGHT**

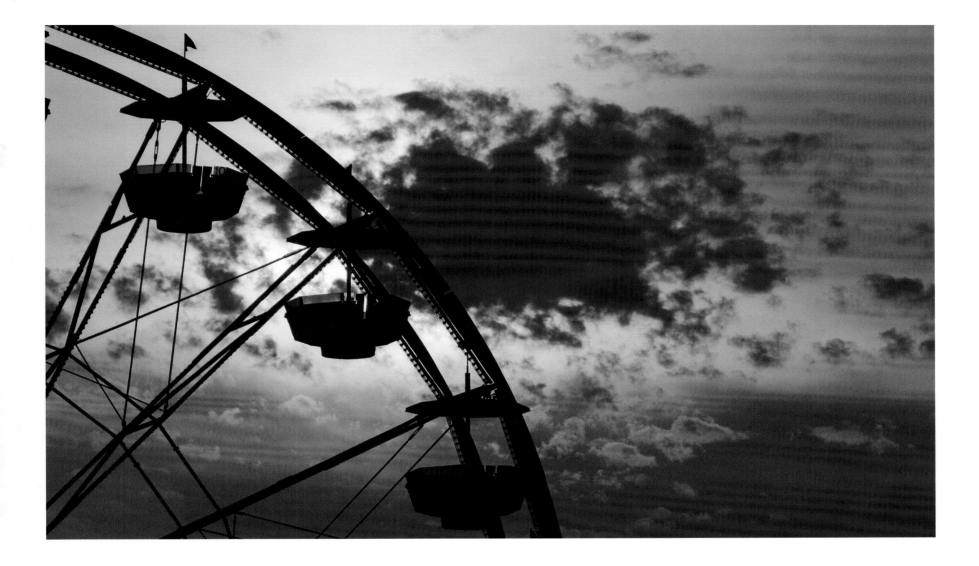

EMPTY AT SUNSET *(above)*
Indiana State Fairgrounds
The Ferris wheel at the Indiana State Fair sits
empty at sunset. 📷 **DAVID FANCHER**

Arts & Culture

SPONSORED BY THE ART INSTITUTE OF INDIANAPOLIS

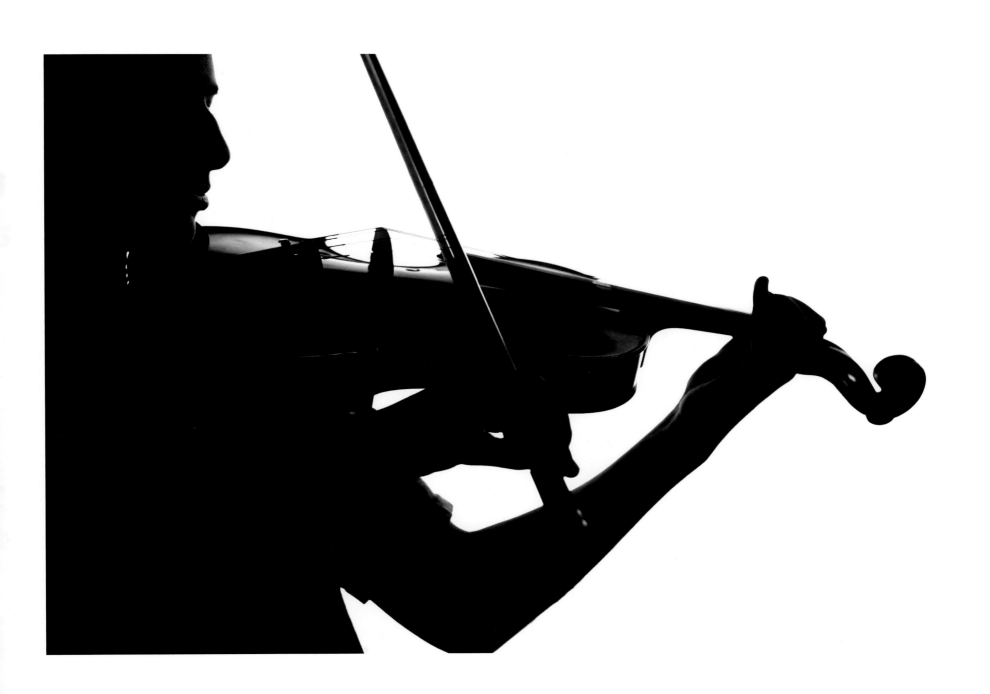

**VIOLIST AT CARMEL
MIDDLE SCHOOL** *(previous)*
Beautiful budding musician from Carmel
Middle School. 📷 **KATHY SHREVE**

★ **LOCAL INDY
SAX PLAYER** *(right)*
Local Indianapolis saxophone player Brian
Taylor plays around the city at different venues.
You may have seen Brian at restaurants,
benefits, charity events or private functions.
📷 **ERIC SANQUNETTI**

UNTITLED *(opposite left)*
Birdies
Henry French and Derek Hanson of
Henry French and the Shameless.
📷 **JOSHUA HOLLANDSWORTH**

**TRINA PLAYS
THE FRINGE** *(opposite right top)*
Singer-songwriter Trina Hamlin performing
at the Indy Fringe. Trina currently calls New
York City home, but Indianapolis is a frequent
stop for her when she's on tour. Most folks
think of her on guitar and harmonica, but
Trina can rock the house with a piano too.
📷 **KARL ZEMLIN**

311 CONCERT *(opposite right borrom)*
Indianapolis
A crowd at the 311 concert at White River
Park. It was awesome! 📷 **ANNETTE WILLIAMS**

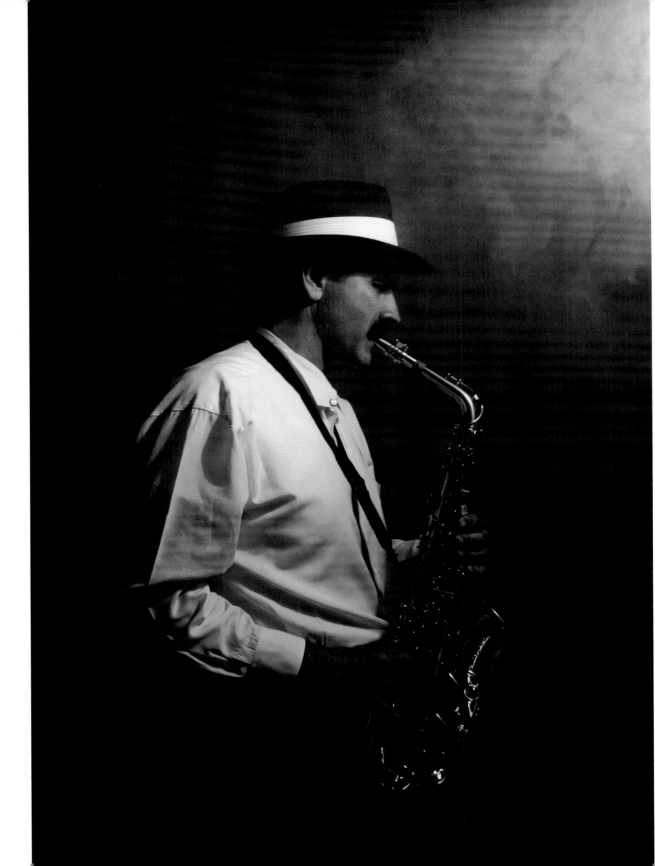

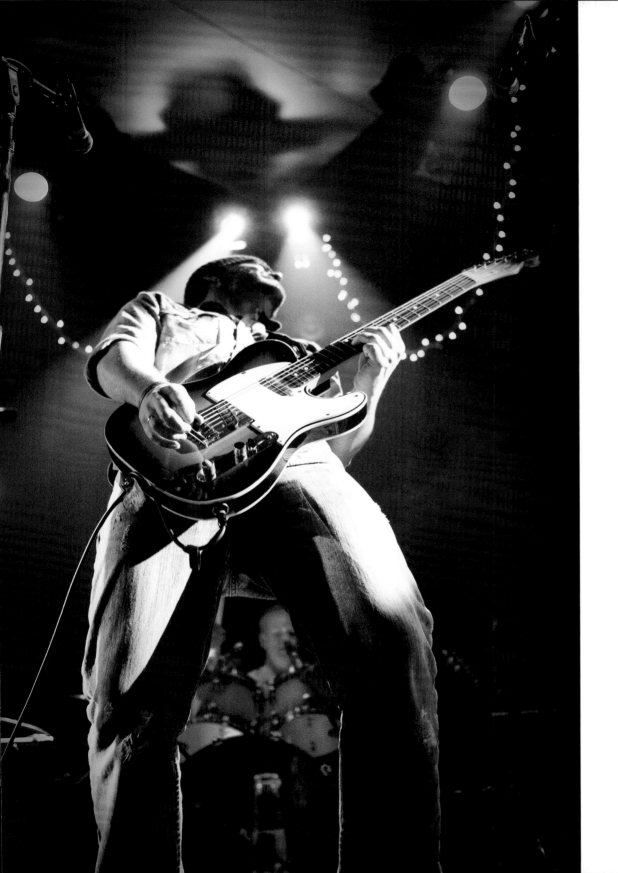
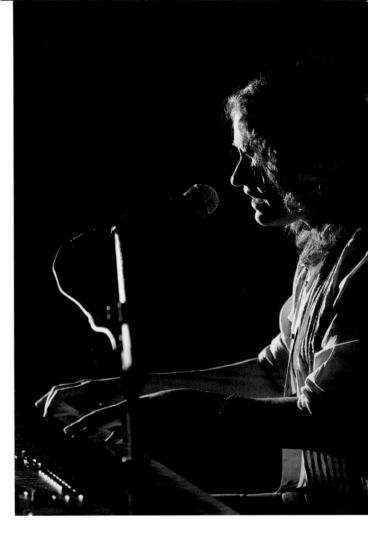
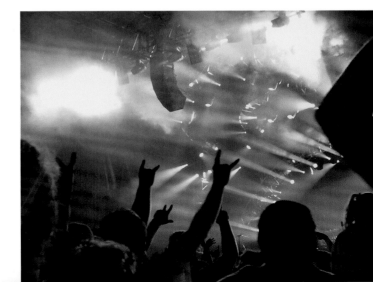

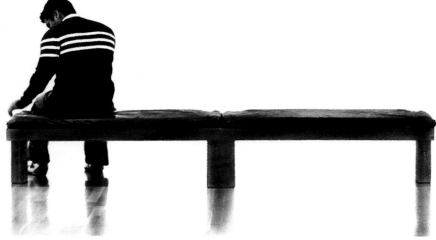

" When I visited the Indianapolis Museum of Art a few years ago, as I panned around with my camera, I noticed a new artistic light from a few of the art pieces ... that's the beauty of art; you can take someone's vision and use it to enhance your own! — COURTNEY BROOKS / CUPIDS ARROW

QUIET *(above)*
Indianapolis Museum of Art
A quiet, peaceful setting – enjoying art at the
IMA. 📷 DOUGLAS HART

TAKING IT IN. *(opposite left)*
This was our fourth time seeing this
exhibit. I never tire of it. It is just so beautiful.
📷 RONI COTTON

HOUSE SCULPTURE *(opposite right top)*
Broad Ripple
Sculpture in the Indianapolis Art Center.
📷 DAN WINSHIP

CUPIDS ARROW *(opposite right bottom)*
Indianapolis Museum of Art 📷 COURTNEY BROOKS

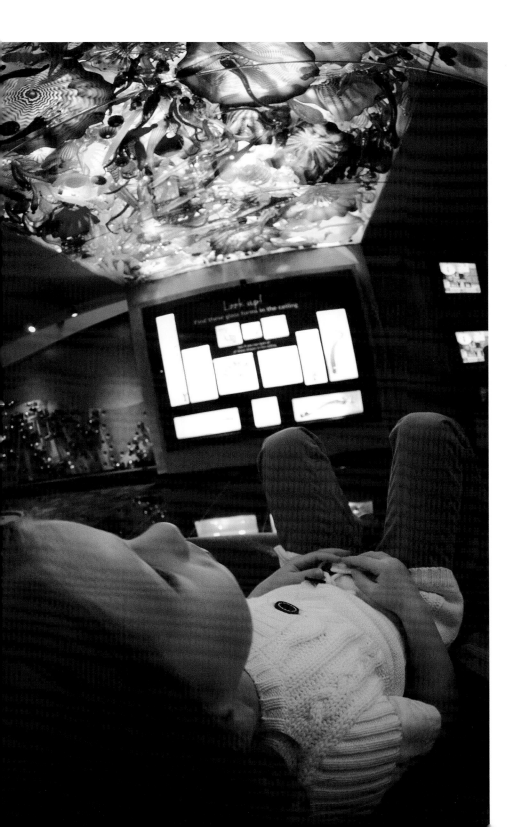

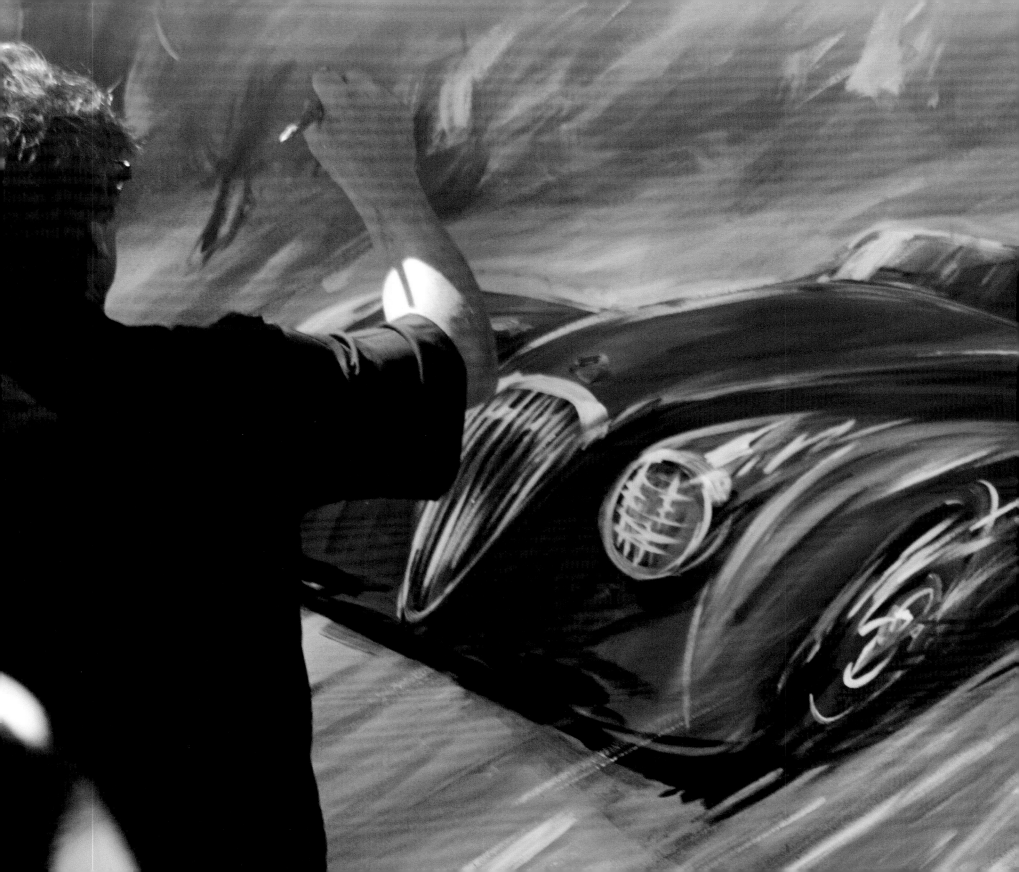

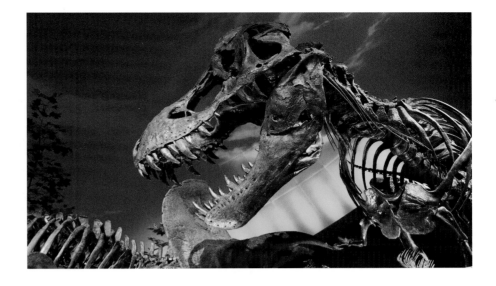

DINOS *(above)*
Indianapolis Children's Museum
In the DinoSphere at the Indianapolis Children's Museum, a T-Rex prepares to attack a
Triceratops. 📷 **ERIC THOMAS**

ARTOMOBILIA *(left)*
Carmel, IN
Artist working on a masterpiece at the celebration of Art and Design of the Automobile.
📷 **SHEKHAR GANGARAJU**

FIRE DANCE *(following left)*
Pike High School
Dancers are silhouetted in red at the production of "Oh My Goth" at the Pike Performing
Arts Center. 📷 **DOUGLAS HART**

★ **RISING UP** *(folliowng right)*
Pike High School
Rising up for the performance of "Oh My
Goth" at the Pike Performing Arts Center.
📷 **DOUGLAS HART**

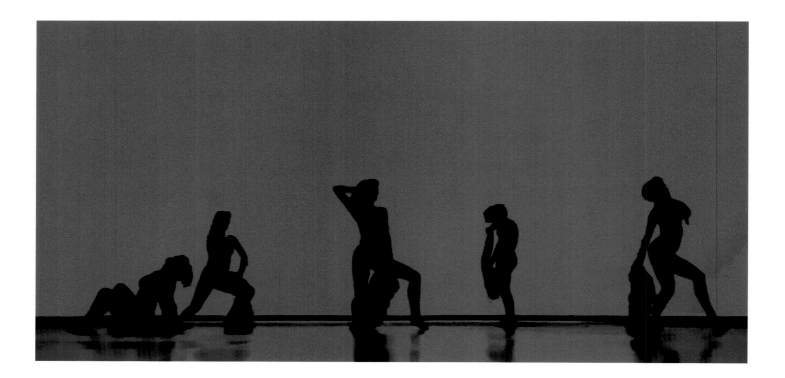

REPEAT OFFENDER BW *(right)*
Scottish Rite Cathedral
The ballroom of the Scottish Rite Cathedral, decorated for a wedding reception. 📷 **EMILY LAZAR**

PERSPICERE IN BLUE *(opposite)*
White River State Park
Stunning wind activated sculpture, built from tubular stainless steel, provides a visual centerpiece to the White River State Park.
📷 **WILLIAM DAWSON**

INDY WINE TRAIL *(below)*
Mallow Run Winery
We have our own wine country here in the Indianapolis area. Seven local wineries belong to an organization called the Indy Wine Trail. Throughout the summer and fall months, they play host to many events that include not only wine tasting but barbecues, pizza, jazz and the Carmel Symphony. 📷 **SARAH KERCHEVAL**

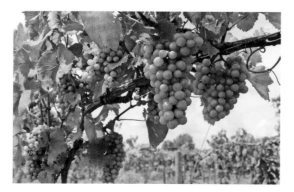

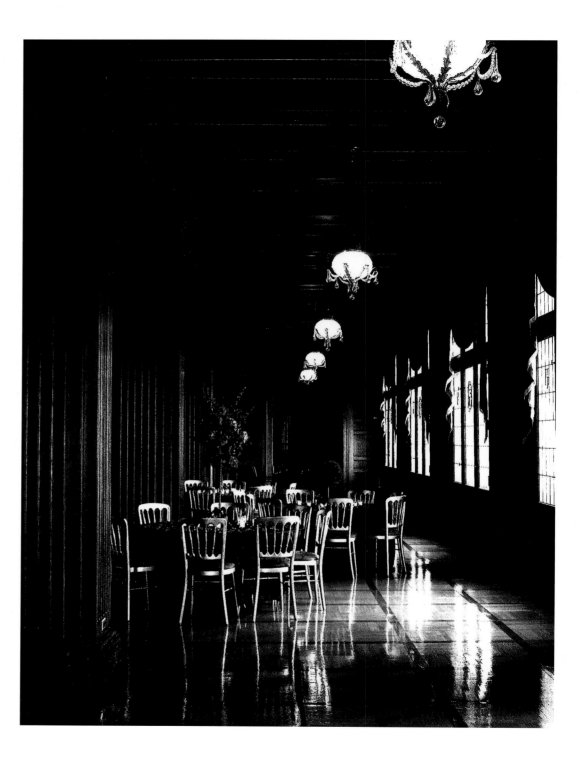

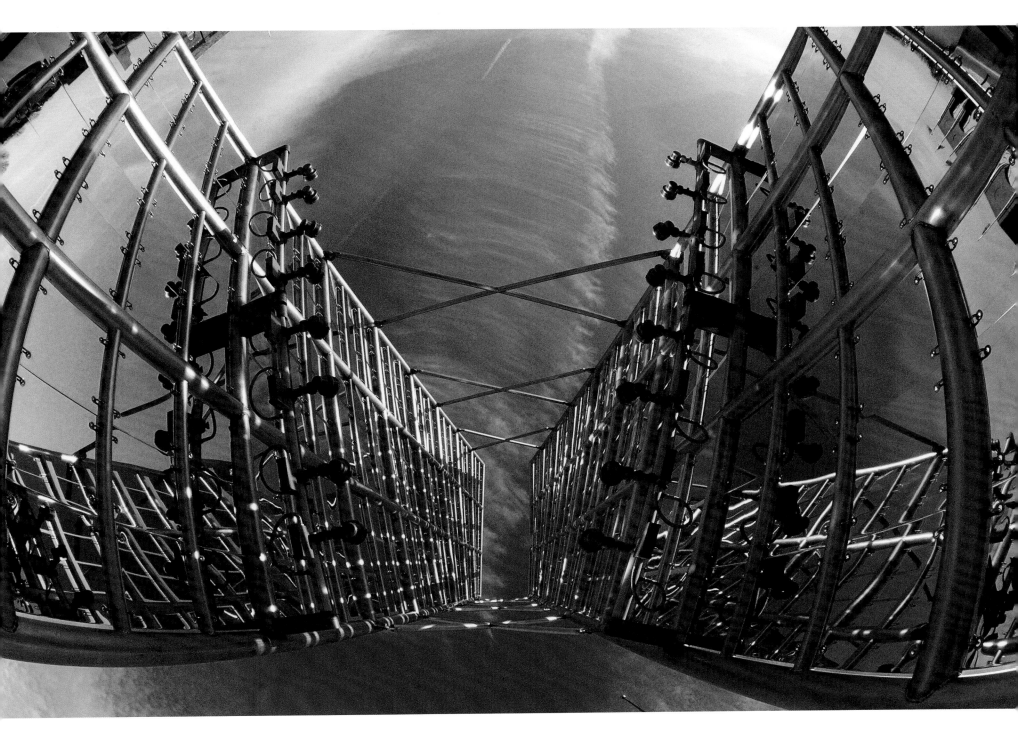

Everyday Life

SPONSORED BY UNCLAIMED FURNITURE AND MATTRESS

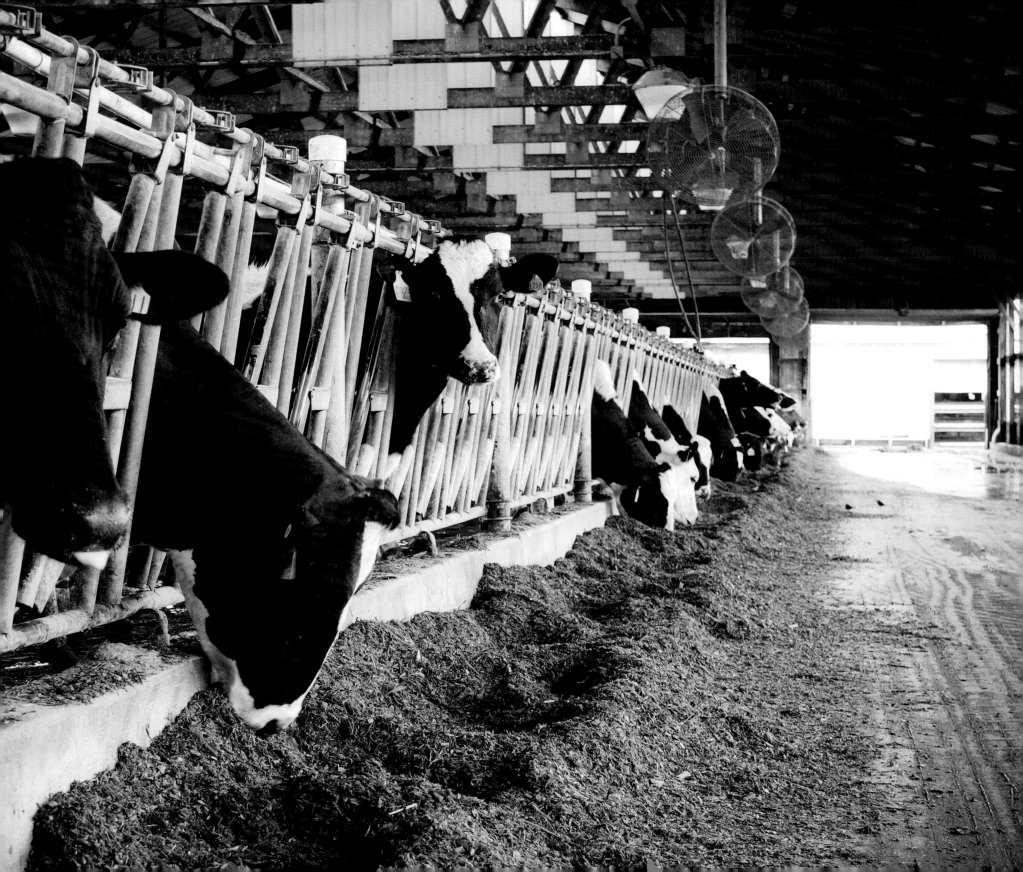

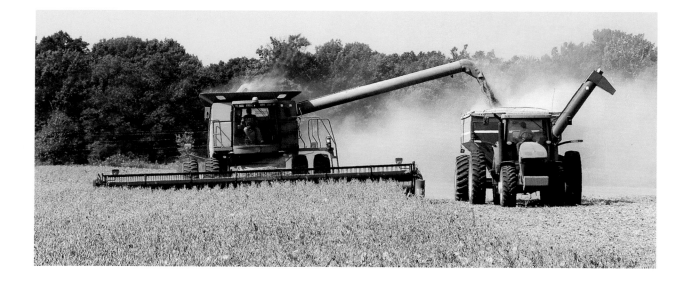

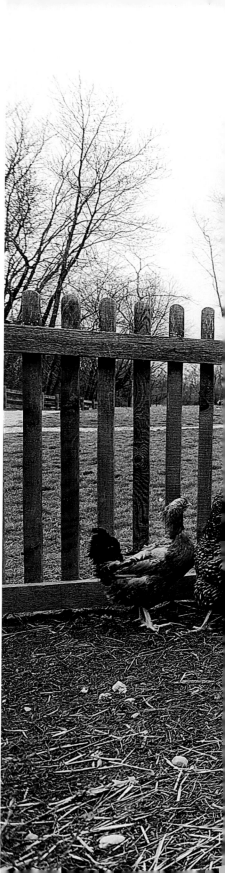

★ **FEEDING TIME** (previous)
Cows eating at Kelsay Dairy Farm in Whiteland.
📷 **JON HERING**

SOY HARVEST. (above)
Avon
Soybean harvest on the west side of
Indianapolis. 📷 **ROBERT HAWKINS**

CITY MARKET SHOPPING (right)
Downtown Indy
City market before lunch. 📷 **CHRIS ROSS**

PIONEER FARM LIFE (far right)
Under the watchful eye of interpreter Dave
Tomasi, Erik Ryden, 4, of Carmel, feeds the
chickens during a visit to Conner Prairie.
📷 **STEVE HEALEY/INDYSTAR.COM**

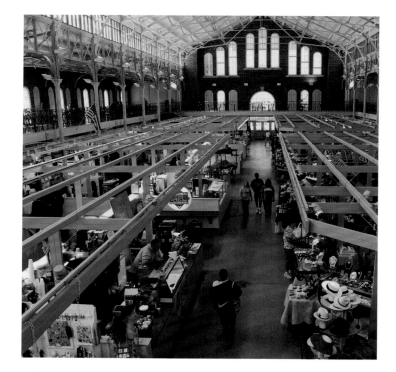

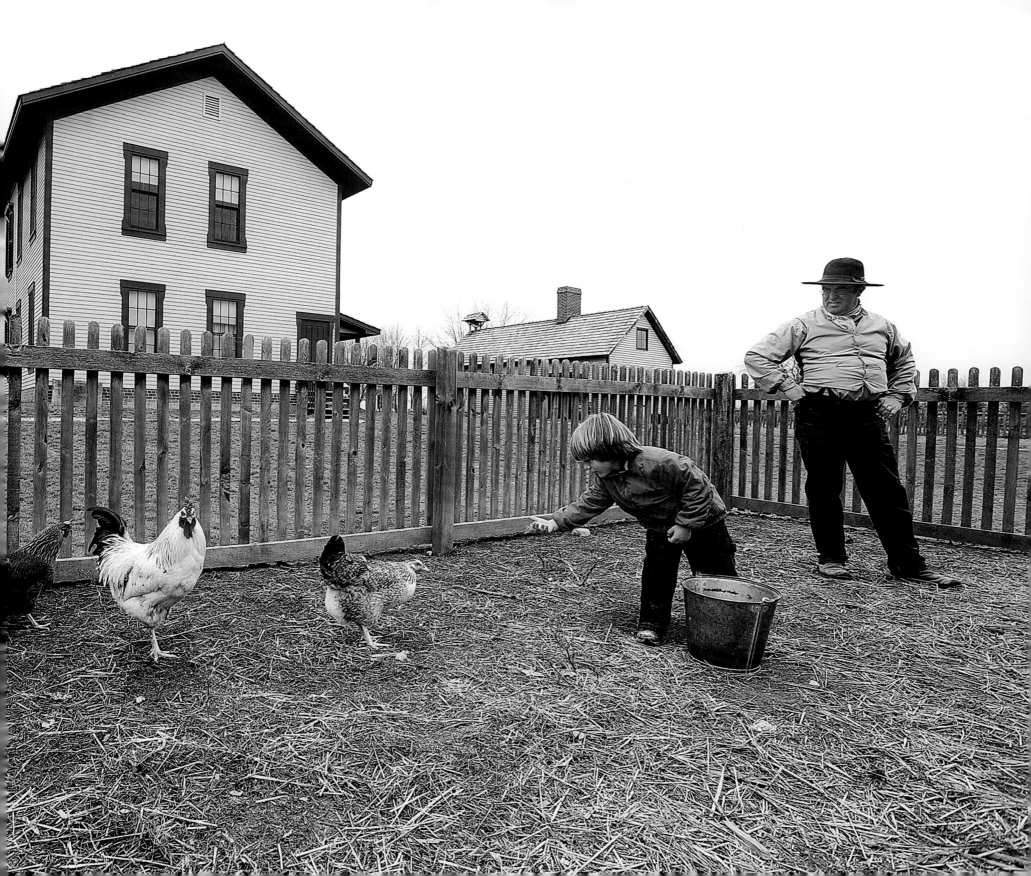

★ **SPRING BREAK AT IUPUI** *(above)*
Taken from inside Indiana University-Purdue
University Indianapolis. 📷 **AGNIS FLUGEN**

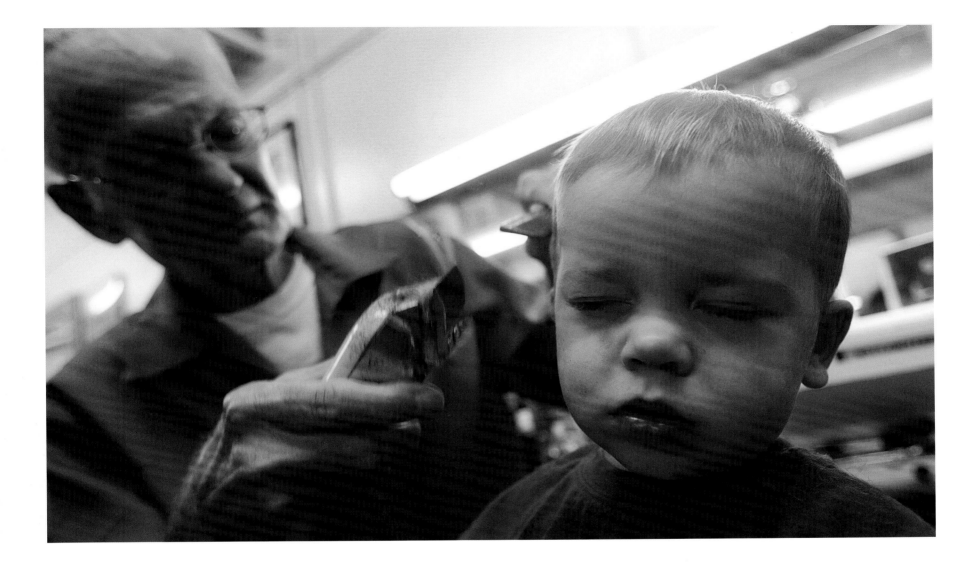

FIRST HAIRCUT *(above)*
Barber Fred Miller cuts 2-year-old Connor Kuh's hair at Fred's Barber Shop in Indianapolis. This was Connor's first haircut.
📷 **HEATHER CHARLES/INDYSTAR.COM**

IN THE FOUNDRY (right)
Peter Bridges positions the ladle with molten steel at 2,955 degrees Fahrenheit and pours the molten steel into the molds.
📷 JAMES YEE/INDYSTAR.COM

A NUN AND HER BIKE (bottom left)
A nun and her bike outside of Herron School of Art & Design. 📷 JENNIFER PARKER

SPRING DAY (bottom right)
Downtown Indianapolis
A spring day after the long winter is a welcome event in downtown Indianapolis.
📷 AARON TRISLER

UP IN SMOKE (position)
East of Morris and Warman
Firefighters aim at the fire below concentrating on the hot spot, trying to knock it down.
📷 RICH JOHNSON

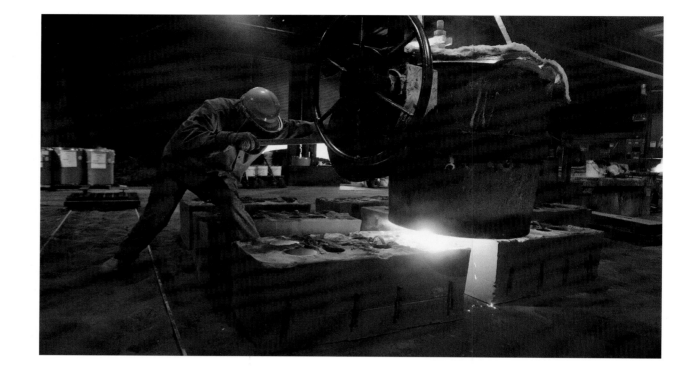

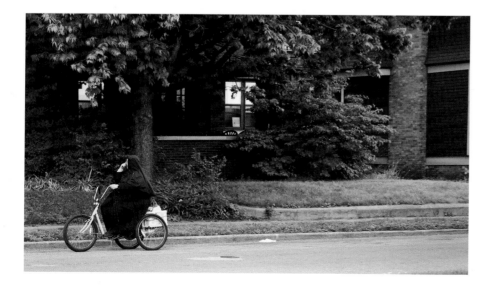

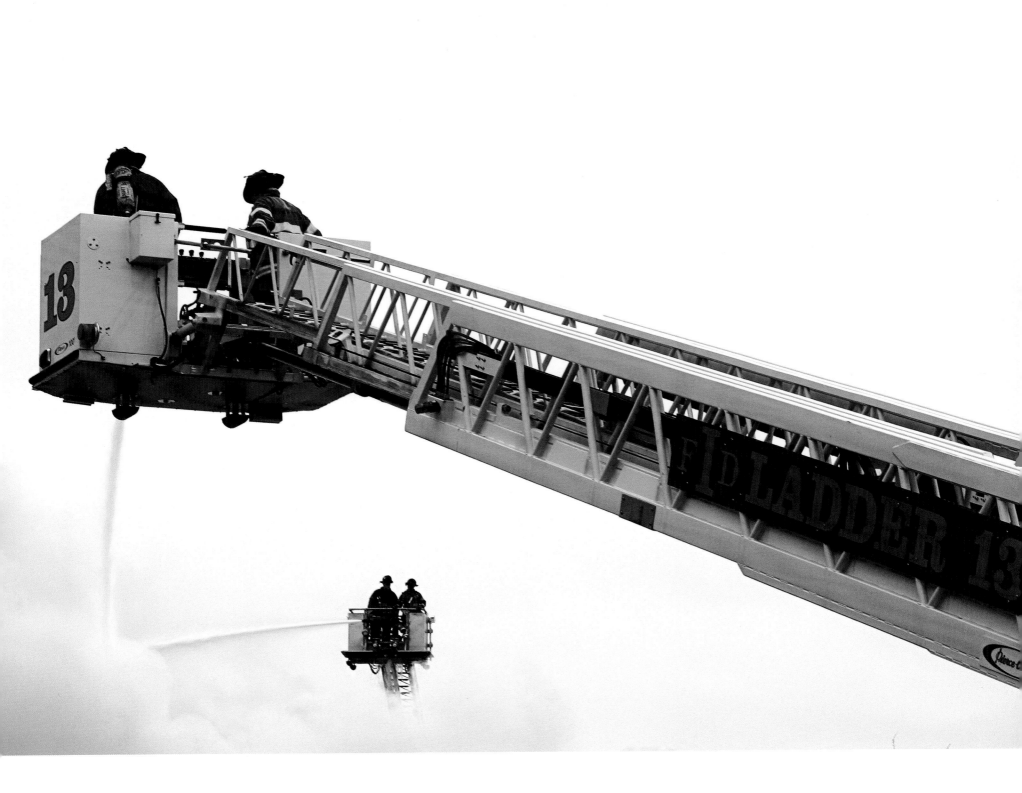

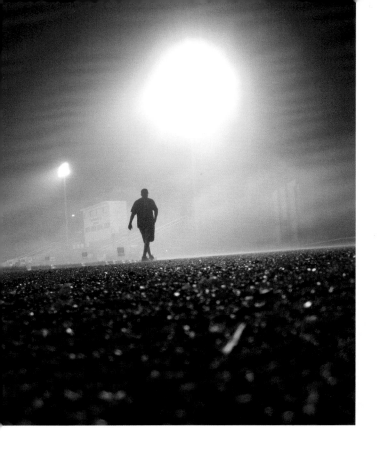

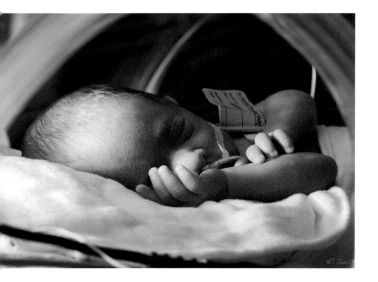

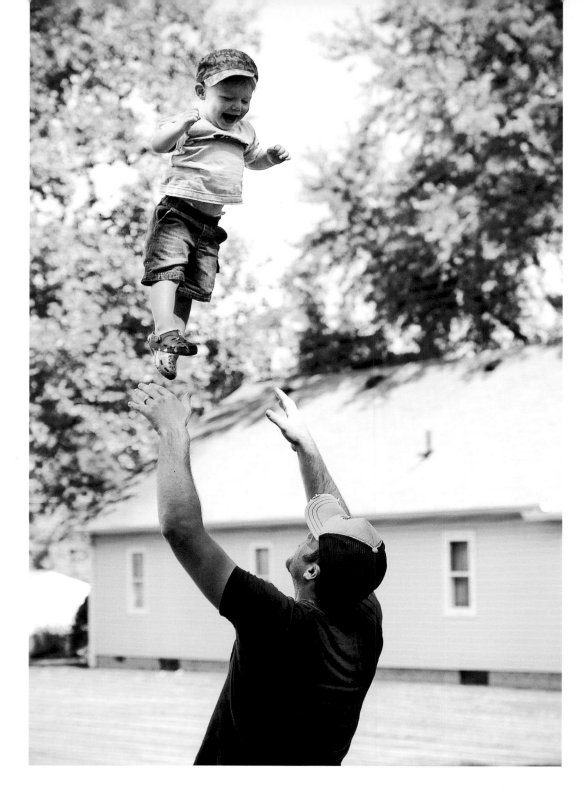

CANCER NEVER SLEEPS *(opposite left top)*
Mooresville High School Track and Field
After the fireworks fade and the community goes to sleep, participants in the American Cancer Society's Relay for Life continue walking through the night (and weather) to represent the fact that "Cancer Never Sleeps." 📷 **LINDSAY MCCAULEY**

THROUGH THE DOOR *(opposite left bottom)*
Indianapolis, IN
Looking through the door of an incubator at a premature baby in Indiana University Hospital's Special Care Nursery. 📷 **T. JASON WRIGHT**

WEEEEEEEEEEEE! *(opposte right)*
A dad doing what dads do. 📷 Rebecca Bretzinger

UNTITLED *(above)*
Indianapolis, Indiana 📷 **EMILY WINSHIP**

Pets

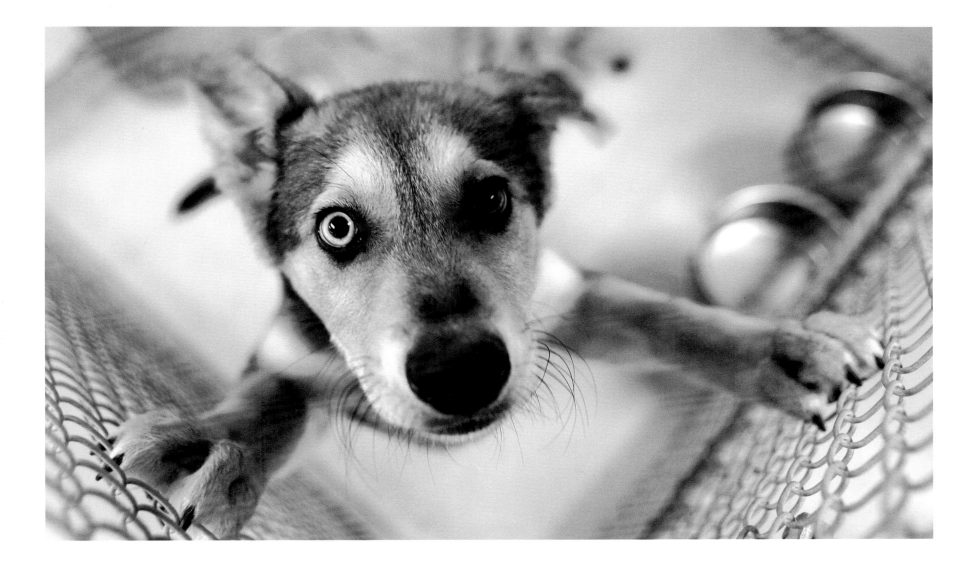

PICK ME *(above)*
A dog waits for a new owner at the
The Humane Society of Indianapolis.
📷 **DANESE KENON/INDYSTAR.COM**

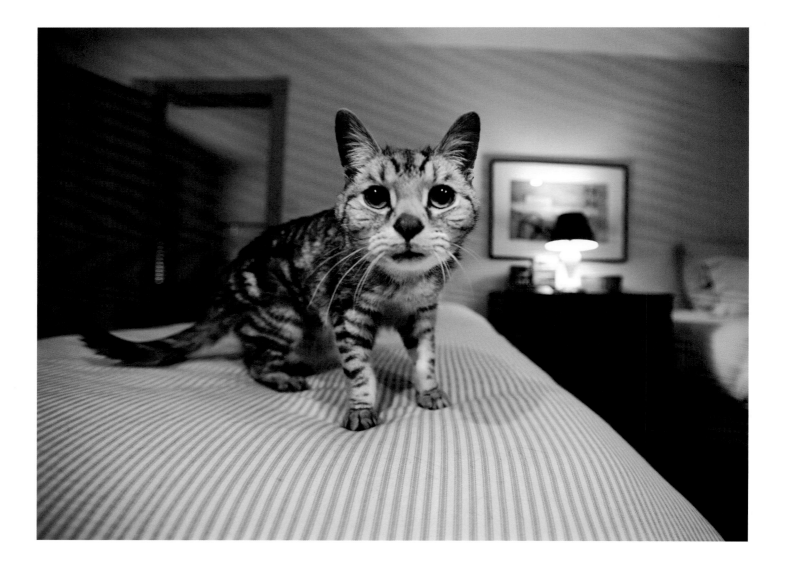

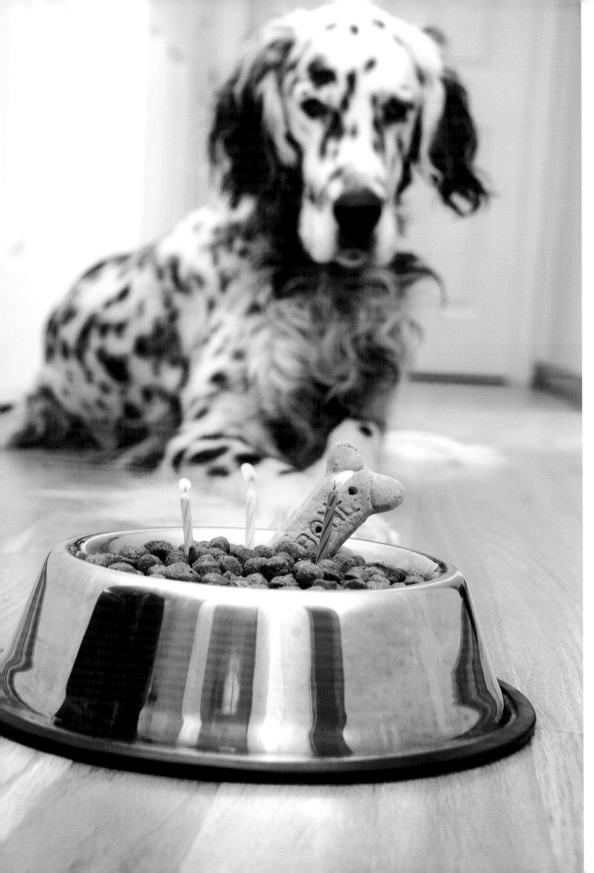

JENKINS BEING CUTE (above)
Greenwood
Jenkins being as cute as possible. He must want something.
📷 **JON HERING**

HAPPY BIRTHDAY! (left)
Birthday "cake" for Sylvester – an English Setter. Quick, Sylvester, make a wish! 📷 **ALEXEY STIOP**

A CLOSER LOOK (opposite)
A cat checks out the photographer during a home tour.
📷 **DANESE KENON/INDYSTAR.COM**

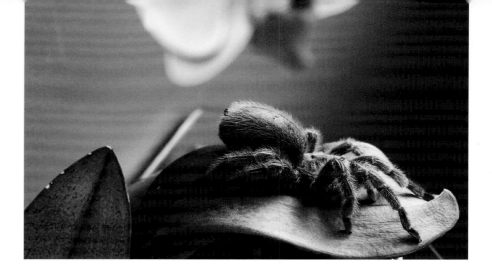
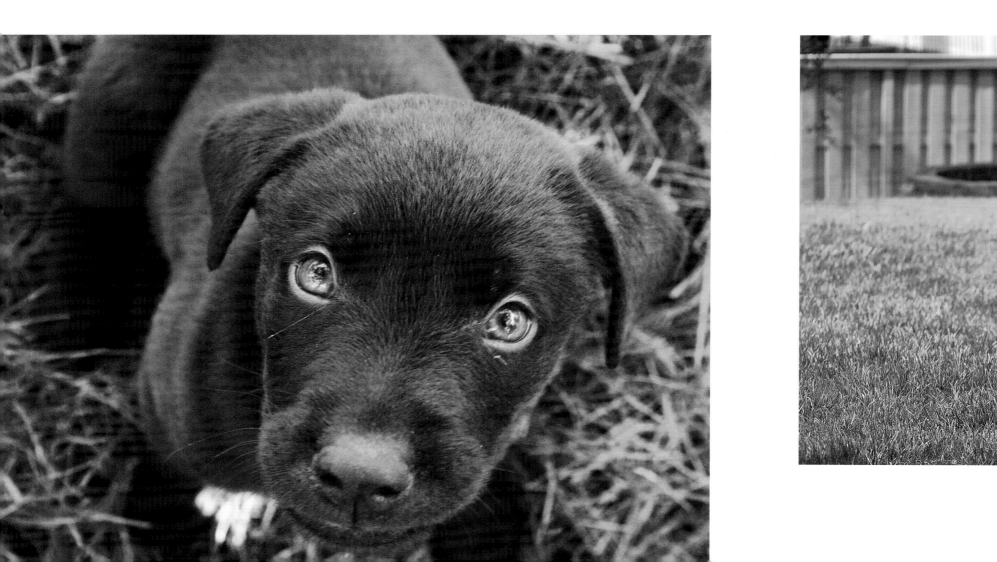

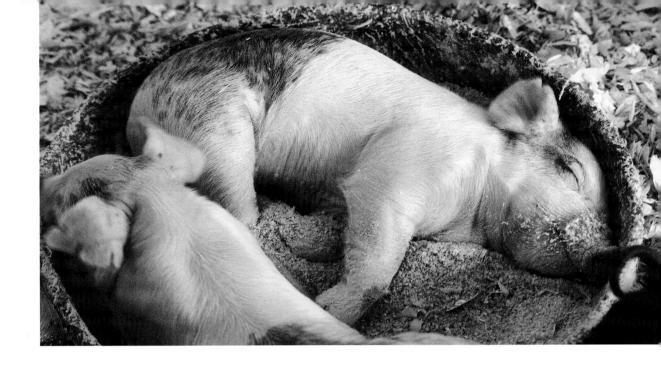

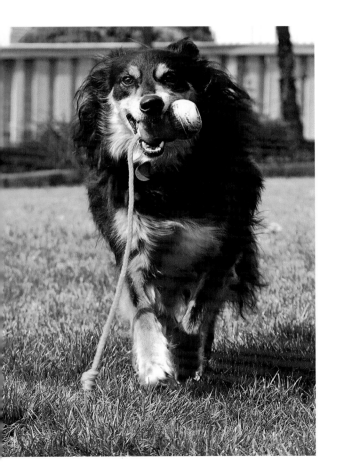

BACK-SCRATCH *(top left)*
Indianapolis
One of the three kittens my Grandfather's dog found – about 5 weeks old taking a break from scratching to see just what exactly it is that I'm doing. 📷 **JENNIFER PARKER**

★ **SLEEPING PIGLETS** *(top right)*
Indianapolis, IN
Piglets napping in their feed dish at the Indiana State Fair. 📷 **WENDY KAVENEY**

FETCH *(left)*
Fishers, IN
You can see in his eyes that he is already anticipating that next throw. 📷 **BETH BUDDENBAUM**

GRACIE *(opposite top left)*
Avon
My sister's cat, Gracie, stares out the back door longing to catch the birds that were nesting in the tree out back. 📷 **ALISSA MOORE**

❝ As I was taking pictures, Jaiden thought the camera was a toy and kept trying to bite at it. — ALISSA MOORE / JAIDEN

WILLY *(opposite top right)*
Indianapolis
Willy is a Rose Hair Tarantula. Most commonly found in South America, these tarantulas can take four years to reach maturity. Willy is five years old and almost six inches in size. 📷 **DENNIS ALLEN**

★ **JAIDEN** *(opposite bottom left)*
Speedway
My sister's chocolate lab, Jaiden, at two months old, stares at me through the lens of the camera. Jaiden is now a year and three months old and still thinks everything is a toy! 📷 **ALISSA MOORE**

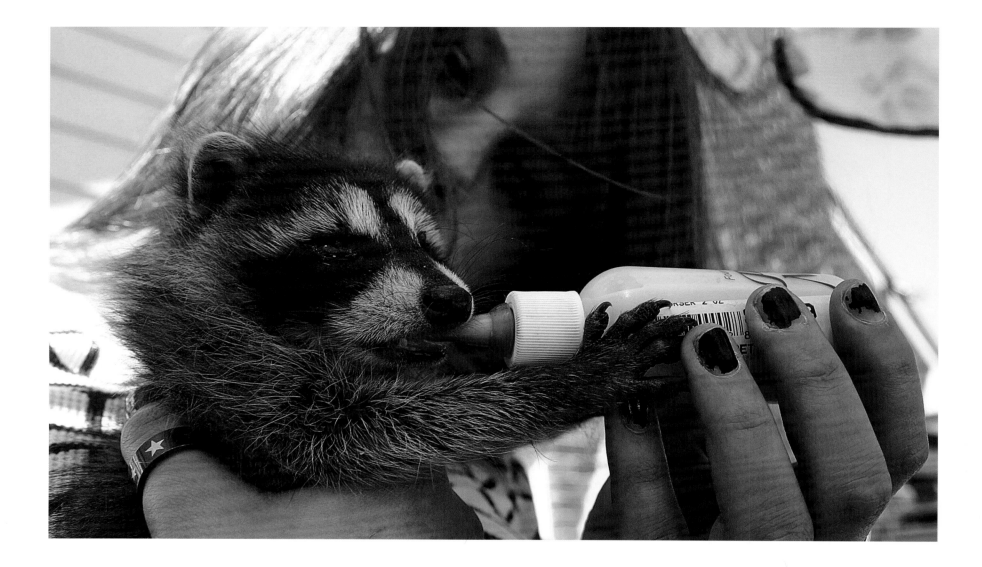

BABY RACCOON (above)
Little Annie, Rescued in Indianapolis.
📷 **ALAN GRUBBS**

Photographer Directory

Capture Indy was made possible by local photographers who were willing to share their talents with the rest of us. Here's a list of everyone whose pictures you'll find in these pages and on the DVD. If you know any of these folks, give them a ring and say thanks for the great book!

(Photographers with Web sites in following list.)

SHELLEY COHEN WOOD
SUSAN ABBOTT
MCKINNEY ABIGAIL
LESLEY ACKMAN
APRIL ADAMS
RACHEL ADAMS
RUSTY ALBERTSON
DENNIS ALLEN
ROGER ALLISON
PAUL ANDERSON
SUSAN ANKROM
ANTHONY ARMSTRONG
PHIL ASHCRAFT
BRYAN BARNHILL
STEPHANIE BASSUENER
NICK BAUER
RACHEL BEACH
RICHARD BEACH
LORAINE BEASLEY
GABRIELLE BELL
JEN BERESFORD
NINA BERRY
RISHAWN BIDDLE
DENNISE BIEGHLER
BRIAN BIGGS
JONELE BILBY
RAOUF BISHAY
AMANDA BOEHNLEIN
ANTHONY BOWLING
DIANNAH BOWMAN
HANNAH BOWMAN
RACHEL BRAU
MICHAEL BREDLOW
LAUREN BREWER
WAYNE BRIGGS
JOLENE BROAD
JENNIE BROADY
ELIZABETH BROWN
BETH BUDDENBAUM
MINDY BUHER
CARL BURKHART
DANIEL BURROUGHS
MELISSA COLLINS
JOSEPH CARDACI
MEREDITH CARLSON-CRISTO

RICHARD CAWTHORNE
JEROME CHAMBERS
ALISON CHANEY
HEATHER CHARLES
RAMON CHAVEZ
ROBERT CHEATEM
DERYL CHEW
BARBARA CHIVERS
COLLEEN CLAIRE
SHANNA CLARK
DOUG CLARK
KRISTI CLARK
JAMES CLARY
JAIME COFFMAN
WENDY COHEN
TRAVIS COLE
KERRI COLEMAN
BRANDY COLLYEAR
CINDI CONWELL
DAN COOK
PHILIP CORNELIUS
LISA COTTER
RONI COTTON
T CRAGHEAD
MATT CRANKSHAW
SCOTT CRAWFORD
WAYNE CREVELING
MARK CRUMPACKER
WILLIAM CURTIS
CHRISTY CUTSINGER
CLAUDIA DANIELS
DONALD DANLAG
BRET DAVID
CHERYL DAVIS
SUSAN DAVIS
DAVE DAWSON
WILLIAM DAWSON
MARK DEHAVEN
RAYMOND DESTEFANO
ZAIRA DEAKIN
DARREN DEDMAN
CORY DEETER
JOHN DEITER
STEPHANIE DEITZ
MICHAEL DELANEY

DR LLOYD A DELMAN
ANDRE DENMAN
SHIRLEY DENNIS
MATT DETRICH
MATT DIAL
LAURA DILLMAN
SHARON DOMINO
KIMBERLY DOYLE
AARON DRAKE
SARAH DUDIK
STEVEN DUKE
JEFF DUNCAN
DOROTHY EASTERLY
LISA EDINGTON
JIM EICHELMAN
KEVIN ELLIOT
SARAH ELLIOTT
ASHLEY EMERY
LINDA ENSLEY
RUTH ESKILSON
FRANK ESPICH
SCOTT ESSIG
CONNIE ETTER
LIN FAN
BEN FAHRBACH
DOROTHY FANCHER
BRIAN FAUX
DAVID FEINBERG
MIKE FENDER
BRAD FENISON
JIM FITZGERALD
RANAE FITZGERALD
MICHAEL FLORENCE
BRYAN FLORES
ERIK FOX
MELISA FRANKLIN
KRISTINA FREY
JUDY FRICK
ZACHARY FROMM
BILL FULTON
LISA GADIENT
TIM GALLAN
CANDY GANZEL
ELIZABETH GARZA
JEFF GERBICK

DIANE GIANGROSSI
WHITNEY GIANT
DAVID GIFFEL
MELANIE GILLIAM
ANGELA GILLIAM
CARALYN GLASS
CURTIS GLEIM
ROB GOEBEL
HILARY GOODNIGHT
JOHN GORDON
MIKE GRANT
SUSAN GRATTON
KIM GRAY
ROME GRAY
DENISE GREER
MICHAEL GRIDER
GREG GRIFFO
ALAN GRUBBS
VICKIE GUY
G H
MARY HC
WILLIAM HAAS
CRYSTAL HACKETT
TIM HALCOMB
CLAUDIA HALL
SUSAN HAM
WES HAMILTON HAMILTON
MAX HANK
SHELLY HANSEN
RON HANSON
BRETT HARBOUR
SUE HARDESTY
PATRICK HARMON
PAM HARRIS
STEPHEN HARRIS
JORDAN HARRISON
DOUGLAS HART
ADAM HARTSOUGH
CHAYA HATHAWAY
JONATHAN HAWKINS
KYLE HAYDEN
AMANDA HAYNIE
CHRIS HAYWORTH
RICHARD HAZELETT
STEVE HEALEY
LYNDA HEDBERG THIES
ROY HEDEEN
DAVID HEDGES
CHRIS HENRY
MARIE HENSON
AL HERMS
ALISON HETTENBACH
LISA HILLMAN
NATASHA HIRTZEL
JOSHUA HOLLANDSWORTH
DIANA HOLLOWAY

KIMBERLY HOLMES
STAN HOLSINGER
HOWARD HOLTZCLAW
PETER HONIOUS
DAVID HOOPER
KATHY HOUGH
BOB HOWELL
JESSICA HUNTER
GARY HUTCHISON
DAVID HYDE
JOEDY ISERT
JENNY JACKSON
SUSAN JACKSON
KASEY JACKSON
ASHLEY JELEN
SHERRI JENKINS
MIKE JENNINGS
KURT JOHANNSEN
LAMAZE JOHNSON
RACHEL JOHNSON
DEB JOHNSON
SUSAN JONES
LAUREL JUDKINS
BRUCE KAMPLAIN
J. KEESLING
KARIN KEHM
MICHAEL KELLY
WILLIAM KENNEDY
DALE KENNEY
DANESE KENON
ANN MARIE KERBY
SARAH KERCHEVAL
JIM KERSHNER
LAUREN KIBBE
ERYNN KINDRED
SCOTT KING
REBECCA KING
KEVIN KIRSCHNER
KRISTIN KLINGER
JOHN KLIPPEL
JOHN KLOTZ
BETH KOLASA
JIN KONG
MILLY KOPECKY
STEVE KRESSLEY
MATT KRYGER
MIKE KUEPER
CATHERINE L
DEE LYNCH
DEANNA LYNCH
CINDY LAHR
SHANTI LALL
COLLEEN LANE
SUSAN LANG
MARI LAPPIN
RACHELL LAUCEVICIUS

DONNA LAWLIS
CHRIS LE SESNE
MARC LEBRYK
JOSEPH LEE
ANGELA LEISURE
CORRI LEWIS
RODNEY LITTELL
LILY LIU
MARY LONG
NANCY LOWHORN
KEN LUCAS
DAVID LUCKEY
JAMIE MARTIN
KAREN MADZELAN
KATHERINE MANNING
SEAN MARCUM
JAMES MARRS
JEFF MASON
KEVIN MATTOX
REBECCA MCBRIDE
LINDSAY MCCAULEY
JAYMIE MCDOUGAL
SHIANNE MCELFRESH
ANDY MCGUIRE
LEANNE MCNEELY
 YEOMAN
ALLY MCNUTT
KELLY MCPIKE
DOUG MCSCHOOLER
THOMAS MEADOWS
LORI MENKE
DAWN MILLER
JOHN MILLS
MIKE MILLSPAUGH
JASON MILLSTEIN
BECKY MINK
GREG MISCIK
TREVA MITCHELL
MIKE MONCRIEF
EVE MONTGOMERY
GARY MOORE
SIMON MORSE
LENA M. MORTON
DONNA MOUNT
KATIE MULLINS
PEGGY MURPHY
RON NAAS
MARY NEARY
NATALIE NEITZ
BRADLEY NEMETH
LEIZEL NETRAL
NHON THIEN NGUYEN
LACEY NIX
SCOTT NOBLE
BOB NOEL
NICOLE NORRIS

MARK NORRIS
KATIE NUSSMEIER
CHARLIE NYE
MELISSA OCONNOR
YOGESH PANDYA
ANDREW PARSONS
ANDERSON PAUL
EDWARD PECK
SALLIE PEELER
MICHELLE PEMBERTON
ALAN PETERSIME
LELIA PETTIGREW
JOSHUA PHILHOWER
VALERIE PHILLIPPE
BRUCE PHILLIPS
MARILYN PIERCE
STEVE PORTER
DAVE PRESSER
JENNIE PREWETT
AARON PRITZ
KRISTEN PUGH

MAUREEN QUINN PIERSON
LAURA R.
JOE ROWLES
GRANT RAFFERTY
ANDY REBMAN
SUZY REED
LEANN REHM
JERI REICHANADTER
TINA REMENDER
NATE RENBARGER
DONNA RICH
SAM RICHE
KELLY RIEMENSCHNEIDER
DONNA RILEY
PAT RING
REYNALDO RIOJAS
BRANDON RITCHIE
AMANDA ROACH
BRIAN ROBERTS
DAVID ROBILLARD
BRIAN ROGERS

KEN ROLFSON
ALAN ROSE
CHRIS ROSS
JESSIE RUTH
STEVE SANCHEZ
RON SANDERS
ERICA SANDERS
DEBORAH SAWYER
ROBERT SCHEER
JESSIE SCHIMMEL
DAN SCHIMPF
DANIEL SCHMANSKI
KAYLA SCHMITT
MICHAEL SCHUG
RHONDA SCHWARTZ
NIKKOLE SEAL
SCOTT SEFTON
LAURA SEIFERT
DAN SEITZ
DAVID SHANK
SISTER MARLENE SHAPLEY

If you like what you see in the book and on the companion DVD, be sure to check out these photographers' Web sites. A few even sell prints so you may be able to snag your favorite photos from the project to hang on your wall.

Chapter Introduction Photographers

The many photographers listed below helped shape the introduction page of each chapter. Many thanks to these fine folks (listed in order of appearance from left to right, top to bottom):

Friendly Faces: Jennifer Parker, Prabhakar Koduri, Jeri Reichanadter, Amanda Haynie, Kevin Kirschner, Jennifer Murray, Kristin Hornberger, Michael Bredlow, Brian West, Alan Petersime, Brook Farling, Duane Dart, Gary Mead, Jon Hering, Alan Petersime, Amanda Haynie, Danese Kenon, Jennifer Parker, Ryan Baxter, Brad Thompson, Diannah Bowman, Deborah Smith, Doug McSchooler, Andrea Sanders, Jon Hering, T. Jason Wright, Rob Goebel, Rebecca Bretzinger, Matthew Yeoman, Mark Matthews, Laurie Burtner.

Scapes of All Sorts: David Stephenson, Ryan Burwell, Tim Lein, Tony Gardner, David Stephenson, Kevin Miller, Alexey Stiop, Jim Kershner, Meg Purnsley, Michael White, Kevin Miller, Agnis Flugen, Nancy Tinsley, Patrick Harmon, Philip Jern, David Stephenson, Joseph Lee, Diannah Bowman, Paul Anderson, T. Jason Wright, Eric Thomas, Kristi Clark, Jim Kershner, Nicole Norris, Scott Sefton, Jim Kershner.

Newsworthy: Joe Konz, Joseph Cardaci, Jeremy Stockwell, Deborah Oren, Charlie Nye, Marc Lebryk, Wayne Briggs, Bill Wills, Danese Kenon, Kevin Elliot, Rich Johnson, T. Jason Wright, Deborah Oren, Kevin Elliot, Matt Kryger, Matt Dial, Ron Sanders, William Dawson, Danese Kenon, Leo Ware, Kris Arnold, Anthony Deak, Sam Riche, Susan Ankrom, Matt Kryger, Whitney Lake, Jacqui Sheehan, Kris Arnold, Rich Johnson.

Landmarks: William Dawson, Kyle Pearson, Kyle Pearson, Serge Melki, Douglas Hart, Serge Melki, Amanda Allton, T. Jason Wright, Aaron Trisler, Carl Van Rooy, Chris Ross, Serge Melki, William Dawson, Dan Tomkins, John Deiter, John Klotz, Matt Detrich, Lindsay Amore, Michelle Pemberton, Kevin Miller, Kim Ort, McKinney Abigail, James Marrs, Stephen A. Crawford, Daniel Schmanski, Donna Rich, Shanna Clark, Matt Heidelberger, Shanna Clark.

Sports & Recreation: Steve Porter, Heather Charles, Mike Allee, Mike Millspaugh, Jacqui Sheehan, Jon Hering, Lisa Hannah, Sallie Peeler, Curtis Gleim, Douglas Hart, Charlie Nye, Robert Scheer, Duane Dart, Wendy Kaveney, Donna Riley, Anthony Tokarz, Fred Boyd, Paul Anderson, Matt Kryger, Ryan Brown, Joe Konz, Jon Hering, Kevin Mattox, Wendy Kaveney, Roger Blood, Jeff Mason, Sallie Peeler, Scott Swain, Chris Ross, Philip Jern.

Arts & Culture: Cindi Conwell, Emily Winship, Heather Charles, Steve Sanchez, Chris Le Sesne, Doug McSchooler, Paul D'Andrea, Serge Melki, Andre Denman, Alexey Stiop, Charlie Nye, Danese Kenon, Serge Melki, Curtis Billue, Chris Le Sesne, Joe Dudeck, Paul D'Andrea, Jordan Harrison, Kathy Shreve, Gary Hutchison, Lisa Hannah, Kevin Mattox, Deanna Smith, Lesley Ackman, Matt Detrich, Matt Kryger, Douglas Hart, Steve Standifer, Tonya Maddox Cupp, William Dawson, Duane Dart.

Everyday Life: Laura R., Brad Thompson, Laura Yurs, Lisa Hannah, Mark Matthews, Joe Konz, Mike Allee, Greg Hansen, Phil Marvin, Brad Thompson, Carl Van Rooy, Gary Mead, Bill Wills, Ross Waitt, Rich Johnson, Sallie Peeler, Emily Winship, Shekhar Gangaraju, Brad Thompson, Jeff Sullivan, Jon Hering, Agnis Flugen, Jon Hering, Doug Wampler, Kim Ort, Dennis Leonardo, Beth Buddenbaum, Sonya Weber.

Pets: Deborah Sawyer, Jeffrey Morgan, Kevin Elliot, Claudia Daniels, Brad Thompson, Jon Theophilus, T. Jason Wright, Karl Zemlin, Duane Dart, Alissa Moore, Bill Wills, Chris Hayworth, Alexey Stiop, Jeffrey Morgan, Chris Hayworth, Josh Adams, Danese Kenon, Mike Moncrief, Bret Robinson, Jennifer Parker, Lou Taylor, Jeri Reichanadter, Jon Hering, Aaron Drake, Aaron Trisler, T. Jason Wright, T. Jason Wright, Sarah Groh.

Prize Winners

When picking from 8,962 photos, it's difficult to nail down what separates the best photos from the rest — especially when so many photos are so good. To help, we enlisted thousands of local folks to vote for their favorite shots. The response was epic: more than three quarters of a million votes were cast. The voting helped shape what would eventually be published in this book. Please note, IndyStar.com photographers were not eligible for prizes. Along the way, the votes produced the prize winners below. Here's a brief explanation of how prizes were determined:

People's Choice: This one's as simple as it sounds. The photo that gets the highest score, according to how folks voted, is given this award. We picked a different winner for the Editors' Choice award, but we think local folks are pretty smart too, so we wanted to reward the photo that people like the most. This is also one of the ways we figure out the grand prize.

Editors' Choice: This award goes to the photo our editors determine to be the best in a chapter. Sometimes it'll be a photo that fits the chapter so well that it stands out above the rest. Other times it could be a photo that is technically excellent. Our editors poured over submitted photos daily during the contest and were constantly thinking about which photo should be the "Editors' Choice." Our editors also helped pick the grand prize photo from a pool of People's Choice photos.

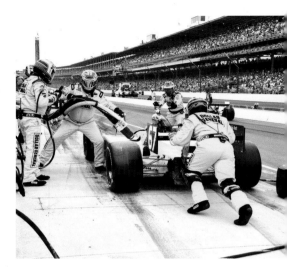

Grand Prize Winner
PHOTO BY MICHAEL DELANEY
page 88

 People's Choice in Friendly Faces
PHOTO BY RON SANDERS
page 5

 Editors' Choice in Friendly Faces
PHOTO BY EMILY WINSHIP
page 11

 People's Choice in Scapes of All Sorts
PHOTO BY STEVE STANDIFER
page 35

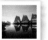 Editors' Choice in Scapes of All Sorts
PHOTO BY T. JASON WRIGHT
page 44

 People's Choice in Newsworthy
PHOTO BY GREG HANSEN
page 60

 Editors' Choice in Newsworthy
PHOTO BY CARL VAN ROOY
page 60

 People's Choice in Landmarks
PHOTO BY PHILIP JERN
page 69

 Editors' Choice in Landmarks
PHOTO BY KEVIN MILLER
page 65

 People's Choice in Sports & Recreation
PHOTO BY PAUL ANDERSON
page 108

 Editors' Choice in Sports & Recreation
PHOTO BY DAVID STEPHENSON
page 106

 People's Choice in Arts & Culture
PHOTO BY ERIC SANQUNETTI
page 112

 Editors' Choice in Arts & Culture
PHOTO BY DOUGLAS HART
page 119

 People's Choice in Everyday Life
PHOTO BY JON HERING
page 123

 Editors' Choice in Everyday Life
PHOTO BY AGNIS FLUGEN
page 126

 People's Choice in Pets
PHOTO BY ALISSA MOORE
page 136

 Editors' Choice in Pets
PHOTO BY WENDY KAVENEY
page 137

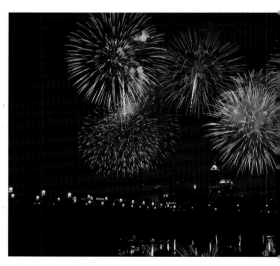

Cover Shot Winner
PHOTO BY ALEXEY STIOP
cover

Sponsors

Locally owned and operated since 1957, Roberts is Indiana's largest photographic supplier. Roberts carries a full line of cameras, supplies and accessories. First-time photographers and long-time professionals alike will find the gear they're looking to purchase and the helpful advice they need to get the most out of it.

Browse Roberts' locations in Carmel or Downtown Indianapolis, or visit them online at www.robertsimaging.com. Either way delivers the personal service and information photographers expect from a specialty retailer and the prices they expect from the Internet.

Visit online: robertsimaging.com

Tom Wood's automotive career began as a new car salesperson for a Mercury-Edsel dealer while he was attending Western Michigan University in Kalamazoo. After running a small Hillman Sunbeam dealership, which later changed into a wholesale-retail used car lot with a body shop, he moved to Indianapolis in 1967 and purchased Hedges Pontiac on East Washington Street.

Tom Wood Inc. has grown to 17 franchises and a full-scale leasing operation out of locations in four cities: Indianapolis and Anderson in Indiana; Lexington, Ky.; and Richfield, Minn. The franchises include: Toyota/Scion, Kia, Nissan, Volkswagen, Subaru, Jaguar, Volvo, Land Rover, Porsche, Audi, Ford, Lexus and Honda.

Visit online: tomwood.com

123 My First Home is a real estate company designed strictly for first time home buyers. We are members of the Better Business Bureau and continue to have an excellent customer satisfaction rating. Our passion is to provide our clients the perfect home along with unbeatable financing. These exclusive programs will save the first time home buyer thousands. You will also experience virtual tours of award winning homes that fit your budget at neighborhoods that fit your lifestyle. You can even start today and move in when your lease is up. We make the entire home buying process Easy, Fun and FREE!

Visit online: 123MyFirstHome.com

The Kroger Central Division has 153 food stores, 128 pharmacies and 54 fuel centers operating under five banners; Kroger, Scott's, Owen's, Hilander and Pay Less, with locations primarily in Indiana and Illinois. It also has five stores in Missouri, one in Michigan and one in Ohio.

Kroger Central Division is dedicated to supporting every local community it serves. In 2008, it contributed more than $10 million to local organizations, primarily focusing on hunger relief, K-12 education, health causes and diversity. At Kroger values honesty, respect, inclusion, diversity, safety and integrity.

Visit online: kroger.com

Located just west of downtown Indianapolis, IUPUI is a world-class campus that offers more than 200 academic programs leading to associate, doctoral and professional degrees. It's home to Indiana's only professional medical and dental schools as well as the largest multi-discipline nursing school in the nation. With a student body of more than 30,000, IUPUI represents all 50 states and 122 countries.

IUPUI alumni account for 85 percent of Indiana's dentists, half the physicians, almost half the lawyers, more than a third of the nurses.

Visit online: iupui.edu

The Art Institute of Indianapolis is a commercial arts school that focuses on learning-centered education. Actively participating students can maximize their creativity and acquire marketable skills and knowledge to pursue entry-level careers in their fields of study. Faculty and staff provide an environment that encourages artistic expression, leadership and responsible decision-making.

Programs are available in Culinary, Design, Fashion Design and Media Arts. Digital photography is a Bachelor of Science or Associate in Science program where students learn in a fully equipped, industry-standard Photography Lab. Scholarships and tours of the school are available.

Visit online: artinstitutes.com/Indianapolis

More three years ago, Unclaimed Furniture & Mattress opened its doors to the general public. Since then, Unclaimed Furniture & Mattress has offered outstanding values on furniture from unclaimed freight, factories that have closed, special buyouts, canceled factory orders, closeouts, closed or distressed retail chains and special purchases.

All furniture is brand new in original factory containers. Shoppers can browse a variety of brands to decorate in style without breaking the bank.

Visit online: shopunclaimed.com

Headquartered in Indianapolis, Marsh operates 99 Marsh Supermarkets and five O'Malia's Food Markets in Indiana and Ohio. The company has 41 pharmacy locations and is the largest pharmacy chain based in the state of Indiana. Marsh also has the distinction of being the first grocery store in the world to use electronic scanners to ring up purchases. And every week, nearly 9,000 Marsh employees serve 2 million customers.

Visit online: marsh.net